Icons of
PHOTOGRAPHY

THE 20TH CENTURY

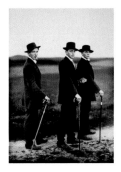

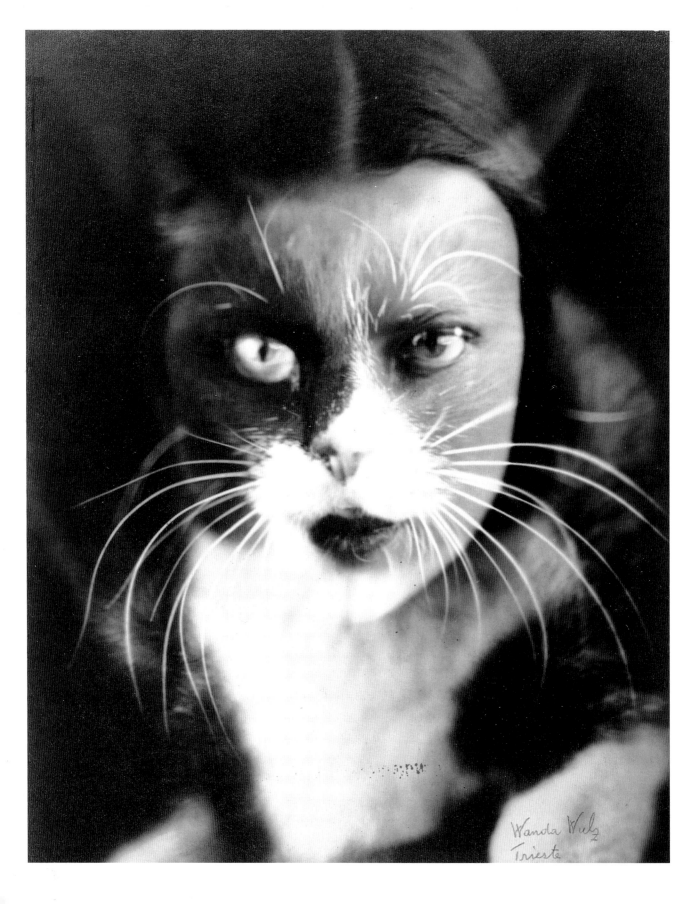

Wanda Wulz
Trieste

Icons of
PHOTOGRAPHY

THE 20TH CENTURY

Edited by Peter Stepan

With contributions by:
Erika Billeter, A. D. Coleman, Klaus Honnef,
Reinhold Misselbeck, Herbert Molderings,
Ulrich Pohlmann, Anne W. Tucker,
and Peter Stepan

Prestel · Munich · Berlin · London · New York

Front cover: Ralph Gibson, *Infanta* (p. 183).
Frontispiece: Wanda Wultz (1903-1984), *Ich und Katze*, 1932.
The Bokelberg Collection, courtesy of Hans P. Kraus, Jr., Inc.,
New York; copyright by Fratelli Alinari, Florence.

The Library of Congress Cataloguing-in-Publication data is
available; British Library Cataloguing-in-Publication Data:
a catalogue record for this book is available from the British
Library; Deutsche Bibliothek holds a record of this publication
in the Deutsche Nationalbibliografie; detailed bibliographical
data can be found under: http://dnb.ddb.de

© 2005 Prestel Verlag, Munich · Berlin · London · New York
(first published in hardback in 1999)

Prestel books are available worldwide. Please contact your
nearest bookseller or one of the following Prestel offices
for information concerning your local distributor:

Prestel Verlag
Königinstrasse 9, 80539 Munich
Tel. +49 (89) 24 29 08-300; Fax +49 (89) 24 29 08-335

Prestel Publishing Ltd.
4 Bloomsbury Place, London WC1A 2QA
Tel. +44 (020) 7323-5004; Fax +44 (020) 7636-8004

Prestel Publishing
900 Broadway, Suite 603, New York, NY 10003
Tel. +1 (212) 995-2720; Fax +1 (212) 995-2733

www.prestel.com

Coordination: Peter Stepan and Irene Unterriker
Copy-editing: Judith Gilbert
Design: Matthias Hauer
Production editing: Danko Szabó, Munich
Typeset in Monotype Apollo and Berthold Akzidenz Grotesk
Originations: Fotolito Longo, Bolzano, Italy
Printing and Binding: Druckerei Uhl, Radolfzell

ISBN 978-3-7913-3336-6

With contributions by

E.B. Erika Billeter
A.D.C. A.D. Coleman
L.D. Ludger Derenthal
K.H. Klaus Honnef
R.M. Reinhold Misselbeck
H.M. Herbert Molderings
U.P. Ulrich Pohlmann
P.S. Peter Stepan
A.W.T. Anne W. Tucker

Biographies compiled by Ulrike Lehmann

Texts by Erika Billeter, Ludger Derenthal, Klaus
Honnef, Ulrike Lehmann, Reinhold Misselbeck, Ulrich
Pohlmann, and Peter Stepan translated from the
German by Jenny Marsh, Dorset
Texts by Herbert Molderings translated from the
German by John Brogden, Dortmund

Contents

Foreword

Photography, which celebrated its 160th anniversary in 1999, has exerted a great fascination from the very beginning: it records motion, aids our memory (so quick to forget the impressions left by people and objects), and realistically shows us places where we ourselves have never been. A magical thing, the camera! It has been credited with the power to steal a person's shadow, and the mysterious interaction of silver and salt made it seem akin to alchemy.

As early as the nineteenth century, there was a scientific explanation for all this, and yet photography has lost nothing of its original magic if we look at the pictures which may be considered its masterpieces ... and the last hundred years have produced a surprisingly large number of these. For this book, one major work each from the oeuvre of more than ninety of the most important photographers was chosen. Altogether they form a "musée imaginaire," a Louvre, so to speak, of photography. Yet no museum or gallery in the world owns all of these "icons."

The selection process was first applied to the overall oeuvre of a photographer. Then, against the background of an impressive corpus of work, a single outstanding photo was selected. In the history of photography there have naturally also been many anonymous masterpieces or less extensive bodies of work, but these were not taken into consideration for this volume. The result of this process is not an assemblage of "photos of the century"—sensational pictures from the spheres of politics, contemporary history and space travel, culture and show business. However paradoxical it might sound, in these latter cases it is the subject of the photograph, not the photograph itself, that is the primary interest. Nor is photography by "artists" in the narrower sense the main focus of our interest here, even if—especially toward the end of the book—several examples of free, creative work are included in order to display the additional facets that photography has gained as an artistic medium over the last few years. It has become unfashionable to attempt to make any distinction between classical and "artistic" photography, and, indeed, it is barely justifiable in view of the change in way the photo-artists see themselves, as well as the multiple links between genres. Although frequently regretted by art theorists, such a distinction is, however, feasible for long stretches of the twentieth century, since, in one case, it is a matter of photography as photography, and in the other, of its artistic instrumentalization. The selection of masterworks presented here demonstrates the beauty of pure photography, which is why photography of the "old school" takes center stage.

Given the countless millions of photos and negatives that are preserved in public and private collections or in photographers' archives, is it not presumptuous to wish to raise ninety individual examples to "icon" status? Why only include works by these particular photographers and not also those by the other two or three hundred who are just as important? Rest assured that this restriction of scope is founded in purely technical reasons; the desire to cover "all" the major names and pictures at some point in the future remains.

Classical photography has received splendid recognition recently and is meeting with growing interest from the general public. The reasons for this are manifold. One is that we see the genre, as such, as belonging increasingly to a past age. The apparently simple world of our grandparents and great-grandparents is brought back to life before our eyes through photographs; this is photography as a nostalgic experience. But there is also another factor. Since the twenties, the novel pictures taken by photojournalists have given readers of the major daily papers the feeling of being "right there," at the pulse of world affairs. Such topicality is today provided less by photographs than by specialized news broadcasts—the technology of moving pictures. Photography is thus falling behind television. Since the invention of color television, at the latest, "old" photography has begun to acquire the patina of history. Although itself born from the craving for pictures, by comparison with today's flood of images it has become rather a quiet, poetic medium. Black-and-white, and static, it forms a restful contrast to the wildly rotating vortex of video clips and television images. Its slow chemistry has been overtaken by digitalized image production.

In the face of the newly emerging visual habits of the twenty-first century, the photographic masterpieces of the nineteenth and twentieth centuries are beginning to take on the qualities of painting, closer to Corot, Monet, and Matisse. Like them, they are full of content, the expression of a contemplation of reality. Their static nature demands concentration, unlike the distracting flow of moving pictures, where the status of the individual image has been reduced almost to the meaningless. What a wealth of "colors" an older photograph printed on paper offers in the broadly orchestrated scale between black and white! Although deliberately restricted, the values and tonal nuances exhibited here stop the eye from missing bright colors.

Many people have contributed to the production of *Icons of Photography*. Our thanks to the photographers and copyright holders, who readily gave permission to reproduce their works, and especially to all the authors with whom I had the pleasure of conducting a lively and intellectually stimulating exchange during the preparation of the volume and who supported me by word and deed. Thanks, too, to the collections—both private and public—for the loan of print material. And, lastly, thanks to my colleagues at Prestel, who joined forces to bring this project successfully to fruition.

Photography of a Century: Three Views

Time and Life

The intensity of the moment: no other visual medium can give us this with such immediacy as photography. Instant photos are spontaneous, vital, and direct. Life seems to be concentrated, condensed, in a special way, especially in photographic masterpieces. It is as though the gap of a few hundredths of a second which records the flow of things suddenly gives insight into a structure of life which is otherwise never so clearly perceived, indeed is hidden from visual access. That technical miracle, the camera, with its polished and precisely focused lenses, allows us a glimpse "behind the mirror," behind the facade. Precisely by "freezing" all movement, it often seems to succeed in revealing the secret formula of all activity.

One of the greatest misapprehensions since the invention of photography in the first half of the nineteenth century is that it merely reproduces reality. Both its technical equipment and its visual interests, differing as times change, reflect the attitude and mentality of the photographer and his audience rather than reality. "We do not see what is 'real,' we see what we are," as the French photographer Willy Ronis poignantly remarked. Like all art, photography creates its own reality. And the best photos are not those which succinctly record what has been seen, but those which understand how to structure this according to rules and laws specific to the genre.

The great thing about it is that the photographic result cannot generally be calculated down to the last detail. In photography, coincidence often plays a role. Whereas the Surrealists first had to develop strategies in order to create access via the artistic process to the uncalculated, the not rationally controlled, the subconscious, and ultimately to the accidental or coincidental, photography by its very nature offers a platform for the latter. It is the accidental medium *par excellence*. And only that photographic combination which is open to this chance factor presents the opportunity for a unique work. Only when all the parameters of an image—balance and movement, controlled and diffuse light, restraint and emotion—miraculously come together in a resonant relationship can a masterpiece be produced. And masters themselves often appear to have no influence over this, even when they strive to furnish the right conditions. Edouard Boubat (see p. 130) did not hesitate to speak of a "blessing" in this context.

"Only when the models are exhausted," runs one of the maxims of fashion photography, "do the best pictures get taken." The controlling mind must first be out of action, the all too carefully thought-out pose relaxed, before atmosphere can envolve. A good picture must be allowed to happen. The accidental, therefore, is simultaneously photography's blessing and its curse. Dozens, often hundreds, of rolls of film are taken before the desired—better said, the unexpected—result is achieved. The wastage rate is enormous, as attested by stacks of contact prints. Happy is the photographer who, looking back over his or her life's work, has succeeded in producing a handful of truly first-class works. Only a few geniuses are granted a richer harvest. But is the situation any different in the case of painters?

Both those photographers who have worked according to a system as well as photographers in specialist fields have managed to produce fascinating pictures, as have those who steadfastly hunted the inspiration of the moment. Blossfeldt concentrated on the outward appearance of plants, Sander, Erfurth, Avedon, and Goldin on human countenance, in order to capture their subject in a consistent, gradual progression. For Atget, Abbott, and the Bechers, architecture has been the *basso continuo* of their visual interest. They have held fast to their themes and explored the secrets those themes had to offer. Renger-Patzsch mastered several fields simultaneously. Things have always been different for the photojournalists and the free spirits among photographers: they press the trigger whenever something seems interesting and noteworthy—an urban impression, a human situation, here a still life, there a portrait, and so on. Their oeuvres, so to speak the records of their wanderings, emanate a sense of great freedom: Munkácsi, Brassaï, Doisneau, Weston, Bischof, Koudelka—to name just a few. Their life´s work is a stream of intensive vision, a journey of discovery to the realms that lie behind our customary ways of seeing things.

Professional training does not seem to be one of the prerequisites for great achievements, as a glance at the biographies of twentieth-century photographers will reveal. Many of them, probably the majority, were amateurs who taught themselves the necessary skills or—gifted with a quick grasp of the subject—learned by watching someone else. Photography is the Eldorado of the self-taught. This may also be one of the reasons why the course of its history is so dynamic (or perhaps, conversely, may explain why other arts have remained so static and monotonous through too much training). From this aspect again, photography reveals itself to be a "spontaneous art." Easily learned, it has also always been open to those who shunned a long and—from an artistic point of view—debatable training or could not afford it. Orthodox doctrines have never been adhered to for long, since, aside from the guild-like system of on-the-job training (from apprentice to journeyman to master of photography), there have always been people who just started experimenting with a camera on their own and who —particularly favored by the Muses—have had the best ideas.

In times when a professional system created by men for men was dominant, photography recommended itself to

women as a free space that was not yet fossilized through structures centuries old or barred to women as a male domain. Photography has made the names of many women famous—more than any other branch of art. This relatively high percentage of female creativity has also contributed to the vivacity of twentieth-century photography, as well as to that of the previous century.

Renaissance of Photography

For decades, photography was primarily considered a trade, and its representatives saw themselves as artisans, not artists. Photography was a commercial art which had to serve different purposes, sometimes clearly demarcated from one another. For example, portraiture: it has always been the photographer's task to make portraits of people. From the time of Daguerre, portraits comprised the greater part of overall photographic output. Generations of photographers have earned their living from them. In the twentieth century, too, portraitists such as August Sander, Hugo Erfurth, Gisèle Freund, Arnold Newman, Cecil Beaton, and Yousuf Karsh have carried on this tradition. Like composers of music inspired by and based on works of literature, portrait photographers have performed a definite task in which they have had to fulfill certain expectations and observe certain rules. And as this is the field in which photography has been most lastingly the heir of painting, the traditions of painting have been able to continue without a break, to an extent not found elsewhere. Compare the portraits produced by Erfurth, for instance, with those of Hans Holbein the Younger. Who does not recall the classical portrait situations: baptisms, confirmations, class photos, team pictures, graduations, weddings, and so forth, not to mention passport photos. These are the rites of passage in all our lives at which the photographer is always present. Those masterly portraits—in statistical terms, an infinitesimal fraction—which one credits with having something to say about the human condition in general stand out like solitaire diamonds from the great mass of portraits which, free of any artistic pretensions, serve solely to register a person's likeness on a given (ceremonial) occasion.

Other branches of photography have serviced commissions from industry—machines, products, factory buildings—as well as from the fashion business and advertising. Even photojournalism, which started its triumphal progress in the twenties, was an "applied" trade. When commissioned by a magazine, the photographer left his studio with its neobaroque backdrops and turned into a reporter who had to get his lens close to the political focal points and—most importantly of all—do it quickly. It was by no means the case that his pictorial trophies were subsequently presented in magazines or newspapers as works of art. Even "icons" of photojournalism that established the fame of many photographers were originally shoved onto a page in a patchwork with a dozen other photos by the picture editor.

The commission structure, which largely governs most twentieth-century photography, and the consequent way in which photographers regard their status as a trade have contributed to the fact that, within the orchestra of the arts, photography has had to be content with an instrument among the back rows. Exceptions confirm the rule: photographers from affluent families who were able to photograph exactly as they liked (Lartigue, for example), and others who understood themselves *a priori* as artists and utilized a camera in this capacity (Man Ray). To the first, we owe Arcadian visions of the lightness of being, to the latter, pioneering experimental achievements and technical innovations.

Yet its time spent in the shadow of the fine arts was not necessarily detrimental to photography. There was no particular market for it outside the commission structure. Galleries were not yet interested in it, and prices were moderate, or a private matter. Producing for the market, taking photographs for museums, galleries, and collectors—none of this happened to a large extent. Until recently, photography was spared the sort of art production which produces strange artistic trends and is frequently explicable only as something arising from the conditions of the "art" market itself. If today, for instance, the format of photographs is no longer measured in centimeters but in meters, this quantum leap in size does not necessarily mean any increase in quality. For a long time, there was no interest in photography as a medium, so it was able to develop along its own lines and produce innovative work. Art's loss of innocence, the discovery of itself as "art," only occurred in the case of photography—with some exceptions and regional differences—at a fairly late date.

The laurels of the artist have only been extended to the photographer in our time. Whereas previously, at auctions, photography ranked as subordinate to print graphics, today it enjoys an independent status, with the achievement of prices to match. Exhibitions devoted to the great names of photography can, in the meantime, expect the same sort of attendance figures as those for major painters. In the United States, developments in this respect were ahead of those in Europe by some decades. When, in 1977, "documenta 6" allocated photography a section all to itself, this led to a split in the organizing body. The renaissance of photography is not merely the result of newly won self-assurance. Artists, too, have made a considerable contribution to this emancipation from the outside by making increasing use of photography ever since the sixties. From the time of Pop and Conceptual Art, art has continually had recourse to photography, drawn inspiration from it, and thus has contributed essentially to photography's establishment. The leap into the muse-

um—in America earlier, in Europe later—took place at a time when classical photography had been sidelined by more recent developments in media technology and had thus acquired the aura of a museum exhibit.

Image and Technology

To a much greater extent than painting (which is based on a comparatively simple "technology" of oil and pigments or egg tempera), photography has been a child of technology ever since it was patented in 1839. The constant advances in the development of light-sensitive emulsions, equipment, and optics opened up new worlds in rapid succession. In the mid-nineteenth century, exposure times were still measured in minutes. It is obvious that subjects had to be selected or treated in a correspondingly static fashion. This is why Maxim DuCamp's pictures of Egypt show almost only buildings and rarely people. He could hardly expect people to stand motionless for minutes at a time (yet a skillful painter could complete a detailed sketch in seconds). DuCamp traveled through the countryside along the Nile with a quantity of baggage inconceivable to us today, loaded down with chemicals and glass plates, a darkroom, and other heavy equipment.

When, in 1924, the small-format Leica camera started production, a new profession—that of the photojournalist—was born. Equipped with high-powered lenses, rock-steady pictures were now possible with very short exposures, which made photography a metaphor for the hunt. The photographer now "lay in wait" in order to take "snapshots." Erich Salomon's *Ah, le voilà! Le roi des indiscrets* (see p. 51) takes us back vividly to this era of the early paparazzi, although indiscretion then was cultivated not for its own sake but for the purpose of providing valid visual documentation of important political events. At the same time, Salomon's photographs are masterpieces because, perhaps for the first time in the history of photography, although they were intended as instant pictures of a particular occasion, they are effective over and beyond that instant, purely as pictures of human beings.

Photojournalists were soon traveling all over the world. Henri Cartier-Bresson went to China several times, spending many months there each trip. Werner Bischof, Margaret Bourke-White, Ed van der Elsken, René Burri, and many others were at home all around the globe. And there were no longer limits to the locations where photographers could operate. Photo-reportages were made from high in the Andes (Bischof), from the mines of South Africa (Bourke-White), even from crisis-hit regions and war zones. Robert Capa became the exemplary war photographer. He and David Seymour created two of the most moving photos in the history of photography (pp. 66–67), both produced during the Spanish Civil War. Capa himself lost his life during a photo campaign in Indochina, Seymour in Egypt.

The spontaneous use of the camera even in eventful, turbulent scenes was a great step forward which opened up new subjects and thereby extended the range of themes. With the development of the mechanics of lighting, even bullets shooting through an apple could be recorded photographically (there is a famous picture of this by Harold Edgerton). Nowadays, suitably high-performance equipment can deliver the remotest star in the universe before our eyes, just like the tiniest particles of a microcosm. Beyond its scientific applications and practical uses, however, the camera as a prestigious technological object has also turned into a fetish.

Many photographers scorn the most recent technological developments and instead deliberately "go archaic" by turning to the simplest types of camera, using heavy equipment —big plate-backed cameras made of wood—and, as in the early days of photography, making their own emulsions. Modern technology is felt to be pure ballast, its ready-made papers and products constricting. Subjectivity is creating space for itself by going back to the basics. The highly sophisticated technology of this century is not necessary to capture the "simple truths" of life. Examples of such a rejection of technical perfectionism are to be found everywhere in contemporary photography. Iconographically, too, there is a noticeable tendency to draw new qualities of expression from earlier formulae: Jeff Wall's work recalls Japanese colored wood-block prints or the cinema, Thomas Ruff's a prototype of the ID or passport photo, while Cindy Sherman takes photographs in the style of Hollywood films. It is the "artists" in particular who playfully permit transitions to other genres and other eras. But Christian Schad's "Schadographs," Moholy-Nagy's photograms, and Man Ray's "rayographs" from the twenties were already attempts to allow the imagination considerable freedom from the camera. In the case of Zille or Wols, it is precisely the apparent lack of professionalism that gives their pictures their special aura.

Peter Stepan

9

Heinrich Zille in Berlin, like Eugène Atget in Paris (see p.12), retained in his photographs something of that atmosphere of the "old" nineteenth century that was drawing to a close and that would very shortly vanish from these great cities under the impact of modern industry and technology. Atget did this encyclopedically and at times officially, for documentational purposes, Zille privately and unsystematically in addition to his work as a lithographer and draftsman. The latter recorded with the camera what everyday life set before his lens; no subject was too "slight." Whether it was junk behind a house, a rubbish heap in Charlottenburg, or a laundry drying area—Zille's eye found everything equally interesting and picture-

worthy. Like no other, he recorded the life of old Berlin in living rooms, backyards, and alleyways, at fairgrounds and markets, in his drawings and photographs. His handling of the camera, then still a cumbersome piece of equipment, retained the charm of amateur photography—for which we should be thankful, since the fuzziness, inadequate lighting, and careless arrangement of people contribute considerably to the impression of spontaneity invoked by these scenes. Zille's "clumsiness" seems almost modern today, and, through the freshness of his gaze, proved to be ahead of his time, compared to the standards of professional photography back then. He avoided poses and stylizations, and the faces of the people he photographed could sometimes hardly be more ordinary.

In the picture opposite, nine boys—including his son Hans—are performing handstands on a sandy slope. The protagonists form an oblique line toward the top of the picture, while the foreground remains empty and is taken up by the play of light and shadow in the hollows in the sand. The row of boys, some already upside down, some still preparing to take position, stands out against the light gray of the sky as a richly varied sequence of movement. It would be decades before children's games of this type were again recorded photographically with a similar directness and freshness (see pp. 85, 131).

The second picture, made around the same time, takes us into the heart of Berlin. It depicts a cobbler, his apprentices, helpers, and family in the close quarters of his shop. Zille never earned money with his photography and eventually gave it up. It was only sixty years later that his negatives and prints were discovered again, in the attic of his house. P.S.

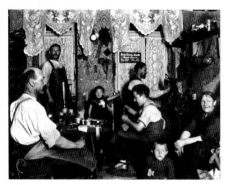

Cobbler Shop, 1899

1858 Born in Radeburg near Dresden. **1872** Trains as a lithographer with Fritz Hecht in Berlin; various jobs. **1877** Active in the Photographische Gesellschaft, in whose studio his first self-portraits are taken in 1882. **1887** First portraits of family members. **1895–96** Landscape photos and first series in Berlin. **1897** Starts intensive work with a 9 x 12 cm instant camera with interchangeable magazine. **1898–99** First engravings and aquatints, adopting motifs from photography.

1901 Participates for the first time in the black-and-white exhibition of the Berlin Secession. **1902** Decreasing photographic activity. **1905–06** Last photographed series, on family subjects. **1907** Dismissed from the Photographische Gesellschaft. **1924** Full member and professor of the Preussische Akademie der Künste in Berlin. **1929** Dies in Berlin.

Further Reading: Kaufhold, Enno. *Heinrich Zille: Photograph der Moderne. Verzeichnis des photographischen Nachlasses.* Munich, 1995.

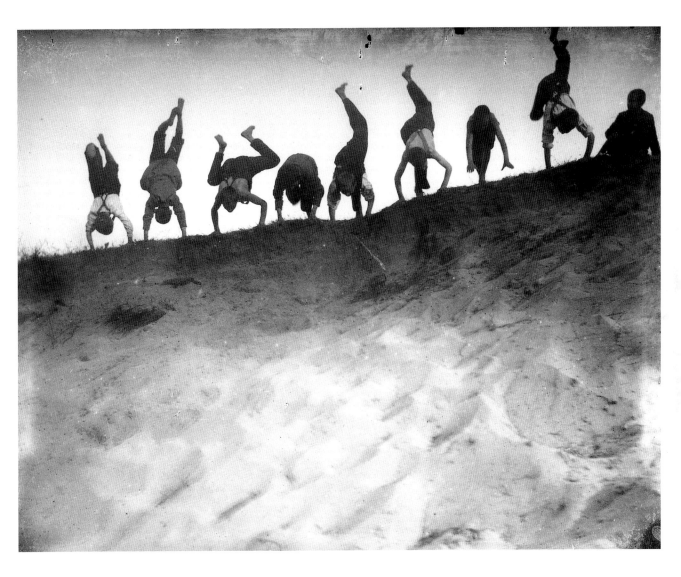

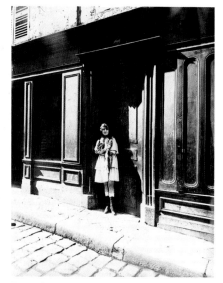

Versailles, Brothel, Petite Place, March 1921

being left to deteriorate in the name of industrial progress. Although Atget started working in what was the most modern visual medium at that time—even if his equipment was no longer up-to-date—he was not attracted to the present but, almost magically, to the past, to the fragile, to what was threatened by decay. He was interested in architecture and the urban environment, but not only in that. The artists of Surrealism discovered in his work phenomena of the unconscious with which they themselves were preoccupied, and the writer Camille Recht spoke of "scene of crime" photography in connection with Atget's pictures. Rather, in his straight, flat style, he was documenting the traditional customs and practices that were becoming ever rarer in the pulsating big city, and naturally also the people, whose smiles, in the awareness of their being out of place and time, evoke a gentle melancholy. Sometimes, too, motorcars strayed into his field of vision—but his technical skills were no match for the accelerated tempo of the metropolis of Paris. Instead, he showed the chateau of Versailles in a desolate condition; at that time there was serious consideration whether it should be demolished. The prostitute standing in the center of the picture *Versailles, Brothel, Petite Place,* without dominating it, so to speak like a showpiece in the middle of a window display, proclaims a world that no longer existed.

They produce a very touching effect in this well-known picture, the barrel organ-grinder and the singing girl, somewhere in Paris, but around them blows the icy breath of melancholy. Even at the time that the photographer asked them to strike their demonstrative poses, they no longer belonged to the real world, no more than the man with the old-fashioned camera which had already been superseded technically. Eugène Atget had struggled through life as an itinerant actor before he discovered photography for himself and chose a theme which radiated an aura that Walter Benjamin described as "near and far at the same time": the old quarters of rapidly developing cities which were

Atget occasionally placed his talent at the service of the French authority for the protection of historical monuments, which initially asked the photographer to record anything that was left that had any architectural substance. He gradually evolved a strikingly modern system of working. Thus, paradoxically, his concepts point to the future of photographic aesthetics, regardless of his subjects. K.H.

1857 Born in Libourne near Bordeaux. **1879–81** Studies at the Conservatoire d'Art Dramatique, Paris. **1881–97** Work as an actor in Paris and Bordeaux. **1897–98** Freelance painter, Paris. From **1898** Teaches himself photography in Paris. **1898–1925** Works as a commercial and topographical photographer. **1926** Discovery of his photographs by Berenice Abbott, who buys his estate following his death, and publishes and exhibits the photographs with the assistance of Julian Levy and André Calmette. **1927** Dies in Paris.

Further Reading: *Eugène Atget: 1857–1927,* Munich, 1981 (4 vols.).

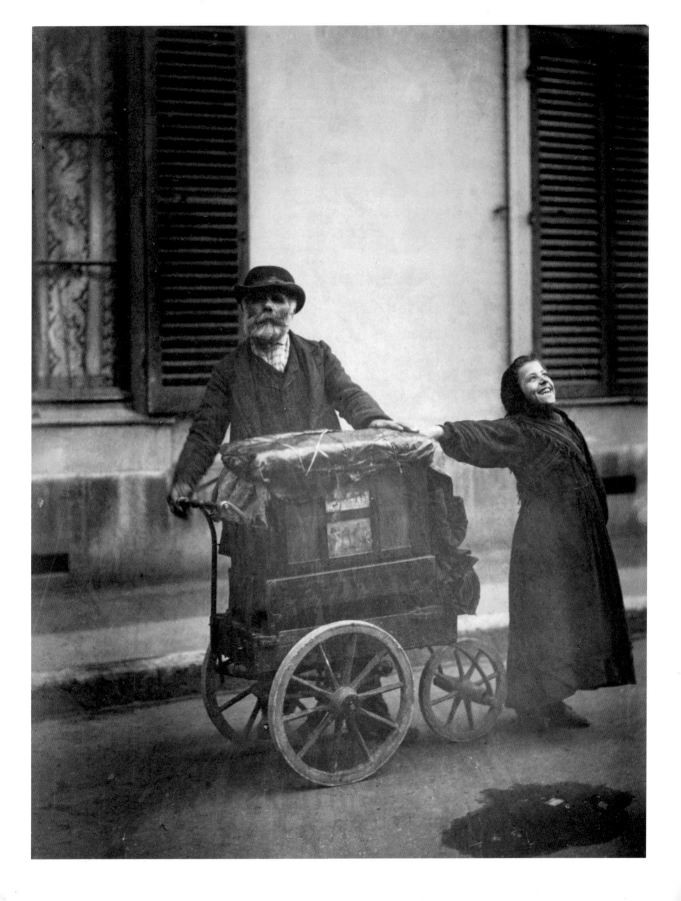

No other artist influenced the development of art in the United States at the beginning of the twentieth century to such a degree as Alfred Stieglitz. With his gallery, 291, opened in 1905, he made the European avant-garde known in New York through his exhibitions of works by Matisse, Rodin, Picasso, Picabia, Brancusi, Severini, and others, and thus inaugurated the modern era on the East Coast. With Photo-Secession, a society founded in 1902 by himself, Edward Steichen, and Alvin Langdon Coburn, as well as the journal *Camera Work*, new artistic demands were formulated for photography, based not on its qualities of reproduction but on spiritual expression. *Camera Work* became the mouthpiece for Symbolism and Pictorialism, but with it Stieglitz also introduced the beginning of a new epoch in photography, no longer oriented toward painting but aware of its own potential.

No photograph represents this radical change as well as *Steerage*. It meets the demands that Stieglitz made

of photography, that it should devote itself to the unspectacular and concentrate on creative possibilities appropriate to the medium. *Steerage* is often described as the first genuine reportage photo. Certainly it fulfills the criteria, at least in regard to content and form. It shows immigrants on the steerage deck of a ship, where they stand cheek by jowl and have to fend for themselves. No attempt was made to pose the photo; it gives the impression of being a chance snapshot, although it has been very carefully composed. The picture is taken slightly from above, the people in the lower part of the deck being clearly unaware of the photographer. Despite the photographer's distant position, the closely packed crowd of people opposite, some of whom are watching him, give the impression of being in the middle of the action. Given this closeness to the action, the spontaneity that the picture emanates, and the dominance of the content, obvious at first glance, the photograph does in fact fulfill three of the major criteria for reportage photography.

Yet this picture did not lead to any great turning point in Stieglitz's work, although he did pursue the principle of directness, the veracity that is particularly evident in the innumerable photos of Georgia O'Keeffe, later his life companion.

Stieglitz always had a polarizing influence, both as a man and as an artist. He had determined opponents, but also unconditional admirers. There is no doubt that he made things happen, and that as a photographer he was among the pioneers of the modern era. R.M.

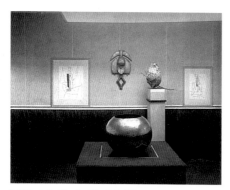

Exhibition in the 291 gallery, New York, 1915

1864 Born in Hoboken, New Jersey. **1881** Moves to Germany. **1882–90** Studies mechanics and engineering, then photography with H.W. Vogel in Berlin. **1883** First photographs taken in Berlin. **1885–86** Active as a freelance photographer for various Berlin magazines. **1890–95** Works as a photo-engraver in New York. **1892–94** Freelance photographer in New York. **1893** Honorary member of the London Linked Ring. **1893–96** Publisher of *American Amateur Photographer*.

1897–1902 Founder and publisher of *Camera Notes* and in 1903–07 of *Camera Work*. **1902** Founder and director of Photo-Secession, New York. **1905** Founder (with Edward Steichen) of the 291 gallery, New York; honorary member of the Royal Photographic Society. **1915–16** Publisher of *291 Magazine*. **1922–23** Publisher of *MSS Magazine*, New York. **1925–29** Director of the Intimate Gallery. **1929–45** Director of An American Place Gallery, New York. **1946** Dies in New York. Further Reading: *Alfred Stieglitz: An American Seer*. New York, 1973.

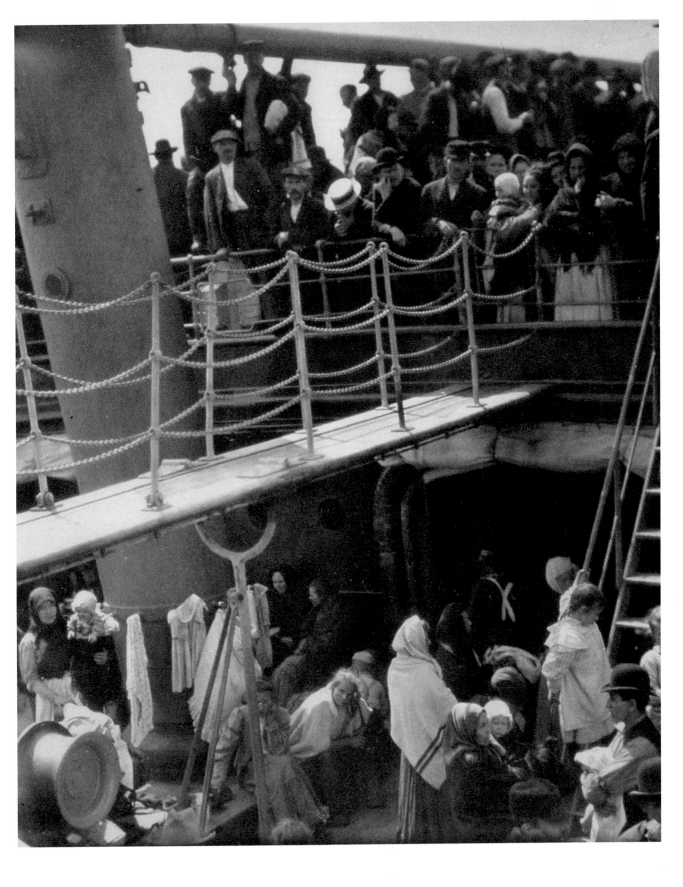

Edward Steichen

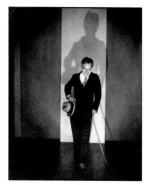

Charlie Chaplin, 1931

Edward Steichen's careers as a photographer and curator spanned the first six decades of the twentieth century. In each of these roles, his creative accomplishments yielded enormous influence. He was foremost a photographer who began working in the Pictorial style, producing some of the most stunning examples of Pictorialist master-prints. Between 1900 and World War I, his photographs were included in every major international exhibition of Pictorial photography. Whether photographing landscapes or portraying intellectuals and artists, such as Richard Strauss, Steichen preferred highly dramatic scenes and poses. After the war, he adopted a modern style, sharpening the picture's focus

and printing on gelatin silver paper with far less manipulation in his printing process. Between 1923 and 1937, Steichen worked as a portraitist and fashion photographer for Condé Nast publications, defining the mode of "celebrity portraits" in America. He retired from Condé Nast at age fifty-eight, and four years later assumed command of a photographic unit in Naval Aviation for the duration of World War II. Steichen's career as a curator began when he joined the Photo-Secession in New York in 1902. He helped design Alfred Stieglitz's magazine Camera Work (originally intended as the journal of the Photo-Secession) and in 1905 transformed his portrait studio at 291 Fifth Avenue into the Little Galleries of the Photo-Secession (later known as 291). Then living in Europe, Steichen worked with Stieglitz (p. 14) to introduce modern European art to America. Among the artists exhibited at 291 were Pablo Picasso, Georges Braque, Constantin Brancusi, Paul Cezanne, and Henri Matisse. During World War II, Steichen resumed his curatorial career by directing two exhibitions for the Museum of Modern Art. In 1947, he assumed the position as director of the photography department at the Museum of Modern Art. In 1955, Steichen opened the exhibition The Family of Man, the most universally popular photography exhibition ever organized. The catalogue is still in print forty years later. He retired from his position at the Museum of Modern Art in 1962 at age eighty-three. A.W.T.

1879 Born Eduard Steichen in Luxembourg. 1881 Emigrates to the U.S.A. with his parents. 1894–98 Studies art with Richard Lorenz and Robert Schade at the Milwaukee Art Students League, followed by training in lithography. 1895 Self-taught, takes photographs in artistic style. 1900–22 Freelance artist in New York (including 1902–06) and Europe, mainly Paris. 1901 Member of the London Linked Ring. 1902 Founding member of the Photo-Secession in New York. Together with Alfred Stieglitz sets up the photo studio 291. From 1905 Organizes exhibitions for the 291 gallery. 1906–14 European travel; encounter with avant-garde European painting. From 1908 Also active as horticulturist in Voulangis, France, and in Connecticut. 1917–19 Photographer with U.S. aerial reconnaissance.

1918 Changes his forename to "Edward." 1923 Abandons painting in favor of photography. 1923–37 Chief photographer at Condé Nast for Vogue and Vanity Fair. Sideline activity for the J. Walter Thompson agency. 1931 Honorary member of the Royal Photographic Society. 1945 Honorary member of the Photographic Society of America. 1945–46 Director of the Naval Photographic Institute of the U.S. Navy. 1947–62 Director of the photography department at the Museum of Modern Art, New York; organizes over forty-five exhibitions, including The Family of Man. 1973 Dies in West Redding, Connecticut.

Further Reading: Edward Steichen. Milan. 1993. Gedrim. Ronald J. Edward Steichen: Selected Texts and Bibliography. Oxford, 1996.

The rubber stamp Lewis Hine used on the back of his photographs up through the 1920s read "Lewis W. Hine/Social Photography." Sponsored in his efforts by public and private organizations concerned with the welfare of the poor and the working class, Hine believed that photographic evidence of social conditions could help to effect social change. And, at least in his own day, he proved himself right; his images served to convince voters and politicians to enact laws against child labor and oppressive working conditions for manual laborers in many industries.

This image of "newsies" or "newsboys"—young children who earned money by selling newspapers on the street (in clearly defined and fiercely defended territories) throughout the urban United States—typifies his approach. Hine's style was straightforward and without elaborate artifice; he believed in eloquent understatement. Here he has depicted one section of a line of boys waiting to return for credit their unsold copies of the Sunday edition of the newspaper. He views them frontally, and formally, ensuring that they all face the camera and attend to the photographic moment. They are thus rendered as recognizable individuals, each with his distinctive expression and body language. But they are also presented taxonomically, so that we can compare their heights and physiques—driving home the small size and tender age of them all, especially the youngest.

Hine shows us neither the beginning nor the end of the line; by implication, then, these boys represent only part of a much larger group waiting patiently here, who in turn symbolize countless others in this occupation across the country. Hine has used a dry-goods store and a carpentry shop as his backdrop for this group portrait, indicating that the setting is a light-industrial area of the city. The boys' clothing, and the snow on the street, tell us that it is winter, and cold—hardly the place, or conditions, anyone would feel are best suited for children on a Sunday morning. To the city dwellers of that era, however, they would have been commonplace, taken for granted, ignored—until Hine forced the citizens to look closely at what went on daily, right under their noses.

A.D.C.

1874 Born in Oshkosh, Wisconsin. **1900–05** Begins training as a teacher at the University of Chicago. **1901** Teaches natural history and geography at the Ethical Culture School, New York. Continues studies at New York University. **1903** Begins to take photographs and starts the photo project *Immigrants on Ellis Island*. **1905** Studies completed. From **1906** Apart from teaching, also active as a freelance photographer. First commissions from the National Child Labor Committee (N.C.L.C.). **1908–18** Regular work for the N.C.L.C. From **1909** Work for the journal *The Survey*. **1918–19** Photographic documentation of the consequences of war for people in the Balkans, commissioned by the American Red Cross.

1919–20 Begins to photograph people working. **1922–29** Commissions for various industrial concerns, including the National Consumers League. **1932** Publishes *Men at Work*, New York. **1933** Participates in the World Fair. **1936–37** Chief photographer of the Works Project Administration in Holyoke, Massachusetts. **1937** Publishes *Technological Change* with David Weintraub. **1939** First retrospective at the Riverside Museum, New York. **1940** Dies in Hastings-on-Hudson, New York.

Further Reading: *Lewis W. Hine: The Empire State Building*. Munich/London/New York, 1998.

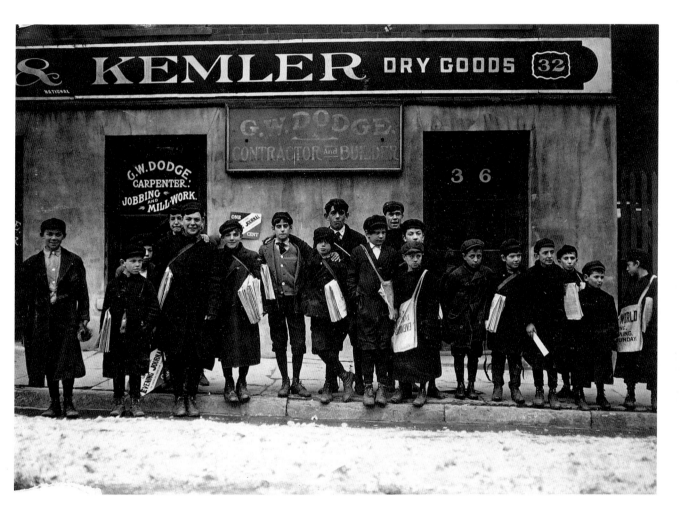

There they stand, on their way to church or the local inn, halting on their way across the open fields in order to give the photographer a chance to take a quick picture. They are photographed slightly from behind, as if to show that they were actually scolded to move on quickly, and only the photographer was preventing them from doing so. All three have their heads turned and are gazing straight at the camera but hold their sticks ready to continue on their way as soon as the photograph has been taken. We know that August Sander planned and staged his photographs, that he had farmers pose for the family album on chairs brought out from the parlor and placed at the edge of the forest. Thus it seems unlikely that these three young men crossed his path by accident just as he, equally fortuitously, was strolling along with his heavy camera over his shoulder. The picture must undoubtedly have been staged, and this is why it is so ingenious. We have the impression that the three farmers are standing still for us, as though time has stopped for a brief moment to allow us to participate in the action.

It was Sander's achievement that he adapted the traditional method of carefully arranging portraits to the new photographic task of documentation. He reconciled the studio portrait with the documentary photo. This gains particular importance because of the documentary system that he followed in his work. Today it is regarded as an early example of Conceptual Art, and it was also not without influence on other developments within the fine arts. Thus Sander and his work in portraiture made an important contribution to the recognition of photography as art. Internationally, he is considered the most famous German photographer of the twentieth century. It seems inconceivable that, after World War II, this artist was almost forgotten, even in his home town of Cologne, until L. Fritz Gruber showed his work at "photokina" in 1951 and again drew attention to his achievements. R.M.

Baker, 1928

1876 Born in Herdorf, Siegerland, Germany. **1897–99** Works for the photographer Georg Jung in Trier. **1899–1901** Spends years traveling as a photographer's assistant, including in Berlin, Magdeburg, Halle, Leipzig, and Dresden. **1901** Employed as first operator in the Photographische Kunstanstalt Greif in Linz, which he takes over with Franz Stuckenberg in 1902 and renames Sander & Stuckenberg. After parting company with Stuckenberg in 1904, renamed Photographische Kunstanstalt 1. Ranges (First-rank photographic art institute). **1904** First color photographs. **1905** First solo exhibition at the Landhaus-Pavillon in Linz. **1910** Moves to Cologne. **1920–25** Important friendships with the "Cologne progressives." Develops overall concept of forty-five picture folders separated into seven groups. First folder on the "peasant as prototype," created within the framework of his *Menschen im 20. Jahrhundert* (Citizens of the Twentieth Century). **1939** Moves to Kuchhausen. **1946** Fire in the cellar of his Cologne apartment destroys 30,000 negatives. **1951** Presentation of his work by L. Fritz Gruber at the first "photokina" in Cologne. **1964** Dies in Cologne.

Further Reading: Sander, Günther (ed.). *August Sander: Citizens of the Twentieth Century: Portrait Photographs, 1892–1952.* Cambridge, 1986.

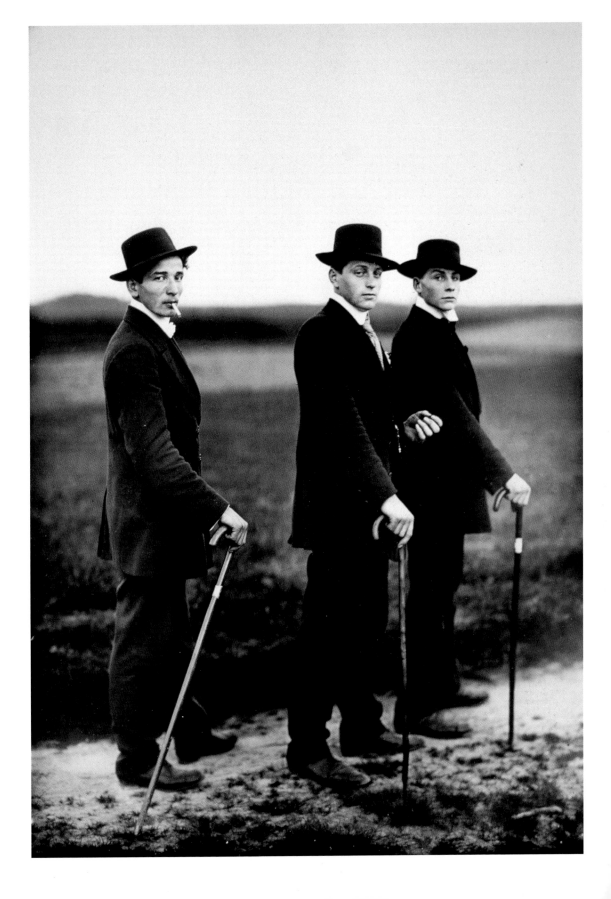

Jacques-Henri Lartigue

The picture is the epitome of speed. It is practically bursting with the pressure of the tempo it shows. Jacques-Henri Lartigue took this photograph when he was still very young, a child prodigy of photography. The laconic title, *Grand Prix of the Automobile Club of France,* merely indicates the type of event, without any explanation of what is happening. A racing car flashes by, the hood already out of view, the back wheels deformed to an egg shape, while the spectators lining the racetrack appear to lean in the other direction (these optical distortions are due to the camera shutter). Tension of the highest degree fills the entire picture, which is dominated by diagonals; nothing remains stationary, and the only visual support is provided by the virtual grid of intersecting angles.

By comparison with this photo, most Futurist paintings seem like labored illustrations. Lartigue created an incunabulum of photography. When he shot—in the truest sense of the word—this picture, instant photography as we know it today had not yet been invented. Fragile glass plates, unwieldy cameras, "slow" lenses, and complicated developing procedures made it difficult to get to grips with the new technology. But this presented no particular problem for the talented boy who had been given his first camera by his father.

As a painter, Lartigue was reasonably successful, but his photographic work only received its deserved recognition very late. His enchanting pictorial world draws its incomparable charm from the state of confusion of the *fin de siècle,* combining a sense of elegance with an unconcealed enthusiasm for technology. Cars, airplanes, and airships were the vehicles involved. Refined society ladies balanced entire botanical gardens on their heads while exposing at most a tiny amount of foot. Gentlemen wrapped themselves up like mummies when they raced along dusty roads in their precarious motorcars, and kept their bowler hats on while posing in front of flying machines assembled through adventurous carpentry. The photographer was one of them; he portrays his peers with complete approval and an occasional hint of irony. Nothing clouded the happiness of "good" society, with its aristocratic features, and the whole of existence was like a never-ending cocktail party in gentle sunshine. The contradictions between the advanced technology and the extravagant fashions were evident, nonetheless. But it was precisely this that gave Lartigue's pictures their quality and significance. K.H.

1894 Born in Courbevoie, Seine. **1902** First interest in photography; self-taught. **1914–18** Volunteers for military service in the French Army. **1915–16** Studies painting with J.-P. Laurens, Décheneau, and Baschet at the Académie Julian in Paris. **1922–78** Active as a freelance painter. Countless painting exhibitions. Photographic diaries. **1963** Solo exhibition at the Museum of Modern Art, New York. **1966** Participates in "photokina," Cologne. **1986** Dies in Nice.

Further Reading: *Jacques-Henri Lartigue: Le choix du bonheur.* Besançon, 1992.

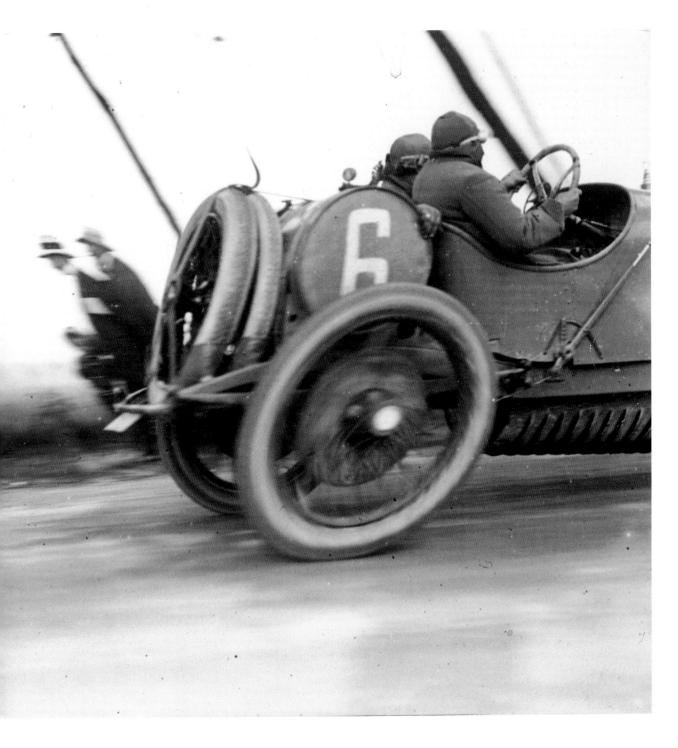

Karl Blossfeldt's plant photographs are the best examples of photography following the precepts of Neue Sachlichkeit. This is best evidenced in his work devoted solely to plants, a microcosm which, enlarged many times, confronts us with monumental beauty. In a photograph such as *Maidenhair Fern*, one of thousands he took, we find a world of its own—for that is what it is—captured in a minimalistic style. The fern in its simple, but living, rhythmic form fills the picture space. Neither background nor lighting distract from the simplicity of its natural form. The photographer records "objectively" what the plant provides him with. Yet there is more to this admirable simplicity. By making the plant the exclusive theme of his picture, Blossfeldt also simultaneously approaches its very being.

We appreciate its natural form—more than we could ever do in nature itself. The photograph allows its form to speak, while Blossfeldt himself stands back. The secret lies in the way that he has rendered his subject as a unique living thing.

This photograph in particular makes it clear how much Art Nouveau imitated natural forms. Albrecht Dürer wrote: "Art lies in nature. Whoever can tear it out, has it." What Art Nouveau artists achieved by borrowing from plant forms, Blossfeldt succeeds in doing by means of precise, direct observation. The maidenhair fern presents itself naked before the camera lens. As a result, the formal beauty of the plant is identified plainly. The concentration on the essential, that Blossfeldt allows to govern every photograph, also defines the overall concept of his photographic work. In 1928, his book *Natural Art Forms* appeared, which today still represents his photo-artistic legacy and at the same time has become a great paradigm of the serial concept in photography.

Walter Benjamin was one of his first contemporaries to recognize Blossfeldt's contribution to the history of photography. "From every calyx and every leaf inner visual necessities spring out at us which, as metamorphoses, have the last word in all phases and stages of what is generated." Blossfeldt himself saw in plants the same artistic/architectural form that determines every work of art. For him, art and nature correspond to each other in their structural regularity. E.B.

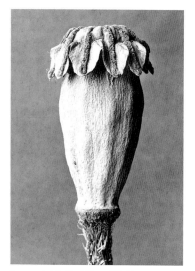

Papaver orientale, Oriental Poppy, 1915–25

1865 Born in Schielo in the Harz region, Germany. **1881–84** Trains as a sculptor in an art foundry. **1884–89** Studies at the Königliche Kunstgewerbemuseum school in Berlin. **1889–96** Study visit to Rome; works there on plant reproductions for teaching purposes; first photographs of plants. **1898** Teaches at the Kunstgewerbliche Lehranstalt in Berlin. **1921** Appointed full professor; establishes an archive of plates with plant photographs. **1926** First exhibition at the Galerie Neumann-Nierendorf, Berlin. **1928** *Urformen der Kunst* (Natural Art Forms) published by Ernst Wasmuth. **1932** Publication of second book, *Wundergarten der Natur* (Art Forms in the Plant World). Dies in Berlin.

Further Reading: *Karl Blossfeldt: Natural Art Forms.* Reprinted edition. New York, 1998. *Karl Blossfeldt: Art Forms in the Plant World.* Reprinted edition. New York, 1986.

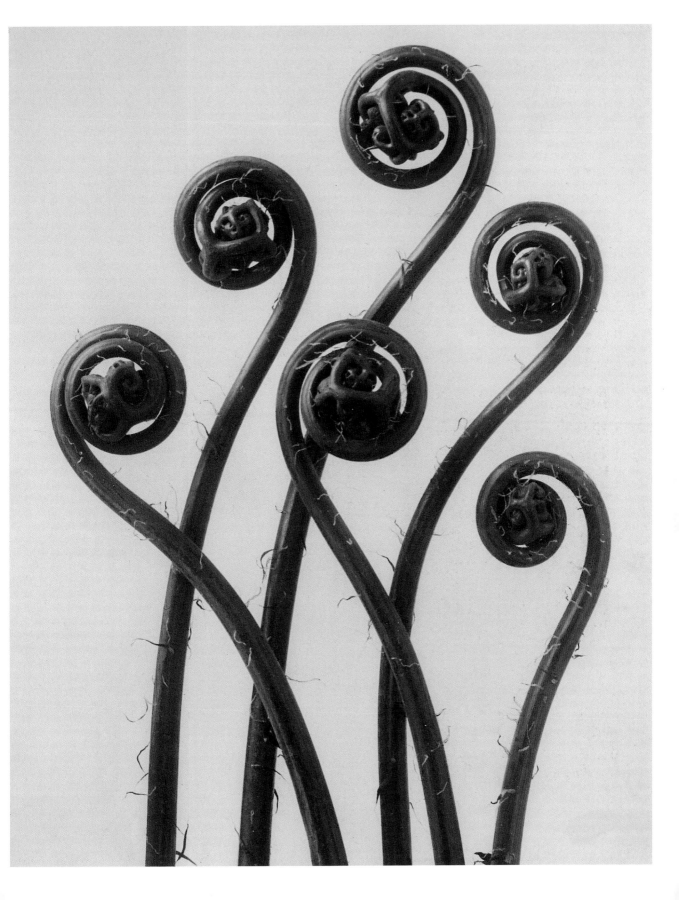

Surrealism is accused of having been much more a literary movement than having had anything to do with the visual arts. In André Breton it had a poet as its spokesman, and so the poetic principle of Surrealism was stimulated by the meeting of contents from differing sources, and by the friction caused by their encounters in text and picture. As it did not stipulate form and shape, Surrealists remained individualists with regard to style.

Man Ray's work introduced a particular note, since he used photography and recognized early on that this medium could reproduce the effects of object-based

art in two-dimensional form. Photography was in a position to preserve the ordinary and to unleash surreal effects through simple confrontations. *Le Violon d'Ingres* illustrates an ancient vision of the cellist who holds his anthropomorphic instrument like a woman between his legs. The simple copying of the sound-box apertures on to the back, the framing of the form by the draped fabric below and the turban above, allows the cellist's dream to become reality: the surreal transformation is complete. In addition, Man Ray makes another borrowing from art history, a back view of a nude painted by Ingres, in other words provokes a multiple encounter, including that of a famous painting with the apertures in a cello's sound box.

Le Violon d'Ingres is one of Man Ray's best-known photographs, perhaps because it realizes not a new fantasy but one that is as old as the instrument on which it is based. With his photographic work Man Ray provided some of the most important stimuli for present-day photographers. Together with Lee Miller he developed solarization, using the technique mainly in portraits but also in nude photography. With his photographs of models of mathematical formulae he adopted a position somewhere between abstraction and reproduction in photography and showed that the one can be identical to the other. With his "rayographs" he also provided a major impetus for cameraless photography. One of the first artists whose photographic oeuvre is more highly regarded than his painting, he made a decisive contribution to raising the artistic value of photography and paved the way to this medium for many later artists. R.M.

Rayograph–Lee Miller, 1931

1890 Born Emmanuel Radnitzky in Philadelphia, Pennsylvania. **1908–12** Studies at the National School of Design, New York. **1915** First work with photography; also involved with film, painting, and sculpture. Meets Marcel Duchamp. From **1917** Co-founder of the New York Dada movement. Publishes various Dada journals with Marcel Duchamp, including *New York Dada* in 1921.

1920 Co-founder of the *Société Anonyme*. **1921** Moves to Paris. Friendly with the most famous artists of his time. **1921–22** First "rayographs" published in the album *Les champs délicieux*. **1940** Moves to Hollywood. **1951** Returns to Paris. **1976** Dies in Paris.

Further Reading: Man Ray. *In Focus*. Los Angeles, 1998. Man Ray. *Self-Portrait*. Boston, 1999.

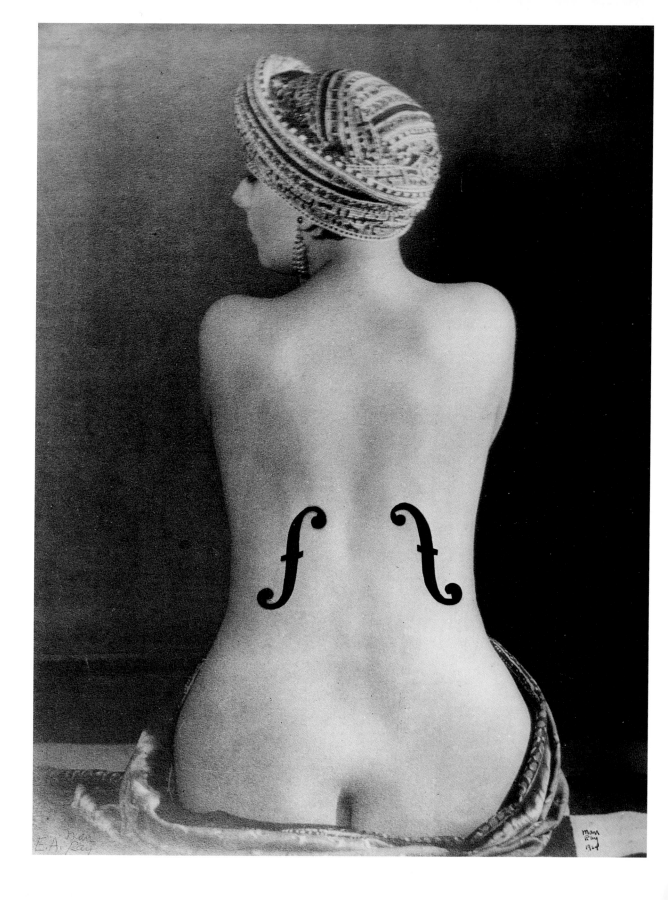

László Moholy-Nagy

Color and light were the basic artistic aspects which preoccupied the Hungarian Constructivist and Bauhaus teacher László Moholy-Nagy throughout his life, whereby he saw light not only as a creative medium but also as a metaphor of reason. In his essay "Directness of the Mind—Detours of Technology," written in 1926 and published in the magazine *bauhaus*, Moholy-Nagy wrote: "Limited and infinite relationships are equally the result of cosmic determination. The chemical-physiological-transcendental influences of interacting relationships materialize in different ways, according to their innate laws—once into blue color, another time into an aggregate, and a third time into a sublimation of the mind. Thought—as a functional result of cosmos-body interaction—is, in its manifestations, a constant emanation of human existence." It is in this context, perhaps, that Moholy-Nagy's "head photograms," of which he produced a good dozen, can best be interpreted. Most of them depict either Moholy-Nagy himself or his first wife, Lucia, but in some cases Moholy-Nagy has also "photogrammed" his friends. One of the most superb works of this series is his *Self-Portrait* of 1926, which

is now in the photographic collection of the Museum Folkwang in Essen, Germany. Moholy-Nagy, recognizable not least by his spectacles, first rested his cheek on the photographic paper and made an initial exposure. Two transparent segments, produced by means of templates and successive exposures, overlap the face, making it reminiscent of a planet in the night sky. Like a plaster cast, the photographic paper shows traces of moisture from the skin, made visible and preserved by the photochemical process. Using the simplest pictorial elements, and waiving all literal symbolism, Moholy-Nagy has created here a self-portrait which, in terms of immateriality and spirituality, is without parallel in the art of the twentieth century. The artist's head, the very seat of consciousness, appears as a luminous figure in the cosmic darkness, a "constant emanation of human existence," to use the artist's own words. H.M.

1895 Born in Bácsborsód, Hungary. **1913** Studies law at the University of Budapest (and again in 1918). **1914** Called for military service in the Austro-Hungarian Army. First chalk and ink drawings while in hospital in 1915. **1920** Moves to Berlin. Contact, among others, with Kurt Schwitters, Hannah Höch, and Raoul Hausmann. **1922** First photograms with the collaboration of his wife Lucia Moholy. First solo exhibition at the gallery Der Sturm. **1923** Appointed teacher at the Bauhaus in Weimar; head of metal workshop and introductory course. Continues working at the Bauhaus in Dessau from 1925 to 1928. **1925** Publishes the standard work *Malerei, Fotografie, Film* as the eighth volume of the series *Bauhausbücher*. First camera photographs. **1928** Moves to Berlin; work for the Stuttgart Werkbund exhibition *Film und Foto*, at which he shows ninety-seven photos and photograms. Active as exhibition designer, set designer, promotional graphic artist, and filmmaker. **1934** Emigrates to Amsterdam, then in 1935 to London. Meets Henry Moore, Barbara Hepworth, and Ben Nicholson. Artistic consultant for the fashion store Simpson, as well as Royal Airlines and London Transport. **1937** Moves to Chicago. Through Walter Gropius is appointed director of the New Bauhaus–American School of Design. **1939** Founds his own School of Design, which in 1944 becomes the Institute of Design. **1945** Contracts leukemia. **1946** Dies in Chicago.

Further Reading: *László Moholy-Nagy*. Newark, 1995. *László Moholy-Nagy: Fotogramme 1922–1943*. Munich/Paris/London, 1996.

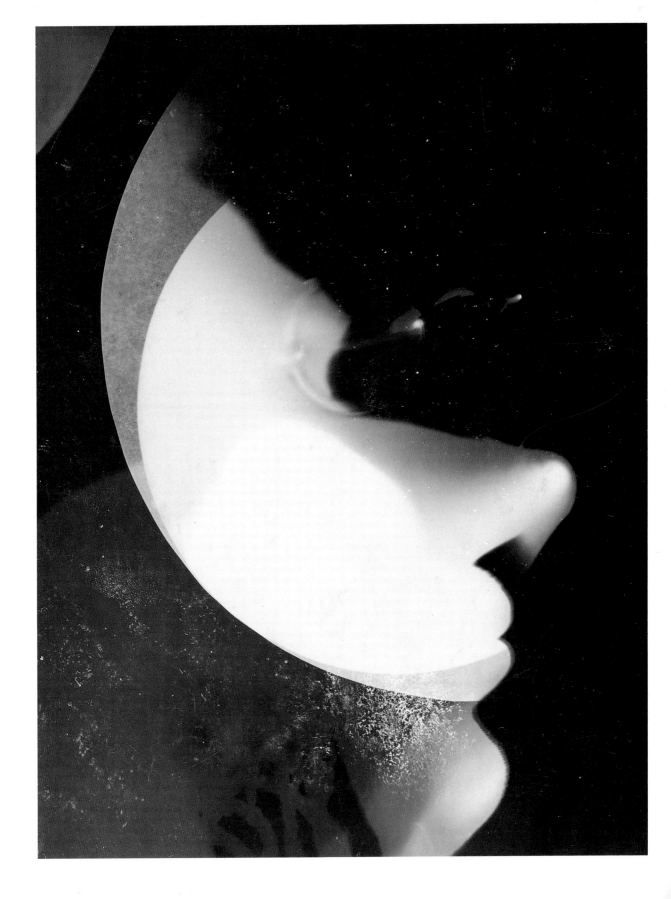

The idiom of this photograph is as laconic as its title. The fork lies against the edge of a plate and, like the latter, casts a deep shadow. Both objects are cut off by the framing of the photo; only a very small portion of the plate is visible. André Kertész composed the image and recorded it from above, at an angle of around 40 degrees. In some versions of the photo, the location—Paris—is also given, which is misleading to a certain extent, since the picture represents one of the most succinct examples of the photographic avant-garde which, at the end of the 1920s, was centered not in Paris but in Berlin and Moscow. Yet Kertész, born in Budapest, was more an advanced photographer with poetic talent and a tendency to use surreal effects than a genuine representative of the avant-garde, like his compatriot László Moholy-Nagy (see p. 28). Nonetheless, the vision of the Neues Sehen (New vision) is demonstrated in an exemplary manner in this simple

still life—as in an earlier photograph of the painter Piet Mondrian's spectacles and pipe. It is not the objects that are decisive but the manner in which they were perceived by the photographer. The aesthetic significance of the picture unfolds within the mode of perception, the specific view of the world.

Kertész taught himself photography and developing techniques. However, he was anything but a technical enthusiast. While still living in Hungary, during World War I, he had recorded the *Swimmer Under Water*, a fleeting apparition in the heavily broken-up surface of the swimming pool; so to speak, a photographic essay using photographic tools. His inclination was towards the incidental, the things that are frequently overlooked. He preferred to portray the drama of the small, unspectacular happenings of everyday life. Although Kertész's photos frequently appeared in magazines, photojournalism made him uneasy: "They want documents, technique, not expressive photographs." He felt at home in Paris. But France's defeat forced him, an emigrant from Hungary, to emigrate further, to New York. There, with the series *View from My Window onto Washington Square* (1953), he made an influential contribution to the development of photography. The square only looks attractive, one critic noted, "when Kertész looks down on it." There could be no more fitting characterization of his photographic art. K.H.

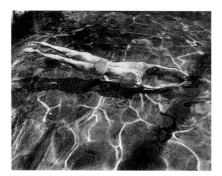

Swimmer Under Water, 1917

1894 Born in Budapest. **1912** Diploma from the Business Academy in Budapest. Employed at the stock exchange. First street photography with middle-format camera (4.5 x 6 cm). **1917** Published several times in the magazine *Érdekes Újság*. **1918–25** Resumes activity at the stock exchange. **1925** Moves to Paris. Countless portraits of artists, street scenes, etc. Meets Brassaï. **1926–36** Freelance photographer for various magazines in France, Germany, and England. **1927** First solo exhibition at the gallery Au Sacré du Printemps. **1928** First Leica. **1928–35** Chief contributor to the magazine *Vu*. **1929** Participates in the

Werkbund exhibition *Film und Foto* in Stuttgart. **1930–36** Works for the magazine *Art et Médecine*. **1933** First publication: *Enfants*. **1936** Emigrates to New York. First solo exhibition there in 1937. Freelance photographer for, among others, *Harper's Bazaar, Vogue, House & Garden*, and *The American Magazine*. **1941–44** Forbidden to publish. **1949–62** Exclusive contract with Condé Nast in New York. Thereafter freelance photographer and artist. **1975–84** Countless trips to France. **1979–81** Still-life series with Polaroid camera. **1985** Dies in New York.

Further Reading: *André Kertész: His Life and Work*. New York, 1997.

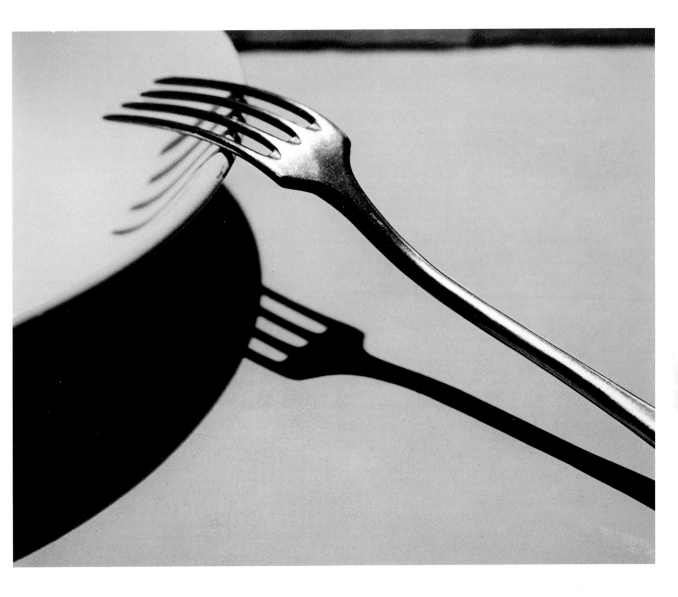

Ruth. Her Hand. 1927

Umbo was, beside László Moholy-Nagy, the most significant photographer of the Bauhaus. Umbo's women's portraits of 1927 made photographic history, even more so than his reportage photography. What was new about Umbo's photography was not just the close-up effect, the extreme proximity of the subject's face to the camera, but also the combination of abstraction and realism, an unusual technique for photography at that time. When rendering as many half-tones as possible was the photographic ideal, Umbo waived the smooth transition from light to dark and proved that facial beauty could be expressed in pure black-and-white contrasts. The graphic impression created by close-ups of the face and the balanced contrast between light and dark was countered by the sensual expression of the eyes and mouth. These seemingly diverging vocabularies of form served a common purpose, namely the expression of a new female image combining sentimentality and pragmatism, erotic sensitivity and cool calculation. Umbo's portraits came to be regarded as the unglossed expression of modern womanhood, the "New Woman" of the twenties.

In 1928, he joined forces with the erstwhile Expressionist coffee-house writer Simon Guttmann in founding the photographic agency DEPHOT (Deutscher Photodienst GmbH) in Berlin, which was to play a decisive role in the development of modern photojournalism. One of its most memorable photoreportages documented the "secret life" of shopwindow dummies. It was published under the title of *A Dangerous Street* in the Frankfurt magazine *Das Illustrierte Blatt*. Here Umbo breathes life into these motionless figures through his photography: as Aphrodite once did with the statue of Pygmalion. With the utmost tenderness, he lends these beautiful, anonymous figures, destined ultimately for the public life of the street, a hint of privacy. He achieved this effect by photographing the dummies during an intermediate phase of their existence, that is, neither during their manufacture nor in their ultimate function in the shopwindow, but in the warehouse, the place where they are still among themselves. What these waxen beauties, with their dreamy gazes and seductive poses, actually do there is left to the imagination. Umbo may have been inspired by the same experience which had prompted Picasso's *Les Demoiselles d'Avignon* (1907). Some of the ladies are scantily dressed, with only silk stockings or dainty shoes, while others are completely naked, raising their arms and exposing their bodies without any shyness. Gazing at these photographs, one might feel transported into the nude drawing class of an art academy. H.M.

 1902 Born Otto Maximilian Umbehr in Düsseldorf. **1921–23** Studies at the Bauhaus in Weimar. **1926** Begins work as a portrait photographer with the support of Paul Citroen. **1928–33** Active for the photo agency DEPHOT in Berlin. **1929** Participates in the international Werkbund exhibition *Film und Foto* in Stuttgart. After **1945** Active as promotional photographer and local photo-reporter for the *Hannoversche Presse*. **1948–57** In-house photographer for the Kestner-Gesellschaft in Hanover. **1957–72** Teaches photography in Bad Pyrmont, Hildesheim, and at the Werkkunstschule in Hanover. **1980** Dies in Hanover.

Further Reading: *Umbo: Vom Bauhaus zum Bildjournalismus.* Exh. cat., Kunstverein für die Rheinlande und Westfalen. Düsseldorf, 1995.

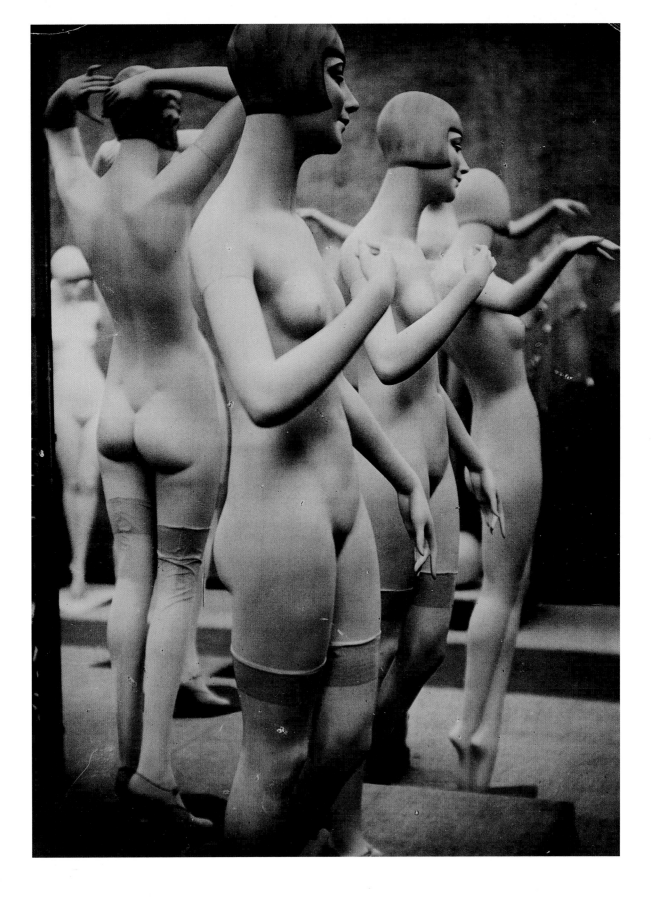

Walter Peterhans

Walter Peterhans' position among the great teachers in the history of photography is exceptional, since he did not just train photographers but also used photography as a means of aesthetic education. After studying at university and a further period of study as a reproduction photographer, he initially trained individual students in a private studio for advertising and portrait photography. He subsequently taught at the Bauhaus and at well-known schools of photography in Berlin,

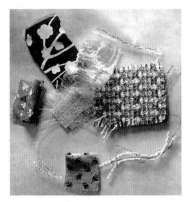

Pythagorean Paradigm, 1929

then, after emigrating to the United States, at the Illinois Institute of Technology in Chicago. As a trained mathematician, Peterhans preferred experimental, yet comprehensible, photography to free, associative works. As a consequence, he taught his students the foundations of visual design in experimental structures,

from which, in exemplary fashion, they worked out the rules and laws of photography for themselves. Later, in Chicago, Peterhans taught exclusively as a professor of visual design, analysis, and art history.

Peterhans worked with a peculiar characteristic of photography, its capacity to force three-dimensional objects into two-dimensionality. From this resulted his arrangements that looked like montages but were not. The objects that he gathered together to form tableaux were mostly of a transitory, unprepossessing nature: scraps of fabric, twigs, leaves, flowers, and shimmering fish-scales. He also liked to work with lenses and glass discs. These compositions achieve beauty through the photographer's ability to bring out and illuminate the materiality of the things and to display them in a new, objective, but often magical proximity to one another.

Portrait of the Beloved poses a puzzle. The objects—fragments of a veil, feathers, curls, and tinsel—seem to hover above the mysteriously glowing background. Their arrangement may at first glance appear to be accidental, but harmonious distribution was achieved by laying them around the stone in the center. The surface attractions are emphasized by clever lighting (one even gains a sense of the consistency of the objects), and material values are suggested. But it is only through its title that the picture becomes a symbolic portrait; the fragments merge into a cryptic declaration of love to a distant woman who embodies tender poetry. L.D.

1897 Born in Frankfurt am Main. **1920–23** Studies mathematics, philosophy, and art history at the Technische Hochschule, Munich, and at the University of Göttingen. **1925–26** Studies reproduction photography at the Staatliche Akademie für Graphische Künste und Buchgewerbe, Leipzig; examination for master photographer's diploma in Weimar. **1929–33** Director of the photo class at the Bauhaus in Dessau and Berlin. **1929** Participates in the international Werkbund exhibition *Film und Foto* in Stuttgart. **1933–34** Teaches at Werner Graeff's Berlin Photoschule. **1935–37** Independent photographer in Berlin; publishes several technical books on photography. **1938** Emigrates to the U.S.A. **1938–60** Professor at the Illinois Institute of Technology in Chicago. **1953** Guest lecturer at the Hochschule für Gestaltung, Ulm. **1959–60** Guest professor at the Hochschule für Bildende Künste, Hamburg. **1960** Dies in Stetten, near Stuttgart.

Further Reading: Eskildsen, Ute (ed.). *Walter Peterhans: Fotografien 1927–1938.* Exh. cat., Museum Folkwang. Essen, 1993.

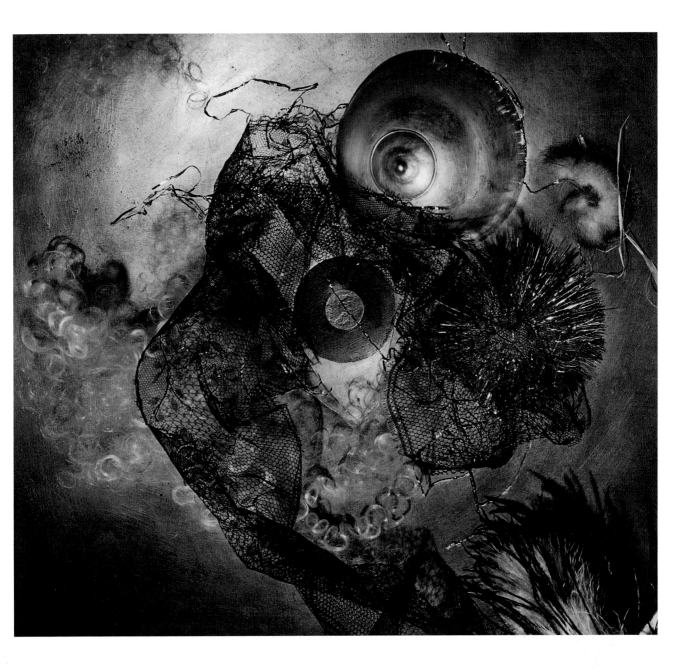

Ellen Auerbach

The strength of this image lies in the fact that it is several things at once. It is a portrait of the actress and dancer Kläre Eckstein: a photo of a fashionable woman in the smart style of the 1920s, with a page-boy haircut, eyebrows plucked thin, and lace gloves. At the same time, however, it is a bravura piece of constructive pictorial composition. The mirror's reflection is the reason for the wide, "architectural" composition. Sometimes artists try to accomplish several things at once in a work, and their attempts at doing so often fail. Here, however, Ellen Auerbach has been successful, since the various components have a mutually intensifying effect. The "styled" head equates with the "design" of the pictorial composition. Despite all the rationality of approach—note, for example, how demonstratively the laws of refraction are presented at the right edge of the picture— this saucy dialogue of a beautiful woman with her own reflection contains its due portion of poetry. The model, however, has clearly not been surprised at her toilette. Rather, the session under the hot flood lamps lasted so long that her lipstick was on the point of melting.

If, in later years, Auerbach maintained she was more of an amateur at that time, then this is a charming understatement, and not just with regard to the masterpiece opposite. Nevertheless, it is true that she had only started photography around a year previously. She rapidly abandoned the "art for art's sake" philosophy of her private teacher Walter Peterhans (see p. 34) in order to practice applied photography in her newly established portrait and advertising studio, ringl + pit. This was the background against which *Eckstein with Lipstick* of 1930 came to be the first high point of Auerbach's oeuvre. Her still-life skills, taught by Peterhans, and the portrait character merge imperceptibly here. Not least, this photograph reveals the Art Deco aesthetic as it also appears in the work of Umbo, Lewis W. Hine, and others. Almost programmatically, Auerbach later professed a form of profound vision: a picture like this, which pays homage to beauty and appearance, was therefore to remain an exception. P.S.

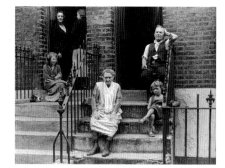

Slums, London, 1935

1906 Born in Karlsruhe. **1924—27** Studies sculpture at the Badische Landeskunstschule under Paul Speck and Karl Hubbuch, in 1928—29 at the Akademie der Bildenden Künste (the Weissenhof) in Stuttgart. Receives her first 9 x 12 camera. **1929** Photographic training as a private student, together with Grete Stern, under Walter Peterhans in Berlin. Photo studio ringl + pit established with Grete Stern, specializing in promotional and portrait photography. **1930—31** Three short films (b/w, 16 mm): *Heiterer Tag auf Rügen* (Happy day on Rügen), *Gretchen hat Ausgang* (Gretchen has the day off), and *Bertold Brecht*. **1933—35** Emigrates with Walter Auerbach to Tel Aviv. Together with him and Liselotte Grschebina founds the studio Ishon, for child photography. Commissions for the Women's International Zionist Organization (W.I.Z.O.). **1937—44** Emigrates via New York to Elkins Park, near Philadelphia. Works for the art collection of the Lessing-Rosenwald family in Jenkintown, Pennsylvania. Together with Walter Auerbach experiments with infrared and ultraviolet light to make restorations and changes in prints visible. **1944** Moves to New York. Freelance work for *Time Magazine* and *Columbia Masterworks* (and again in 1949—51). **1946—49** Works with a child psychologist at the Menninger Clinic for Psychology, Topeka, Kansas. Photographs and two 16-mm films on infant behavior. **1953** Teaches photography at the Junior College of Arts and Crafts in Trenton, New Jersey. **1955—56** Journey to Mexico with Eliot Porter. Color and black-and-white documentation on Mexican churches. Publishes *Mexican Churches* (1987) and *Mexican Celebration* (1990). **1965—84** Educational therapist for children with learning disabilities at the Educational Institute for Learning and Research, New York. 2004 Dies in New York.

Further Reading: *Ellen Auerbach. Berlin. Tel Aviv. London. New York.* Munich/New York, 1998.

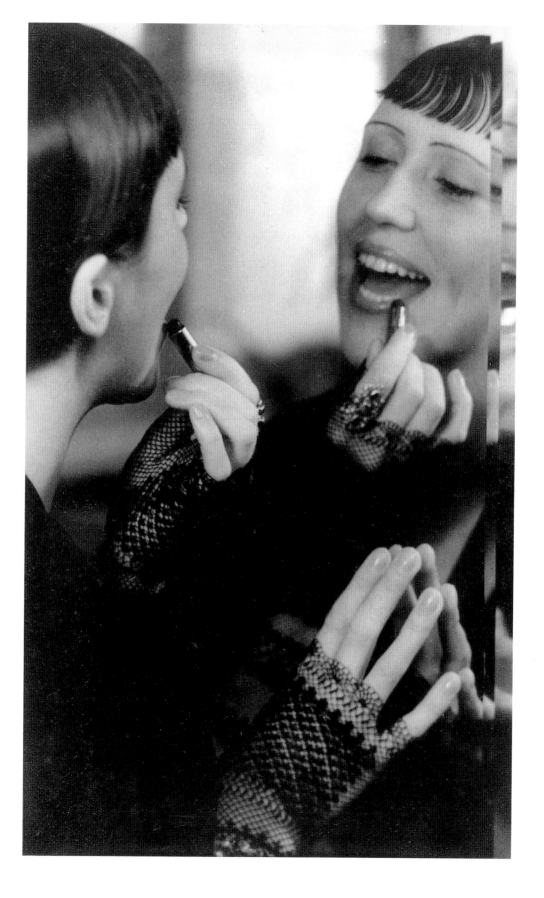

Little has offered such a lasting challenge to photography as the mirror. There can hardly be a photographer who has not been tempted to take a photograph of him- or herself in a shopwindow, induced by the fascination of seeing one's own self superimposed on what can be seen through the window. Camera optics are ideal for mixing different visual planes, thereby making the resulting image impenetrable for the viewer. Looking into a mirror, however, usually lacks such effects, and so it has only been met with interest when it produced distortion—as in the work of Anton Stankowski or Albert Renger-Patzsch, for example in the latter's well-known portrait of his own reflection in a car headlamp.

In this self-portrait, which is her most famous picture, Ilse Bing—"the queen of Leica" —has nevertheless succeeded in bringing the mirror to enigmatic speech. The photo is divided austerely into vertical and horizontal lines, reminiscent of Bauhaus work, and yet it gives the impression of being extremely light and apparently accidental. Also, Bing appears in profile through the use of a second mirror. Ultimately, this is a photo about photographing, since we can see Bing's right eye twice, directed towards her subject and calculating in a concentrated manner. Her left eye appears to be covered by the camera and yet is visible, merging with the camera in the darkness. This "becoming one" with the Leica is immediately put into proper context by Bing's profile, since we realize that her eye and face do not even touch the camera. Quite clearly, photography is a procedure undertaken from a distance; only the gaze links the photographer with her camera equipment.

In addition, this picture is fascinating because we seem to be stared at with such intensity. Even though, at the time the photo was taken, that could not possibly have been the intention, the photographer was aware that her eye would inevitably be fixed on the person looking at the completed image. Her searching gaze disturbs and yet attracts the viewer, all the more so when one realizes that this gaze—the most fascinating element of all portraiture art—survives even beyond the photographer's death. R.M.

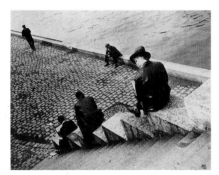

Three Men on Steps at the Seine, 1931

1899 Born in Frankfurt am Main. From **1920** Studies mathematics and physics, later art history at the University of Frankfurt. **1929** Acquires a Leica (her camera for the next twenty years). Works for the *Illustrierte Blatt*. **1930** Moves to Paris; photography for the journalist Heinrich Guttmann. From **1931** Freelance photo-reportage and architectural photography; fashion and advertising commissions for, among others, *Vu, Arts et Métiers Graphiques, Le Monde, Harper's Bazaar*, and *Vogue*. **1941** Emigrates to the U.S.A. From **1957** Exclusively color photography. **1993** Stops work following a severe car accident. **1998** Dies in New York.

Further Reading: *Ilse Bing: Three Decades of Photography*. Exh. cat., New Orleans Museum of Art. New Orleans, 1985.

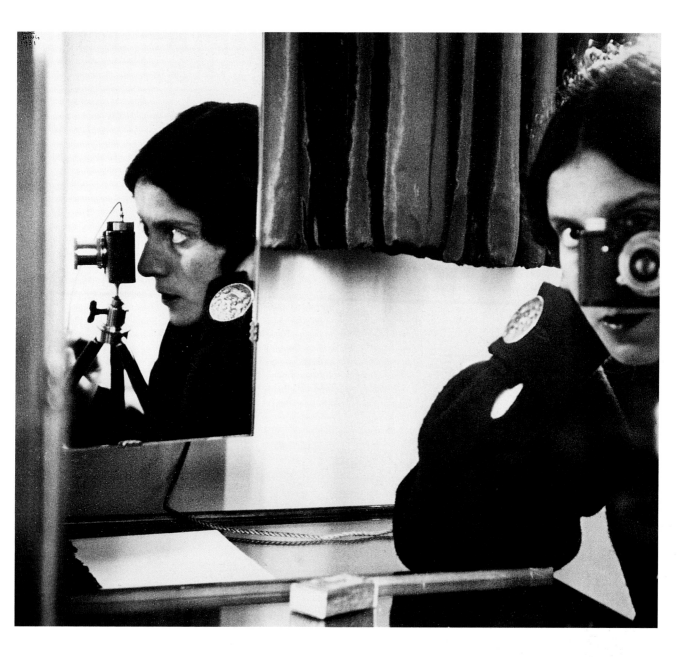

Hugo Erfurth

The portrait *Otto Dix with Brush* is the most impressive document of a long-standing artistic friendship, and, at the same time, a testimony to the fruitful dialogue between photography and painting in the first half of the twentieth century. Presumably the German Expressionist painter Dix and the successful court photographer Hugo Erfurth, who had already made a name for himself before 1914 as a portraitist of renowned artists and writers, first met in Dresden following Dix's return home from the war. Erfurth took the first photographic portraits of the painter frontally and in profile around 1920, with subsequent extra portrait sessions as well as photographs of Dix's wife Martha, his children (1927–33), and his parents in Gera (1926). Whereas Erfurth's camera initially recorded the Dresden painter with a grim expression and close-up (as a bogeyman of the bourgeoisie), the later portraits speak a different idiom. The photograph reproduced here corresponds more to the classic type of representational portrait of an artist; the painter, by then a professor at the Dresden Kunstakademie, is presented as a doyen of his field, in his smock and with brush and palette as attributes. Characteristic for the reproduction of the angular physiognomy of innumerable Dix portraits is the measuring, piercing look with which the painter favors the viewer—a symbol of the artist's precise, critical talent for observation, which was expressed in the shocking realism of his paintings.

Like many of his photographs, Erfurth printed this portrait as an oleograph, which gives a painterly touch to the rather severe expression. This work—a mixture of the concepts of Neue Sachlichkeit and the aesthetics of artistic photography—is characteristic of Erfurth's style. It established his reputation as a portraitist of prominent people in the arts and sciences, as well as the bourgeoisie and nobility during the Weimar Republic. His photographs of the dancer Mary Wigman, the poet Gerhart Hauptmann, the architect Hans Poelzig, and the painters Oscar Kokoschka, Marc Chagall, Max Beckmann, Paul Klee, and Max Liebermann are further examples of this. U. P.

Austrian Writer Franz Blei, 1914

1874 Born in Halle an der Saale, Germany. **1893** Participates in an international exhibition of amateur photographs at the Kunsthalle, Hamburg. **1895** Trains with the court photographer Wilhelm Höffert in Dresden. **1896** Takes over the Dresden studio of the court photographer Schröder. **1906** Buys the Palais Lüttichau in Dresden, where he sets up Lichtbildnerei Erfurth, a studio "for modern and artistic photography." From **1925** Photograms and photos for advertisements, in addition to portraits. **1929** Teaches photography for advertising at the Akademie für Buchgewerbe und Graphische Künste, Leipzig. Participates in the exhibition *Film und Foto* in Stuttgart. **1933** Moves to Cologne. **1943** Apartment, studio, and archives destroyed in bombing raid. Moves to Gaienhofen on Lake Constance. **1948** Dies in Gaienhofen.

Further Reading: Drewitz, Bodo von and Schuller-Procopovici, Karin (eds). *Hugo Erfurth (1874–1948): Photograph zwischen Tradition und Moderne.* Cologne, 1992.

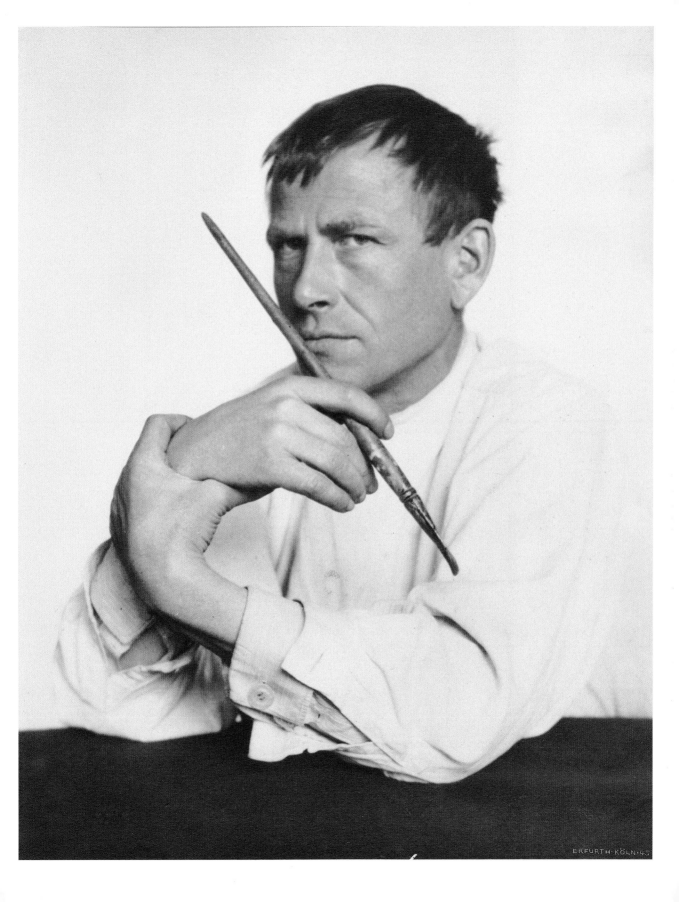

Photography was more or less handed to Lotte Jacobi in her cradle, since her great-grandfather had earned his money with daguerreotypes. But she herself would only arrive at her studio on Berlin's Kurfürstendamm in a roundabout way. She actually wanted to be in ‚films. Only when she was forced to make her own living did she decide to follow the family tradition. In the twenties, it was easy for women to make themselves independent as photographers; hardly any other profession offered such good opportunities for advancement. As a specialist in theater and dance photography, as well as a sought-after portraitist, Jacobi rapidly acquired a reputation as a photographer of prominent people. Pictures of movie stars, portraits as well as

Girl, Berlin, c. 1930

snapshots from their private lives, were in demand by many magazines of the Weimar Republic years.

In 1929, a portrait of the graphic artist and sculptor Käthe Kollwitz appeared on the cover of the first issue of the magazine *Die schaffende Frau* (Working woman). Jacobi photographed her with a large-format plate-back camera and a special soft-focus portrait lens. The photograph's strict frontality brings the viewer face-to-face with the artist's clear features. The close cropping of the picture, the simple distribution of planes, the contours softly merging into the neutral background; all this focuses concentration on Kollwitz's firm, watchful gaze. As someone who condemned social injustice and war and as an artist, she impressed Jacobi as she did so many women of her generation. The photograph and its place of publication stylized Kollwitz as a leading figure, whose commitment to social and political change was considered to be as exemplary as her position as an independent, creative woman.

Jacobi continued to work as a portrait photographer after she was forced to emigrate by the National Socialists in 1935. She left for the United States, where she also attracted prominent people as her subjects: other emigrants such as Albert Einstein and Thomas Mann, but also Eleanor Roosevelt and J. D. Salinger. In doing so, she created one of the most impressive portrait galleries of important personalities of the mid-twentieth century. L. D.

1896 Born Johanna Alexandra (known as Lotte) in Thorn, West Prussia. **1908–09** Experiments with self-built pinhole camera; first photos with a 9 x 12 Ernemann camera. **1914–16** Attends courses in art history and literature at the Academy in Posen. **1920** Moves to Berlin. **1925–27** Studies photographic and cinematic techniques at the Staatliche Höhere Fachschule in Munich. First film camera. **1927** Returns to Berlin; works independently in her father's studio. **1929** First Leica. Contact with John Heartfield. **1930–31** Works for the photo agency Press Clichee in Moscow. **1931** Meets Tina Modotti in Berlin. **1932–33** Journey to Moscow, Tadjikistan, and Uzbekistan, taking nearly 6,000 photos. **1933–35** Publishes in magazines under the names "Folkwang-Archiv,"

"Behm's Bilderdienst," "Bender u. Jacobi," "Lloyds." **1935** Emigrates to New York. **1938** Gives lecture at the Photo League. Meets Berenice Abbott. **1947–55** Involved with cameraless photography; *Fotogenics* created. Moves to Deering, New Hampshire. **1970–71** Sets up a photographic department at the Currier Gallery in Manchester, New Hampshire. **1973** First retrospective at the Museum Folkwang, Essen, organized by Otto Steinert. **1974** Awarded title of Honorary Doctor of Fine Arts by the University of Durham, North Carolina; further honors in the 1970s and 1980s. **1990** Dies in Concord, New Hampshire.

Further Reading: Beckers, Marion and Moortgat, Elisabeth. *Atelier Lotte Jacobi: Berlin/New York.* Exh. cat., Das Verborgene Museum. Berlin, 1997.

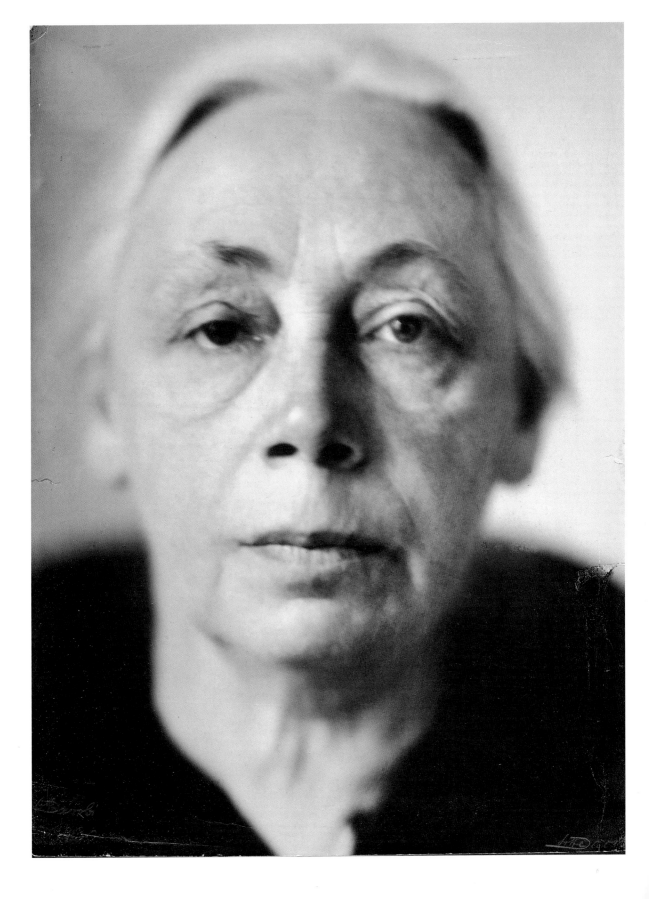

In this photograph of a group of people demonstrating, all the qualities Tina Modotti strove to achieve in her photographs are present: perfection of composition, emotion, movement, commitment, and topicality—her mastery of which ensures the picture's timeless message.

Worker's Hands, 1926

Modotti learned her trade from Edward Weston (see p. 74). The great master of "straight photography" awakened her talent to see clearly, to grasp an optimal situation quickly, and turn it into a valid picture. Modotti wanted to do "honest photography." She wanted truth, but truth supported by perfection of form. In this respect, she was closer to life than Weston. She was not a reportage photographer, but she was linked with reportage through her work. She was also one of the first women photographers to rove the streets with her camera in order to capture life in the raw. During a stay in Mexico, she made the people of this country her subject matter. She captured the tumul-

tuous 1920s and 1930s that followed the Mexican Revolution—of which she was an unconditional advocate—in photographs that are unique contemporary documents. But each of her photographs goes beyond the documentary; they are masterworks of photography.

In the photo reproduced here, Mexican workers are holding a demonstration. But we see only sombreros, filling the picture to its edges. The hats are the symbol of the workers, moving towards a target, in motion. The way in which the light falls gives direction to this movement. In this swaying sea of hats, everything that Modotti wanted to say is obvious: people are claiming their due rights and doing so in a spirit of solidarity. Although it was taken in an instant, there is nothing accidental about this photo. It is scanned and composed by means of light and shade. The experience of a moment has been given lasting stature. This particular demonstration took place on May 1, 1929, in Mexico, but all demonstrations in all countries of the world are represented in this photograph. Despite the fact that the location is clearly identified by the sombreros, Modotti has succeeded in producing an image that has become a symbol of the demand for human rights, beyond time and beyond national boundaries. This imagery can sometimes become condensed in Modotti's work into an emblem, for example in her photo of two hands holding a spade. Here no words are necessary to understand Modotti's credo. For her, humanity was the supreme principle, governing the content of the photographic work which gave expression to her political convictions. E.B.

1896 Born Assunta Adelaide Luigia Modotti in Udine, Italy. **1908–13** Works in a textile factory in Udine. **1913** Emigrates to the U.S.A. **1913–14** Works in a silk factory in San Francisco. **1914–17** Freelance dressmaker in San Francisco. **1920–21** Active as an actress in Hollywood, including in *Tiger Lady* (1921). **1921–25** Studies photography with Edward Weston in Los Angeles and Mexico City. Works as an independent photographer. **1923** Emigrates to Mexico. **1927–30** Contributing editor to the magazine *Mexican Folkways*. **1930** Deported from

Mexico due to political agitation. Occasional photographer in Berlin. **1931** Meets Lotte Jacobi. **1931–34** Gives up photography while living in Moscow, then in 1934 in France, and in Madrid and Valencia between 1935 and 1938. **1936–38** Reporter for the republican newspaper *Ayuda*, Madrid. Works for various underground movements, as well as for the International Red Cross (Socorro Rojo) in Madrid. **1939–42** Lives in Mexico. **1942** Dies in Mexico City.

Further Reading: *Tina Modotti: Photographs.* Exh. cat., Philadelphia Museum of Art. New York. 1995.

Uncle Robert's Poor Being Served Lunch, 1926

"Only one single photographic picture in existence has influenced me," declared Henri Cartier-Bresson, in reference to the picture opposite. "Such zest for life, such richness, the picture still overwhelms me today," he added. We see three black boys racing into the foaming surf of Lake Tanganyika. Photographed from behind, they form an arrow, while their intersecting arms and legs produce the field of tension in this triangular composition. This picture appeared in 1932 in the prestigious yearbook *Das deutsche Lichtbild*, a mirror of achievements in German photography, one year before Hitler wrote the book's foreword and one year before the creator of this photograph, Martin Munkácsi, was forced to emigrate. Munkácsi was the undisputed master of the snapshot; he cultivated the quick snap as the aesthetic metaphor of modern life in the big city, in which energy and dynamism, restlessness and a sense of being driven are evident—all expressed in an elegant perfection of form. It is no coincidence that he revolutionized the rigid fashion photography genre in the United States by giving it the freshness of instant photography.

The Austro-Hungarian empire was still extant when Munkácsi was born in a Hungarian region that is now part of Romania. While still quite young he was successful as a journalist in Budapest. His extraordinarily sharp yet sensitive powers of observation brought him, logically, to photography. He taught himself the technical requirements without professional assistance. With a homemade wooden camera he photographed everything his eye fell upon: scenes of everyday city life, the arrival of a minister before the Hungarian Parliament, dancing in the streets, a carriage in the rain, a goalkeeper who, even as he falls, stares in disbelief at the successfully positioned ball, or the poor being fed in a soup kitchen (opposite). In this photograph, the empty plates and spoons are in marked contrast to the full pot, the stooped recipients to the stout man doling it out. For the sake of an original viewing angle, Munkácsi scrambled up ladders, climbed high walls, and took part in perilous motorcycle and automobile races. In Berlin, the early capital of the dawning media age, his photographic idiom matured into an unmistakable style. He worked for the powerful Ullstein publishing house, and as a photo-reporter for the *Berliner Illustrirte Zeitung* enjoyed a legendary reputation. He traveled all over the world by car, ship, and plane, and during a stay in the United States he forged contacts with the press baron William Randolph Hearst. When an issue of *Harper's Bazaar* containing his famous pictures of Palm Beach hit the newsstands, the world of fashion photography trembled.

Munkácsi dominated the fashion photography scene into the 1940s and influenced such photographers as Richard Avedon and William Klein (see pp. 146, 120), before the media star himself fell out of fashion. K.H.

1896 Born Martin Marmorstein in the Hungarian city of Kolozsvár (now Cluj-Napoca, Romania). Self-taught in photography. **c. 1902** Family name changed to Munkácsi. **1911–13** Trains as a painter in Budapest. **1914–21** Reporter, writing for *Az Est, Pesti Napló, Színházi* in Budapest. **1921–27** Sports photo editor at *Az Est*; active for the weekly magazine *Theatre Life* in Budapest. **1927–30** Contract as photographer with the publishers Ullstein in Berlin; active there for the *Berliner Illustrirte Zeitung, Die Dame, Koralle,* and *Uhu.* **1930–33** Freelance magazine and press photographer, working among others for *The Studio, Harper's Bazaar, Das Deutsche Lichtbild, Photographie,* and *Modern Photography* in Berlin and New York. **1934** Emigrates to the U.S.A. **1934–40** Contract as fashion photographer with Hearst Newspapers, Inc. in New York, working for magazines including *Harper's Bazaar, Town and Country, Good Housekeeping, Life,* and *Pictorial Review.* **1940–46** Photographer under contract to *Ladies' Home Journal,* New York. **1946–63** Freelance photographer. Works for King Features, Henry Ford, and the Reynolds Company. Also cameraman and lighting designer for TV films in New York. **1963** Dies in New York.

Further Reading: *Martin Munkácsi.* An Aperture Monograph. New York, 1992.

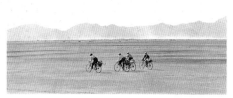

Sunday Cyclists, 1966

Manuel Alvarez Bravo was the founder of the photographic modern era in Latin America. He learned his trade from the German photographer Hugo Brehme, who had chosen to live in Mexico. Bravo's awareness of photography as an independent aesthetic medium was schooled by Tina Modotti, whom he met in 1927. It was also through Modotti that he became acquainted with European and American representatives of the photographic avant-garde. He belonged to a circle of friends associated with the Mexican muralists, who were developing a genuine sense of their own culture for the first time, as a result of the Mexican Revolution. He worked within the intellectual sphere of his painter colleagues Diego Rivera, Frida Kahlo, David Alfaro Siqueiros, and José Clemente Orozco, all of whom were committed to a single great purpose: Mexico. "Mexicanidad" became the leitmotif for their art. In Bravo's work, too, we find a purely Mexican content. At the center are the people he encountered every day, in all walks of life, in the metropolis of Mexico City, in the quiet countryside, or in the Pueblos, at that time still untouched by tourism. It is primarily the Indian population which dominate in Bravo's photographs.

The subject in *The Dreamer* is also an Indio. The photographer saw a sleeping boy in the street, a totally unspectacular subject, and photographed him exactly as he was. But, without Bravo changing anything at all, it has become a picture full of humanity. The background is completely neutral. All we see is a sleeping boy and the masonry of a wall. But, precisely because of the hardness of the stone, it is made evident that the living body is quite a different substance. The sleeper is relaxed, at ease. His dream has transported him into another world, one in which he forgets the hardships of his life. Shining patches of light fall on his face. It is a moment of peace and quiet such as is granted to even the poorest; everybody can dream. Bravo conveys all this in one silent picture. It is a silence that characterizes much of his work.

Sunday Cyclists was produced more than thirty years later. But the picture is again stamped by the unique fluidity that is common to the work of Mexican photographers as a group. The cyclists seem tiny in the immensity of the flat, bright landscape and the endless sky. They are people between heaven and earth, who perhaps have no other goal than to experience another piece of this world. E.B.

1902 Born in Mexico City. **1918—22** Studies painting and music at the Academia Nacional de Bellas Artes, Mexico City. From **1922** Self-taught involvement with photography; meets Hugo Brehme in 1923. **1925—27** Lives in Oaxaca. **1927** Meets Tina Modotti. From **1930** Works as a photographer for Diego Rivera, José Clemente Orozco, David Alfaro Siqueiros, and Rufino Tamayo. **1938—40** Meets André Breton. Participates in several exhibitions initiated by Breton in Europe. **1943—59** Photographer of the Mexican film trade union; active as a photographer, cameraman, and teacher at various universities in Mexico. **1959** Founding member of the Publishers Fund for the Mexican Plastic Arts. **1972** Donates his early works to the Instituto Nacional de Bellas Artes, thereby laying the foundation for a photographic collection in the Museo de Arte Moderno, Mexico City. **1990** Retrospective at the Museum of Photographic Art, San Diego. **1997** Retrospective at the Museum of Modern Art, New York. 2002 Dies in Mexico City. Further Reading: Bravo, Manuel Alvarez. *Revelations: The Art of M.A. Bravo.* San Diego, 1990.

Erich Salomon

Any of today's paparazzi would consider it an honor to enjoy the start of a career that Dr. Erich Salomon had. In 1928, Salomon secretly took photos at a trial with a hidden camera and thereby experienced his first major success. The *Berliner Illustrirte Zeitung* bought the photos and paid him a sensational fee amounting to two months' salary. That sealed his decision to terminate his working relationship with the publisher Ullstein and work as a freelance photojournalist for *Berliner Illustrirte Zeitung*, the *Münchner Illustrierte Zeitung*, *Fortune*, *Life*, and other papers. Salomon had learned that the press was especially interested in pictorial information that was considered secret.

He discovered the advantages of the Ermanox camera as a working tool; it had a fast lens that allowed him to take photographs without a flash. In addition, he developed methods to avoid drawing attention to himself. Thus he would dress exactly like the politicians

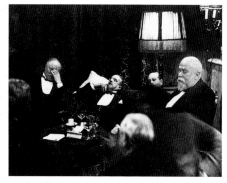

Night Session of the German and French Ministers at the War Debts Conference in The Hague, January 1930

he wished to photograph so that he could mix unobtrusively among them, place the camera somewhere in a corner and talk to them, and activate his shutter release via a long cable. He always hung around until people were used to him, and he was still there long after other photographers had left. At the same time, he was treated with a certain amount of tolerance, as his pictures did not seek to expose but to report authentically. In the end, politicians felt that Salomon's pictures presented them to the nation in a way that was congenial to them. Nevertheless, even he was sometimes forced to leave the room, and when the French foreign minister Aristide Briand noticed during a meeting that Salomon, despite a general ban on journalists, was still there and taking photographs, he cried out: "Ah, le voilà! Le roi des indiscrets." Salomon managed to record the very moment when the finger was pointing at him.

Salomon justified his political photo-reportage on the grounds of its factual interest and his own objectivity. He gave the viewer the feeling of being right in the middle of what was going on. Over and above their topical relevance, however, the pictures he took were "symbols" of his genre, pictures of political life as such. R.M.

 1886 Born in Berlin. **1906–09** Studies zoology and engineering in Berlin. **1909–18** Studies law at the universities of Munich and Berlin. **1914–18** Military service and captivity. **1920–21** Works at the stock exchange. **1921–22** Works in a piano factory in Berlin. **1923–25** Sets up and runs a car and motorcycle rental company. **1926–28** Publicity work for the publishers Ullstein in Berlin; contact with photography. Buys his first camera (Ermanox); **1927** First photos. **1928** Takes pictures of a tribunal with a hidden camera–published in the *Berliner Illustrirte Zeitung*. **1928–32** Freelance press photographer, works for various daily papers.

1931 Publication in Stuttgart of *Berühmte Zeitgenossen in unbewachten Augenblicken* (Famous contemporaries in unguarded moments). **1932–43** Resident in The Hague, Holland. Continues to work as a press photographer for newspapers and magazines in Holland, London (*The Daily Telegraph*), and New York (*Life*). **1943** Deportation to Scheveningen, then to Theresienstadt and Auschwitz. **1944** Killed at Auschwitz.

Further Reading: *Erich Salomon 1886–1944: Aus dem Leben eines Photographen.* Munich, 1981. *Erich Salomon: Porträt einer Epoche.* Berlin, Frankfurt, Vienna, 1963. *Erich Salomons Fotos 1933-1940.* Amsterdam, 1996.

Graffiti, "The Sun King," 1945–50

Henry Miller called Brassaï the "eye of Paris." In fact, no other photographer threw such light on to everyday life in this metropolis as did Brassaï. Destinies seem to fan out through these photos. He combed the streets and cafés of Paris for living images. Even before he pressed shutter the release, the picture was already there before him. "I invent nothing, but I imagine everything." In every gesture that he observed, in every situation that offered itself to him, he sought the intensity of the moment. The pair of lovers in a café is a thoroughly banal scene in a Parisian bistro. So why does this become a valid picture? Because Brassaï gave visual structure to the shapeless, the formless, in the flow of time. He was less interested in the actual situation, the man about to kiss the woman.

Brassaï saw the movement, saw the visual character of the spontaneous act. In an instant, he chose the picture and captured what was so special about this scene; the fact that it is reflected in the mirrors on the wall intensifies its significance. Brassaï has succeeded in combining reality and fiction in a single image. The woman's face appears twice. We see the man from behind, but his face is also presented to us in the mirror. His head forms the center of the picture and is simultaneously at the intersection of vertical and horizontal. From the spatially undefined flow of reality, Brassaï has isolated a situation and converted it into an image. The gesture of the woman, born out of the moment, and her spontaneous facial expression are in contrast to the still life on the table, which looks as though it had been arranged especially for the photographer. But here again, it was chance that positioned the objects, and the photographer's eye captured them just as they were.

Always astonishing in Brassaï's work is the strong presence of people. They fill every setting with their physical volume and reveal the photographer's genuine involvement. No photograph was taken just for its own sake. Despite all his transformation of life into a photographic image, Brassaï's pictures were always a confession of humanity. He was, moreover, a pioneer in the discovery of new themes. He was the first to notice the graffiti in the streets of Paris and, as early as 1932, took photographs of the city at night. But his particular interest lay in people, including his artist friends, especially Picasso. Brassaï transposed the everyday elements of human existence into pictures that are full of aesthetic value but also human warmth. E.B.

1899 Born Gyula Halász in Brassó, Transylvania, Hungary (now Brasvo, Romania). **1918–19** Studies at the Academy of Art in Budapest, **1921–22** at the Akademische Hochschule in Berlin-Charlottenburg. **1924–30** Works as a painter, sculptor, and journalist in Paris, with links among others to Picasso, Dalí, and Braque. **1925** Contact with Eugène Atget. Assumes the pseudonym Brassaï (derived from his birthplace, Brassó). **1926** Meets André Kertész. **1930** Begins to take photographs with a Voigtländer camera. **1930–40** Freelance photographer for the magazines *Verve*, *Minotaure*, and *Harper's Bazaar* (from 1937). Publication of *Paris de nuit* (1932). **1932** Starts photographing graffiti on Parisian walls. Forbidden to practice his profession during the German occupation of France, he nevertheless photographs Picasso's sculptures and drawings and writes the book *Conversations avec Picasso*. From **1945** Resumes work as magazine photographer, including for *Harper's Bazaar* (until 1962), *Lilliput*, *Picture Post*, *Labyrinthe*, and *Réalités*. **1945–50** Ballet designer, Paris. **1962** Stops photographing. **1984** Dies in Beaulieu-sur-Mer, France.

Further Reading: *Brassaï*. Chicago, 1977. *Brassaï: The Artists of My Life*. New York, 1982.

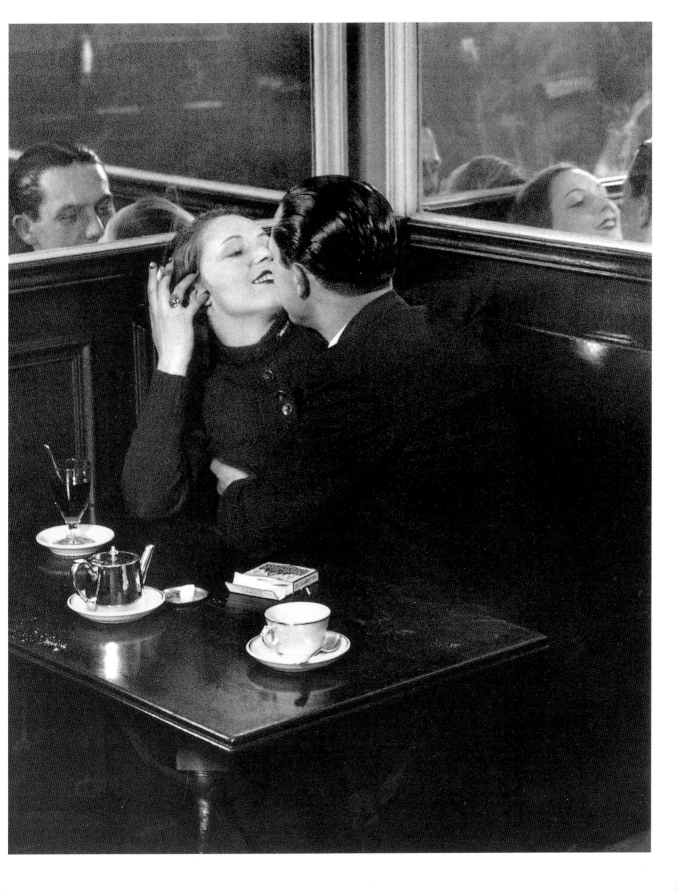

Herbert Bayer

Herbert Bayer, head of the printing and advertising department at the Bauhaus, Dessau, from 1925 until 1928, was the archetype of the modern graphic designer whose work embraces the techniques of typography, photography, and draftsmanship. Bayer's aim was to translate Constructivism and Surrealism into the pictorial language of advertising and, by the same token, into the aesthetics of everyday life. In 1926, influenced by the Parisian school of Surrealism, Bayer began to create dream pictures through the medium of the photomontage. His series *Man and Dream*, originally planned as a story in pictures but never finished, was published in 1936 in a portfolio simply entitled *11 Photomontages*. His *Self-Portrait* of 1932,

the most famous photomontage of this series, shows the artist looking at his own reflection in a mirror and seeing himself turn to stone. A piece has broken away from his shoulder, revealing his petrified inside, and he holds the piece in his left hand, staring in amazement at the gap which it has left. The narcissistic glance at the mirror has suddenly changed into a look of horror. Such nightmare images are in the tradition of the photomontages—known as "double portraits" or "joke portraits"—which became very popular in amateur circles at the turn of the century. They showed the portrayed subjects meeting themselves in the street, or carrying their heads under their arms.

Herbert Bayer's photograph *Lonely City Dweller* is meant to be a self-portrait, too, or in any case this is how he designated the surviving print in the Bauhaus Archive in Berlin. This photograph must be the most remarkable and captivating metaphor ever to have been devised by Bayer: a pair of hands held up against the facades of city tenements, with a pair of eyes staring out at us in the palms of the hands. What Bayer visualizes here is the converse of a normal, everyday gesture. The very hands with which we shield our closed eyes in an attempt to escape the hustle and bustle of the outside world, to concentrate entirely on ourselves, now stare at us. The act of seeing, of perceiving the world from a distance, here conjoins with the act of touching and feeling, of experiencing the world at close range. But what does this have to do with the loneliness of the city dweller? Is Bayer perhaps trying to say that people living in the city are just "eyes," rich in visual impressions, but poor in human contacts? H.M.

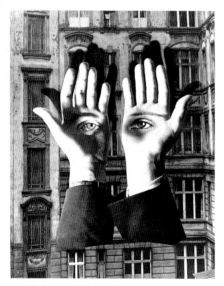

Lonely City Dweller / Self-Portrait, 1932

1900 Born in Haag, Austria. 1921–25 Studies at the Bauhaus in Weimar. 1925–28 Head of the Bauhaus printing and advertising workshop in Dessau and, among other things, responsible for designing Bauhaus printed material; adopts the techniques of photomontage and collage for free and applied graphic art. From 1928 Increasingly turns toward photography. Director of the advertising agency studio Dorland in Berlin. Until 1930 art director of *Vogue*. 1929 Participates in the international Werkbund exhibition *Film und Foto* in Stuttgart. 1938 Emigrates to the U.S.A. Artistic director of the advertising agency Dorland

International in New York. 1946–67 Design consultant for the Aspen Development and Container Corporation of America in Aspen, Colorado. From 1964 Artistic consultant for the Atlantic Richfield Company. 1985 Dies in Montecito, California.

Further Reading: Chanzit, Gwen Finkel. *Herbert Bayer and Modernist Design in America*. Ann Arbor, 1987. Cohen, Arthur Allen. *Herbert Bayer*. Cambridge, 1984. *Herbert Bayer: Visuelle Kommunikation, Architektur, Malerei. Das Werk des Künstlers in Europa und USA*. Ravensburg, 1967.

This photograph—*Black-and-White Nude,* from 1936—is more famous than its creator. Whenever outstanding examples of photographic aesthetics are cited, this picture is regularly included among them. One of the reasons is its conciseness of form. Two nude figures, cropped above and below, the one on the right black, that on the left white, curve their bodies against each other so that an "X" shape is produced in the structural reduction. The black overlies the white, which in reality

Eva-Chançon, c. 1932

is not white but a subtle gray that stands out clearly against the neutral, almost white background.

The aesthetic perfection of the photograph is the result of extensive experimentation. What looks like a complete instant photo is, in fact, a montage. The black-and-white nudes are identical. It is not just the same model involved, it is a mirror image of the same figure. Which of the two is authentic cannot be determined from the photo, although it gives rise to many

speculations. The black figure represents the negative version of the white one and must, according to the logic of photographic technique, have preceded it. The visual irritation is deliberate. Thus, as we perceive it, the black nude overlaps the white one, although the color black connotes depth in visual art. The reflections of light on the dark body weaken this impression, as does the unusually light ground. The perfect symmetry of the formal structure corresponds, moreover, to the flat character of the overall concept of the picture. *Black-and-White Nude* displays the rich "color" spectrum of black-and-white photography in every conceivable nuance, subtly setting the picture plane in motion. In reality, this is a visual essay on the aesthetic possibilities of black-and-white photography.

Although one of the four leaders in his field in Germany—the others being Renger-Patzsch, Blossfeldt, and Sander—Heinz Hajek-Halke is a photographic artist whose importance is only gradually becoming clear. One reason for this is his primarily artistic grasp of the photographic medium, characterized by experimentation. His photographic work is varied and versatile, and cannot be compared with that of any other German photographer. It ranges from Neues Sehen to "subjective photography." Film was one of his major sources of inspiration, and its aesthetic principle, the montage-like collision of individual moments of perception, determined the organization of his pictures. He fluctuated between the spheres of commercial and non-commercial art in Berlin in the twenties. After the war, Hajek-Halke became the leading representative of an aesthetically oriented photography. He invented "light graphics." Through photo-mechanical manipulation of the negative and through external effects such as scratches, patches of soot, and glue, he succeeded in producing images of worlds never before seen. K.H.

1898 Born in Berlin; raised in Argentina. **1915–17** Studies at the Königliche Kunstschule, Berlin (and again from 1919). **1923–25** Works as a fisherman in Hamburg. **1924** First attempts at photography. **1925** First experimental works. From **1927** Collaboration with the publisher of *Deutsches Lichtbild.* From **1933** Scientific research into micro-organisms, use of macrophotography. **1937** Journey to Brazil. Picture reportage on a snake farm and first abstract pictures and photograms. From **1939** Industrial and aerial photographer for the Dornier works while in the German army. **1945** Held prisoner by the French. Sets up a snake farm to produce venom for the pharmaceutical industry. From **1947** Resumes activity as a photojournalist and experimental photographer. **1949** Co-founder of the "fotoform" group in Saarbrücken. From **1955** Professor of graphic arts and photography at the Hochschule für Bildende Künste, Berlin. **1983** Dies in Berlin.

Further Reading: *Heinz Hajek-Halke, der große Unbekannte.* Introduction by Klaus Honnef. Afterword by Michael Ruëtz. Göttingen, 1997.

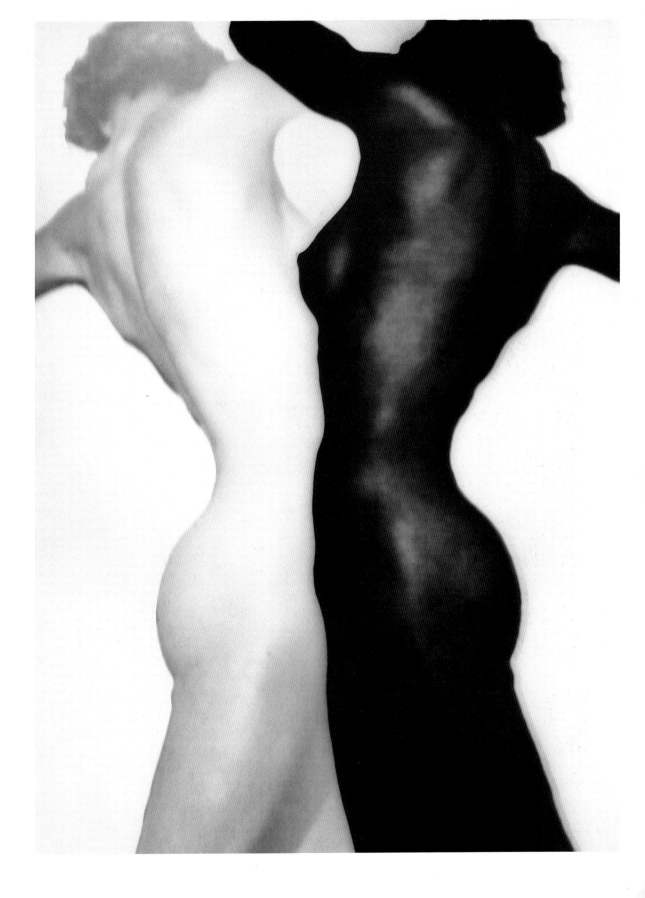

Henri Cartier-Bresson

Henri Cartier-Bresson is the Raphael of twentieth-century photographers. With apparent ease he succeeded in producing one masterpiece after another. In retrospect, hardly any other photographer has produced a greater number of bravura pieces. What is more, in his advanced years, he was able to afford the luxury of declaring his photographic oeuvre complete, so that he could devote himself chiefly—as in his youth—to drawing and painting. And that was some twenty years ago.

Alicante was one of Cartier-Bresson's very first pictures, the work of a twenty-five-year-old genius who frequently recorded ladies of the streets on his journeys through Spain and Mexico. Here he has surprised his "models" at their toilette. The woman at the back is shaving the neck of the woman standing in front of her, while the latter, who reacts to the young photographer with a mixture of female pride, professional distrust, and curiosity, is arranging the hair of the woman sitting in front of her. Something between a genre scene and a group portrait, this photograph—a masterpiece of the grotesque—charms us with its wealth of ambivalent gestures and facial expressions. A display of full-blooded life, as fascinating as it could possibly be, the picture found its way twenty years later into Cartier-Bresson's main work, the series *The*

Europeans, where it represents liberal Spain shortly before the outbreak of the Spanish Civil War.

Alicante is one of the most indiscreet, most direct photographs by Cartier-Bresson, who in his later years discarded the audacious for a classical approach. He was a Frenchman through and through, and his art became an expression of high cultural taste. He gave his pictures great constructive clarity, against the tectonics of which he brought out the uncalculated, the human "coincidence" in contrapuntal fashion. Despite the immediacy with which he recorded his contemporaries—full of charm, spirit, and irony—Cartier-Bresson turned out to be a conscientious "constructor." In his pictures he subjugated lines, surfaces, movements, and the intermediate stages of gray between black and white, into a whole, according to almost musical patterns and laws.

As an aesthete, Cartier-Bresson was primarily concerned in the greater part of his work—even in his reporting trips to China, India, or Cuba—with the picture, and only afterwards with what was being portrayed. Often the assembled persons are arranged and interwoven in a highly elaborate, decorative manner. At the same time, as he admits, his concern all through his life was to penetrate "into the living heart of the human being." P.S.

1908 Born in Canteloup, France. 1922–23 Studies painting with Cotenet and from 1927 to 1928 with André Lhote, Paris. 1928–29 Studies painting and literature at Cambridge University. 1931 Begins career as photographer. 1932 First exhibition in the Julian Levy Gallery, New York. 1934 Photographer for an ethnographic expedition to Mexico. 1935 Freelance photographer. Studies film with Paul Strand in New York. 1936 and again in 1939 Camera assistant to Jacques Becker and André Zvoboda for Jean Renoir. 1937 Works on documentary films in Spain. 1940–43 In German captivity. 1943–45 Active in the M.N.P.G.D. (French underground photographers' association). From 1945 Freelance photographer in Paris, 1946 in the U.S.A. 1947 Founding member of the photo agency Magnum, New York and Paris, together with Robert Capa, David Seymour, and George Rodger. 1948–65 Travels to Burma, Pakistan, Indonesia (1948–50), Russia (1954), China (1958–59), Canada, Mexico, and Cuba (1960), Japan and India (1965). From 1973 Gives up photography and returns to drawing and painting. 2004 Dies in Paris.

Further Reading: *Henri Cartier-Bresson.* Boston, 1998. Cartier-Bresson, Henri. *Tête à tête.* Boston, 1998. *Henri Cartier-Bresson: Seine Kunst–Sein Leben.* Munich/Paris/London, 1997.

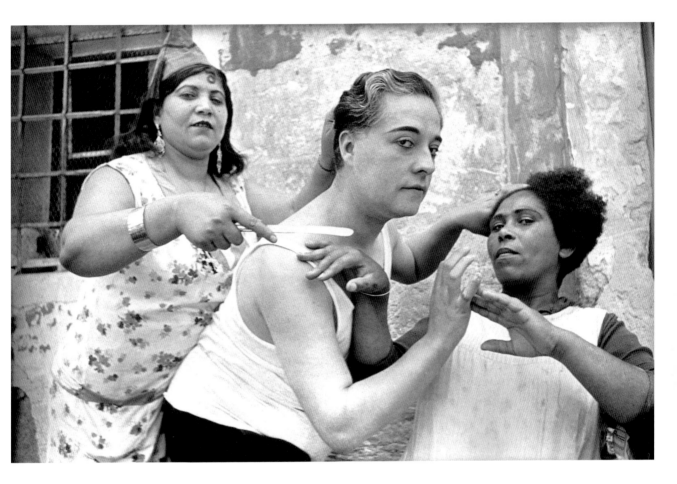

Martín Chambi

Martín Chambi was the first Indian photographer in the history of photography in Latin America. When he opened a photographic studio in Cuzco in 1920, he quickly became the most famous portrait photographer in his town. But he did not simply produce portraits from his commercial studio. Over the years he created a photographic encyclopedia of society in Cuzco and the villages in the Andean hinterland. As a result of his photographs we know quite a lot about the social structure of the country in the 1920s and 1930s. Chambi was a master of the group portrait, but at the same time he was the first to photograph Machu Picchu, which had been discovered in 1911 by the Englishman Hiram Bingham. Chambi's splendid landscape pictures revealed his particular love for the Andes, but his main passion was reserved for the Indio.

The photograph here is typical for Chambi when he was working not in the studio but out in the field. Here he could capture both the people and the splendor of his natural surroundings. He came across the flute-playing Indio with a llama on one of the journeys that he liked to undertake even under the most difficult conditions. At the same time, he recorded the majesty of the landscape and the Indio's familiarity with it, who in this remote place has absentmindedly reached for his flute; a moving South American pastoral scene to which Chambi once gave the title *Tristeza andina*. The photographer was attempting to capture the immense silence, peace, in an image. He himself was so closely connected with this landscape that he knew how to make his people's feelings visible. He was a committed follower of "Indigenismo," which first formed itself into a political movement during his lifetime, and it could hardly have wished for a better interpreter than Chambi; the concerns of the Indios were also Chambi's. In the countless portraits that he took in the course of his life, it was those of the Indian population that made him famous. Through his skillful rendering of man and landscape, but also through the precision of his architectural photos, Chambi outgrew his contemporaries to become a novelty in Latin American photography. In his country, remote from the great cities of the world, he created in isolation an oeuvre of timeless quality. E.B.

1891 Born in Coaza, Peru. From **1900** Works for the Santo Domingo Mining Company in Carabaya. **1908** Moves to Arequipa; apprentice to Max T. Vargas until 1917. **1917** Moves to Sicuani. First exhibition in the Centro Artístico in Arequipa. **1920** Moves to Cuzco. Establishes a studio there. **1925** Participates in an international exhibition in La Paz, Bolivia. **1934** Publication of his photographs in *Cuzco Histórico*, Lima. **1936** Travel and photography in Chile. **1938** Opens a studio gallery in order to exhibit studio portraits. **1964** Participates, together with his son Victor, in the Primera Convención de la Federación de Arte Fotográfico in Mexico City. **1973** Dies in Cuzco.

Further Reading: *Martín Chambi. Photographs 1920–1950*. Washington/London, 1993.

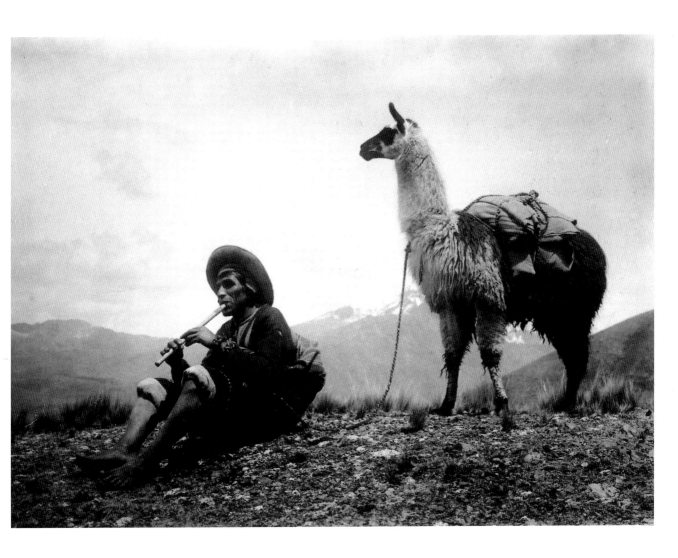

Alfred Eisenstaedt

Alfred Eisenstaedt, one of the best known photojournalists of the twentieth century, spent the first few years of his professional life in Germany before emigrating to the United States in 1935. There, he was among the very first photographers for the magazine *Life*, founded in 1936, for which he published more than ninety cover pictures and carried out innumerable commissions. Owing to his mobility, Eisenstaedt was an ideal photoreporter, constantly ready for action, who experienced things as they happen, at the very pulse of time.

As Eisenstaedt reports in his book, *The Eye of Eisenstaedt* (1969), the photograph of the Graf Zeppelin was taken in 1934 during a transatlantic flight to Rio de Janeiro and appeared in his photo-reportage, *Seven Days in a Zeppelin*. Some damage to the dirigible's outer skin had to be repaired, and Eisenstaedt was only permitted to take a total of three photos of the incident. At that time, the LZ 127 Graf Zeppelin, which in 1929 had undertaken the first flight around the globe, had already traveled across all the continents and would soon have crossed the ocean for the hundredth time. The fascination of this marvel of technology, which was always good for a newspaper story and therefore accompanied on its travels by reputable photographers, was also exploited by the Nazis. Thus, in 1933, the Graf Zeppelin was an attraction at the National Socialists' party conference in Nuremberg and, decked out with an enormous swastika on its stabilizing surfaces, was misused for propaganda purposes on its journeys around the world as a symbol of progress of the Third Reich. Only the explosion of its successor, the LZ 129 Hindenburg, at Lakehurst, New Jersey, in 1937 brought the construction of zeppelins, as well as the propaganda dreams, to an abrupt halt.

The unusual perspective of the picture, which ultimately we owe to the photographer's adventurous spirit, gives an impression of the exhilarating beauty and danger of a trip through the air in the zeppelin. The photograph also arouses associations with the heroic daring of the workers in Lewis W. Hine's photos of the Empire State Building. U. P.

1898 Born in Dierschau, West Prussia (today Poland). **1913–16** Studies at the University of Berlin. Self-taught in photography. **1916–18** Military service. **1919–21** Works as a belt and button vendor in Berlin. **1927–29** Freelance photographer for *Weltspiegel*. **1929** Decides to become a photographer. **1929** Works as a photojournalist for the Pacific and Atlantic Picture Agency (later part of Associated Press). **1929-1935** Works for the *Berliner Illustrirte Zeitung*, among others, in Berlin and Paris. **1935** Emigrates to the U.S.A. Freelance photographer in New York, including for *Harper's Bazaar*, *Vogue*, and *Town and Country* until 1936. From **1936** Regular photographer for *Life*. **1966** First publication: *Witness to Our Time*. **1995** Dies in Oak Bluffs, Martha's Vineyard, Massachusetts.

Further Reading: *Eisenstaedt: Germany*. New York, 1980.

"In order to educate man to a new way of seeing, one must show him everyday, familiar objects from totally unexpected perspectives and in unexpected situations," wrote Alexander M. Rodchenko in 1928. That was the year he bought himself a Leica, having given up painting the previous year in favor of photography and anxious put his ideas into practice. As in Alvin Langdon Coburn's photographs of New York, the Leica allowed him to observe and react to situations more rapidly, to give visual expression to the pulse-beat of the mechanized age. It allowed him to take up unusual positions, greatly shorten perspectives, delve into details, and record movement. Such

pictures had never been seen previously in the Soviet Union, nor anywhere else for that matter.

Somersault is a prime example of the recording of a movement within an instant, isolating it in a way that is impossible to do with the naked eye. The eye perceives aerial acrobatics as a sequence of movements, the phases of which we can describe afterwards, but the details of which we are unable to record in our visual memory. Many of Rodchenko's photos revealed the details of motion sequences for the first time, although, unlike Eadweard Muybridge (1830-1904), he was concerned not with an analytical dissection of the phases of motion but with a culminating point which would summarize the decisive characteristic of the acrobatics in a picture. The concept of a human ball soaring in the air is epitomized in *Somersault*. With such works, Rodchenko enabled photography to take its place among the artistic avant-garde of the era, alongside Constructivism and Cubo-Futurism. He is thus considered a pioneer in integrating the photographic gaze into the fine arts, while preserving and fostering photography's own qualities as a medium.

R.M.

Trumpet-Playing Pioneer, 1930

1891 Born in St. Petersburg. 1910–14 Studes at the Kasan Art School. c. 1914/15 Moves to Moscow, with further study at the Stroganoff Art School, where he meets Vladimir Tatlin and Kazimir Malevich. 1920–23 Creates the triptych *Three Colors: Red, Yellow, Blue*. 1922–24 Involvement with photomontage, poster art, and book design. From 1924 Takes first photos with a large-plate camera. From 1925 Works with a hand-held camera and develops characteristic style with extreme angles of vision. 1930 Founding member of the group October, from which he is excluded in 1931. 1935 Is rehabilitated and participates in the exhibition *Masters of Soviet Photo Art* in Moscow. 1933–41 Works for the magazine *SSSR na stroike*, which he founded with Varvara Stepanova. From 1950 Experiments with color photography and magazine design. 1956 Dies in Moscow.

Further Reading: *Alexander Rodchenko: Painting, Drawing, Collage, Design, Photography*. Exh. cat., The Museum of Modern Art, New York, 1998. Dabrowski, Magdalena. *Aleksandr Rodchenko*. New York, 1998. Noever, Peter. *Aleksandr M. Rodchenko and Varvara F. Stepanova*. Munich, 1991.

David Seymour

Even in non-belligerent countries, the Spanish Civil War mobilized public opinion to a degree that few earlier military confrontations had done. The modern media, film and photography, together with newsreels and magazines, contributed greatly to make this first conflict between Communism and Fascism comprehensible as the start of a struggle for world domination. Numerous photographers, including Robert Capa, Henri Cartier-Bresson, Hans Namuth, and Gerta Taro, went to Spain in order to support the republican government on the propaganda front against Franco's rebellious troops. Their pictures appeared in France in high-circulation magazines aimed at workers, such as *Vu* and *Regards*, but also in the American magazine *Life*.

David Seymour's *A Hand Grenade Attack*—like Robert Capa's photo of the republican soldier who has just been fatally hit by a bullet (p. 68)—was among the first photos to report direct, "live," on death in battle. Seymour—Chim, as his friends called him—was present at the attack, was part of the war machine, as can be sensed at once. The smudges, the coarse grain of the enlargement, the seemingly arbitrary cropping; all these are tools of the photographic idiom that confirm this witness quality. They make clear the strain felt by soldiers, the danger, the brutality of war. Here there is no running away from violence, no escape from death.

War refused to let Seymour go. In World War I, he worked as a reporter for the United States Army, then took photographs for UNESCO on the fate of children in war-torn Europe. It was also in a war that he died. He took over the presidency of the Magnum photo agency from Capa, who died in 1954 while reporting on the Vietnam War, only to be shot dead himself during the Suez War in Egypt in 1956. L. D.

1911 Born David Szymin in Warsaw. **1929–31** Studies art and photography at the Staatliche Akademie für Graphische Künste und Buchgewerbe, Leipzig. **1931–33** Studies at the Sorbonne, Paris. **1933–39** Freelance photographer in Paris, Spain, Mexico, and North Africa, among other places. Regular contributor to the magazine *Regards*, as well as to *Vu*, *Ce Soir*, and *La Vie Ouvrière*. Adopts the pseudonym "Chim." **1939** Moves to New York. **1942–45** Photo reconnaissance and interpreter for the U.S. Army in Europe. **1946–56** Travels on behalf of UNESCO to document the effects of war on children, to Poland, Greece, Italy, Hungary, Czechoslovakia, and Germany. **1949** *Children of Europe* published through UNESCO. **1947** Founds the photo agency Magnum together with Robert Capa, Henri Cartier-Bresson, and George Rodger. **1954–56** President of Magnum. **1956** Dies in Suez, Egypt.

Further Reading: Bondi, Inge. *Chim: The Photographs of David Seymour*. Boston, 1996

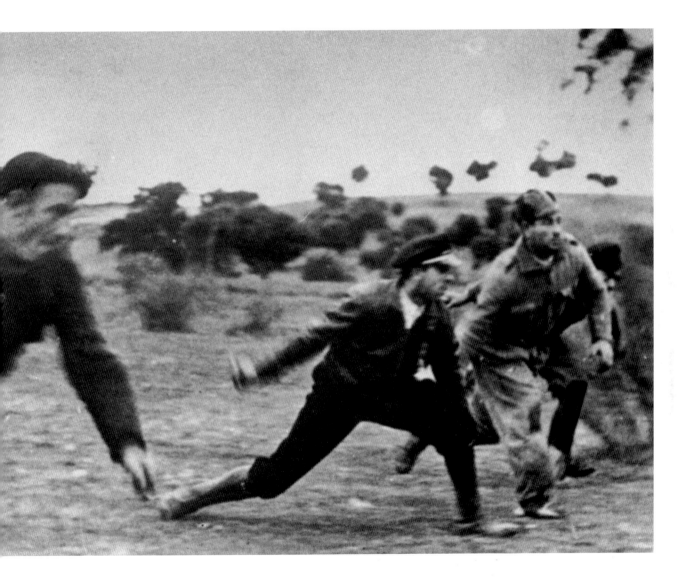

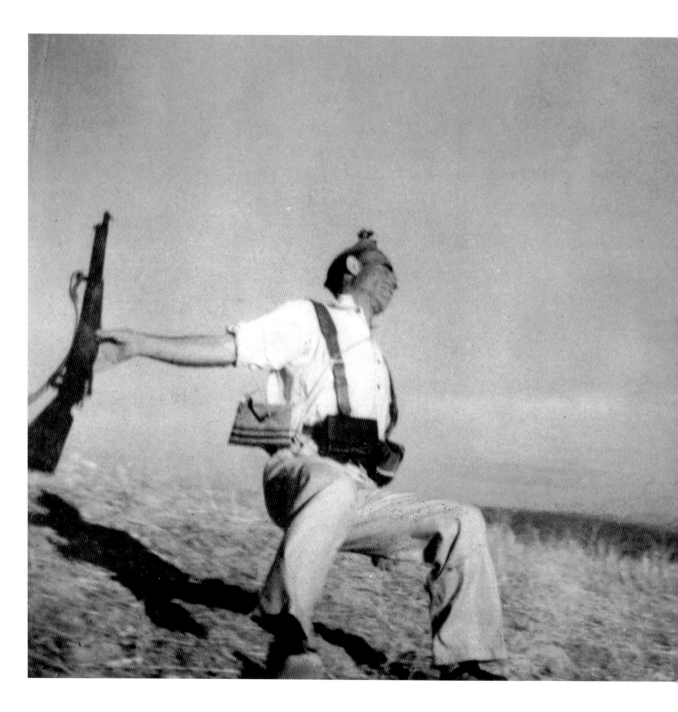

Robert Capa

One of Robert Capa's very first pictures became one of his best known. After finishing his training as a photographer with the publishers Ullstein and the news agency DEPHOT (Deutscher Photodienst), Capa started documenting the Spanish Civil War as a freelance photojournalist. He included a photo of a collapsing soldier who had just been hit by a bullet among the first pictures he offered to editorial offices. This picture became famous under the title *Death of a Loyalist Soldier*. The moment of death, recorded by a camera, fascinated the press and the general public. It aroused the sensation of being close to the killing and being killed. Never before had such a photograph been seen.

Of course, it also provoked discussion, primarily focusing on the question of whether it was a genuine a snapshot or had merely been posed, although the impact of the picture made the answer to this irrelevant. Nevertheless, this picture and its consequences taught Capa the principles for his future work. He realized that the aura of a photo, its impact on the viewer, is all the greater, the more directly the latter feels confronted by what is happening. Reportage photography aims to produce an effect, and this cannot be done from a safe distance. The photojournalist must therefore be right in the center of things if he is to produce powerful images. Capa drew on this realization for his guiding principle: "If your pictures aren't good enough, you aren't close enough"—a maxim that cost him his life on May 25, 1954, in Thai-Binh, Vietnam.

Capa's ability to concentrate violence, suffering, the fear of death, and destruction on the battlefield into a single picture, without directing his camera at the superficially spectacular, and without getting "too close" to those who were suffering, was what made him a master photographer. Although his photos show war zones, they are in fact documents against war, injustice, and oppression. The Robert Capa Gold Award has been presented in his honor ever since 1955, and he was the initiator of the International Fund for Concerned Photography. R.M.

1913 Born André Friedmann in Budapest. Self-taught in photography. From **1930** Works as a photographer. **1931–33** Studies political science at the University of Berlin. **1931** Works as a photo lab technician at the publishers Ullstein, Berlin. **1932-33** Photo assistant at the agency DEPHOT (Deutscher Photodienst). **1933–39** Freelance photographer in Paris. From **1933** Calls himself "Robert Capa." **1935** Co-founder of the agency Alliance. **1939–41** Freelance photographer. War reporting during World War II for *Life*, New York. **1941–46** With the U.S. Army in Europe. **1947** Founding member of the photo agency Magnum, New York and Paris, together with Henri Cartier-Bresson, David Seymour, and George Rodger. **1948–54** President of Magnum. War photographer in Indochina for *Life*. **1954** Fatal accident in Thai-Binh, Vietnam.

Further Reading: *Robert Capa: Photographs*. New York, 1996. Whelan, Richard. *Robert Capa*. Lincoln, 1994.

This picture is among the most famous in the literature of photography. Few photographs have been published more frequently, and the image has become imbued with almost mythical qualities. It embodies the self-confidence of a country whose spirit cannot be broken, even under adverse circumstances. The American photographer Dorothea Lange took the picture at a time when the United States was in the throes of an economic depression of never before experienced dimensions, and the international economic crisis even proved to be traumatic for Europe. A woman who looks older than she is, her face with clear-cut

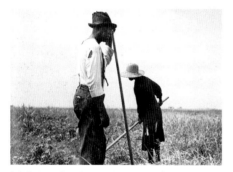

Field Hands on a Cotton Plantation, Greene County, Georgia, 1937

features and wrinkled brow, gazes sceptically, a little morosely, but with determination into an uncertain future. With her left hand she holds a small child bundled up on her lap; two other children rest their heads against her shoulders. The photographer caught her in three-quarter view: one of the countless itinerant laborers who roamed the west and the south of the United States searching for a living of some kind, no matter how meager. Borrowings from the traditions of European art history, images of the Madonna, are evident here and give the picture its decisive visual power. Lange photographed the woman from various angles, but only this particular picture caught the exact moment that kindles the emotional impact.

The United States Government, under President Franklin D. Roosevelt, had commissioned a select group of photographers, male and female, to document the misery of such people, who were not profiting from New Deal politics. These documentary pictures, it was hoped, would stir employers in the industrial regions, by then once again prospering, as well as those in the big cities. *Migrant Mother* became the model for such endeavors. Its creator was a committed photographer. Originally a teacher, Lange always used photography as an educational tool. Yet, she was deeply wedded to the myth of America, although this never clouded her critical eye. The exhausted workers in *Field Hands on a Cotton Plantation, Greene County, Georgia* are a good example. They slave away all day for a few dollars, only to start again the next morning. The vertical lines dominate the picture structure, lightly countered by the diagonal of the tool held by the black woman to the right of center, with her back bent. In spite of the hardships her subjects had to endure, the photographer believed that only an individual's contribution could change the world. Together with Margaret Bourke-White (see p. 100), Dorothea Lange was the most American of American photographers. K.H.

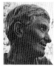

1895 Born in Hoboken, New Jersey. **1913** Decides to become a photographer. **1914–17** Studies at the Training School for Teachers, New York. Assistant in various photographic studios, including that of Arnold Genthe, New York. **1918** Works as a photo-finisher at Marsh's Dry Goods and Photo Supply Store, San Francisco. **1919–34** Freelance photographer with her own studio in San Francisco. **1934** Contacts with the "f-64" group. **1935** Moves to Berkeley, California. Marries

Paul Schuster Taylor; thereafter collaboration with the California Rural Rehabilitation Administration (Resettlement Administration), later Farm Security Administration. **1965** Dies in Marin County, California.

Further Reading: *Dorothea Lange: American Photographs.* Exh. cat., San Francisco Museum of Modern Art, 1994. *Dorothea Lange: Photographs of a Lifetime.* The Oakland Museum, 1982.

On leave from his duties as a member of the Farm Security Administration's photographic team in the summer of 1936, Walker Evans accompanied James Agee on an ostensibly journalistic assignment into cotton country. It was the height of the Great Depression; they had come to report on conditions in the rural south of the United States, and had decided to do so not by surveying the broad scene but by immersing themselves in the lives of a small group of tenant farmers' families.

This bleak, somber, formal study of the Fields family at once epitomizes and denies its function. It

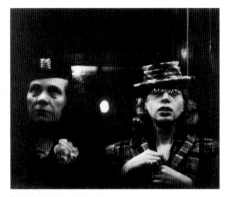

Subway Portrait, New York, 1938-40

gives us everything such a portrait traditionally offers: the nuclear family unit, several generations, emblems of the home, possessions, and social status, as well as a self-conscious, formal presentation to the lens for posterity's sake. Yet what this picture makes all too

clear is that these six people have virtually nothing but each other, and that they are terribly fragile, frighteningly vulnerable, and in great peril.

Deemed unpublishable by the magazine that had sent them, the resulting document achieved book form a few years later, sold a few hundred copies, and vanished for decades. Yet, arguably, no book except Robert Frank's *The Americans* has had a more resonant impact on the field of documentary photography than their collaboration, *Let Us Now Praise Famous Men*.

Several researchers have revisited the Fields family in recent years, interviewing the still-living children and their descendants about their recollections of Agee and Evans, the experience of being photographed during those difficult times, and the consequences to them this picture and its companions have had as visual archetypes of hardscrabble, rural, Depression-era survival. Understandably, they are somewhat embarrassed by these images today; they did come through, after all, even if against the odds, and do not enjoy being seen in such desperate straits. One can understand their desire to forget such hardship; yet one must also feel grateful that, at a time when they had nothing to offer but the blunt fact of their own existence and the determination to endure, they were willing to share that with Agee and Evans and, through those two empathetic strangers, with us. A.D.C.

1903 Born in St. Louis, Missouri. **1922** Attends Phillips Academy, Andover, Massachusetts. **1922–23** Studies literature at Williams College, Williamstown, Massachusetts; teaches himself photography. **1923–25** Moves to New York, where he works in a library. **1926–27** Journey to Europe; studies at the Sorbonne, Paris. Snapshots with a roll-film camera. **1928** Begins freelance activity in New York. From **1930** Uses a large-format camera (16.5 x 21.6 cm). First publications. **1933** First solo exhibition at the Museum of Modern Art, New York: *Walker Evans: Photographs of 19th-Century Houses*. Photo campaign in Cuba.

1935–37 Regular photographer for the Farm Security Administration (F.S.A.). **1938** Publication of *Walker Evans: American Photographs*. First photos of the subway. **1941** Publication of *Let Us Now Praise Famous Men*. **1945–65** Chief editor and photographer of the magazine *Fortune*. **1948** First retrospective at the Art Institute of Chicago. **1964–74** Professor of graphic arts and design at Yale University, New Haven, Connecticut; Professor Emeritus 1974–75. **1975** Dies in New Haven.

Further Reading: *Walker Evans*. Los Angeles, 1998. Thompson, Jerry L. *The Last Years of Walker Evans*. New York, 1997.

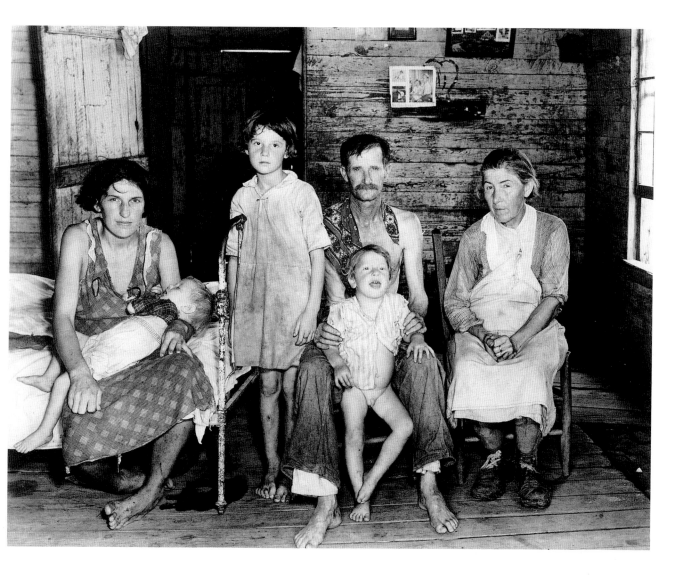

Edward Weston

For Edward Weston, photography was the medium through which to approach the world as something complete, true, and unique. Like his friends from the "f-64" group, to which Ansel Adams and Imogen Cunningham belonged (pp. 94, 128), he sought to experience the mystery of nature optically, to describe the singularity of its structures through his pictures.

In 1934, during a visit to Oceano in California, Weston noted in his diary: "I took a few photographs there of the dunes, which herald a new epoch in my work. I must return there—the material is created for me." He photographed these sand formations over and over again. Their silhouettes, constantly altered by the wind, and their surfaces shaped by the light prompted him to record natural phenomena in an absolute pictorial form. *Oceano* comes from those years of constant work. Edward Steichen photographed clouds for

decades, while for Hans Finsler it was the egg whose perfection repeatedly drove him to convert it into the two-dimensionality of a picture. For Weston, it was the dunes of Oceano; through his lens they become a hymn to the structure and movement of nature. He experiences them as a rhythmically moving sea of waves on to which the wind traces a fine, ornamental pattern. The sun throws its glistening light on to the light-colored sand, producing deep shadows that make it dark and secretive. The infinite nature of a sand dune resonates in the composition of the photograph. The dunes have no limits. They fill the entire picture space, leaving only a narrow gap for the sky. The real view of the dunes is broken up through the parallel layering of light and dark.

For Weston, photography was a "wonderful expansion of our vision." He believed in the "majesty of the moment." He saw every photograph already complete before his eyes, even before he started to make the exposure. He never cropped a photograph—his respect for his subject was too great. But he conjured with his camera the never before perceived, and this is part of the fascination of his art, as evidenced by his famous photo, *Cabbage Leaf*. In his work, a precise look at reality is combined with the simultaneous recognizing of its visual nature. Weston himself was well aware of this capability, which he conceded to only a handful of other photographers. E.B.

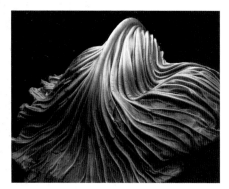

Cabbage Leaf, 1931

1886 Born in Highland Park, Illinois. **1902** Given a camera (Kodak Bull's-eye no. 2) by his father; subsequent involvement with photography, self-taught; particular interest in portrait photography. **1906** First publication. **1907–08** Postcard photographer in Los Angeles. **1908** Studies photography at the Illinois College of Photography, Chicago. **1909** Assistant in the studios of George Steckel and A. Louis Mojonier. **1911** Establishes his own studio in Tropico. **1917** Member of the London Salon of Photography. **1920** Meets Imogen Cunningham and Dorothea Lange in Los Angeles. **1921** Tina Modotti becomes his student. **1923** They go to Mexico, where they set up a photo studio together. First photographs of clouds. **1927** Moves to Glendale, California. Meets Ansel Adams. **1928** Opens a portrait studio with his son, Brett Weston, in San Francisco. **1929** Moves to Carmel; participates in the exhibition *Film und Foto* in Stuttgart. **1932–34** Founding member of the "f-64" group. **1935** Opens a portrait studio with Brett Weston in Santa Monica. **1938–58** Wildcat Hill Studio in Carmel. **1946** Retrospective at the Museum of Modern Art, New York. **1951** Honorary member of the American Photographic Society. **1958** Dies in Carmel.

Further Reading: Mora, Gilles (ed.). *Edward Weston: Forms of Passion—Passion of Forms.* London, 1995.

Albert Renger-Patzsch

No genre has stirred the emotions of the art scene as much as the question whether factual photography is, or could be, art. Albert Renger-Patzsch regarded himself all his life as a photographer with high formal and technical standards. In the 1920s, he had already rejected the tendency to want to make art with photography, as László Moholy-Nagy, Man Ray, and Christian Schad were doing at that time. "Let us leave art to artists and try, with the tools of photography, to create photographs that can hold their own through their photographic qualities," was how he put it in 1927 for the magazine *Deutsche Lichtbildner*. Today, after the lengthy

"Katharina" Colliery in Essen, 1954

debates of the seventies and eighties, his photographs are viewed as art; even his advertising and commissioned work is considered to be of high quality—

icons of factual photography. A few years ago, even the juxtaposition of the terms "art" and "factual photography" would have been considered inherently contradictory. But now that a young generation of artists, conceptually motivated, is employing factual photography, Renger-Patzsch is claimed as the forefather of the visual tools they use.

His late work, too, which he devoted to trees and rocks, breaks with the tradition of the confrontation with nature (particularly the German variety), familiar since the paintings of Caspar David Friedrich. Renger-Patzsch's photos of trees are not landscape pictures in the traditional sense, as they are more closely cropped and the photographer enters into the landscape he is recording. However, they retain too much distance to allow their interpretation as detailed views of nature. Renger-Patzsch is no Romantic, although his nature photos are anything but objective visual documents. Probably the most appropriate term to describe the feelings conveyed in his superb photographs of German forests and woods would be Sublime. The eye of the architectural photographer positions the tree-trunks as though faced with the pillars of some Gothic cathedral. His mastery as a photographer of objects is demonstrated again with regard to nature. His photos testify to the inner order of things, their relationship to one another. Whether, as in the present photograph, his subject is woodland, whether he photographs plants or rocks, glass cylinders, or parts of a spinning machine, Renger-Patzsch takes care—either in front of the lens or through the lens—to arrange his subjects in accordance with the dimensional proportions that, in the final analysis, give the image its structure. "I base this on reality as space. This space should be cropped in such a way that it produces a well-ordered picture when projected onto the plane." This is the straightforward description of the artist's approach. R.M.

1897 Born in Würzburg, Germany. **1916–18** Serves in World War I. **1919–21** Studies chemistry at the Technische Hochschule in Dresden. **1922–23** Heads the photography departments of the Folkwang-Archiv and the Auriga-Verlag in Hagen. Works as a photographer on the book series *Die Welt der Pflanze* (The plant world). **1925** Settles as an independent photographer in Bad Harzburg; publishes his first book, *Das Chorgestühl von Cappenberg* (The choir stalls of Cappenberg). **1928** Moves to Essen. **1933–34** Teaches at the Folkwangschule, Essen. **1944** Moves to Wamel near Soest. **1966** Dies in Wamel.

Further Reading: Wilde, Ann and Jurgen, and Thomas Weski (eds). *Albert Renger-Patzsch. Meisterwerke.* Munich/Paris/London, 1997.

Paul Outerbridge, Jr.

Paul Outerbridge, Jr., is probably best known for his simple still life, a black-and-white image from 1922 of a man's shirt-collar resting on a chess board. It is an image that, though made on commission as an advertisement for Ide, a collar manufacturer, so resonated with an elegant surrealism that the inveterate chessplayer Marcel Duchamp viewed it as a "readymade," clipping it from a periodical to pin on his bulletin board.

That mix of the functional and the creative, the applied and the imaginative, remained a hallmark of Outerbridge's work throughout his comparatively brief career. He enjoyed working with the most difficult yet durable of the photographic printmaking processes—platinum for his monochrome work and Carbro (carbon printing) for his pioneering exploration of color. This image exemplifies his achievements in the latter form; it moves the eye, and with it the mind, through three layers of insubstantiality.

We first see the seductive form of the bather, all warm flesh tones against a background of cool aquamarine, her red-lipped mouth and white teeth drawing attention from her sensual figure to her upturned face with its ecstatic expression. Yet she proves illusory, diffused and dematerialized by the intervention of the patterned shower curtain, whose upper folds in turn become a series of streaks of reflected light, none of them ultimately any more tangible than the other. What begins as an erotic promise evolves into a meditation on the extra-physical levels of sexuality.

Outerbridge took classes at the Clarence White School of photography in New York in the early 1920s, where he encountered not only the pictorialist ideas of White but also the modernist concepts of Paul Strand and Max Weber; he also studied with the sculptor Alexander Archipenko, and conversed with Alfred Stieglitz. From there he went to Paris, where he worked for French *Vogue* and met Duchamp, Dalí, Picasso, Braque, Man Ray, and other major figures. Next he studied filmmaking in Germany in the late 1920s, absorbing the influence of Bauhaus aesthetics, German Expressionism, and cabaret theater before returning to the United States. As a result, one can find virtually all of the currents of early twentieth-century photography and art moving through his compact oeuvre, which comprises a mere two decades. A.D.C.

Ide Collar, 1922

1896 Born in New York. 1915 Studies at the Art Students League, New York. 1916 Designs stage sets, together with Rollo Peters. 1917 Enters the Army. Begins taking photos. From 1921 Training at the Clarence White School. 1923 Meets Alfred Stieglitz; studies with Alexander Archipenko. Until 1925 Works as commercial photographer. Goes to Paris, where he meets Duchamp, Man Ray, Brancusi, and Picabia. 1926 Freelance work for *Vogue*. 1929 Returns to New York. 1930 Opens his own studio; experiments with the carbon color process. From 1936 Active as freelance photographer. 1947 Extensive travel and picture reportages. 1958 Dies in New York.

Further Reading: Howe, Graham. *Paul Outerbridge, Jr.* New York, 1980. *Paul Outerbridge: A Singular Aesthetic.* Santa Barbara, 1981.

Horst P. Horst set important markers in twentieth-century photography, unforgettable images that even people who are not particularly knowledgeable about photography find embedded in their memory. *Main-bocher Corset* tops the list, but *Odalisque* (1943) and *Electric Beauty* (1939) are also among them. And Horst's compositions created in cooperation with Salvador Dalí, such as *Dalí Costumes* (1939) or *Surrealistic Still Life* (1941), are no less fascinating.

Of all these pictures, *Mainbocher Corset* stands out particularly because it also marked a turning-point in Horst's own life. "It was the last photo I took in Paris before war broke out. At four in the morning I left the studio, went back to my house, collected my luggage, and at seven got into the train to Le Havre, where we

boarded the Normandie. We all felt that war was imminent. Too many weapons, too much talk. And we knew that it would never be the same, whatever happened. In Paris I had found a family, a way of life. The clothes, the books, the apartment—everything was left behind. I myself had left Germany... experiencing the same loss all over again. The photograph had some-thing quite unique—for me it is the quintessence of that moment," he said.

In photojournalism, it is frequently the case that important historical situations provoke the creation of important images. It is not a matter of course that the tension of a historic moment may have a similar effect on the fashion photographer, that the last photo taken three hours before departure is not made quickly and absentmindedly, but with full concentration, absorb-ing the situation. In fact, Horst later that said he him-self could no longer understand how he had taken the picture, and that he would be incapable of repeating it. A woman fashion photographer once confided to the author that, in her experience, the best photos were produced when the models were exhausted. Possibly it was such a situation that reigned in Horst's studio when he took *Mainbocher Corset*. It is a great work which can easily be ranked alongside historic images of "rear views" from Ingres, by way of Degas, to Man Ray. R.M.

Still Life, 1937

1906 Born Horst Paul Albert Bohrmann in Weissenfels an der Saale, Germany. **1926–28** Studies architecture at the Kunst-gewerbeschule, Hamburg. **1930** Assistant to Le Corbusier in Paris. Turns to photography, encouraged by George Hoyningen-Huene. **1932–34** Photographer at Condé Nast's *Vogue*, Paris; from 1934 on the staff there. Works on commission for various fashion houses in Paris, including Coco Chanel. **1939** Emigrates to the U.S.A. Staff photographer at *Vogue* in New York. **1943–45** Serves in the U.S. Army as army photographer.

Works for the magazine *Belvoir Castle*. **1946** Again at *Vogue*, New York, until studio closes in 1951. **1951** Innumerable major journeys, including to South America, Europe, Beirut, Israel. From **1952** Contributes to *House & Garden*, New York. **1974** Solo exhibition at the Sonnabend Gallery, New York. **1977** Partici-pates in "documenta 6," Kassel. **1984** First retrospective at the International Center of Photography, New York. **1999** Dies in Palm Beach.

Further Reading: *Horst: Photographien aus sechs Jahrzehnten*. Munich/Paris/London, 1991. Misselbeck, Reinhold (ed.). *Horst–Magier des Lichts*. Heidelberg, 1997.

This picture of a stout woman in a bathing suit was taken on Lisette Model's first commission for the New York magazine *Harper's Bazaar*. It was used in July 1941 to illustrate the article "How Coney Island Got That Way" and was captioned: "Coney Island Today, the Bathing Paradise of Billions—Where Fun is Still on a Gigantic Scale." In contrast to the superlatives of the caption, the photo shows not the teeming beaches of "New York's bathing paradise" but an individual portrait of a middle-aged woman who—her back to the sea — is happily waiting, hands propped on knees, either to catch a ball or for someone to join her. This is no foam-born Botticelli Venus who stands before us (she is more like one of Rubens' creations), but she nevertheless radiates great charisma. With strong diagonals in the rectangular composition, her physical presence

fills the entire picture with life. As was her general custom, Model enlarged the photo in such a way that the figure of the woman is barely contained within the boundaries of the picture on all sides. The simple volumes are accentuated, and the movement of the body is captured at the instant of greatest accumulated tension. The black of the hair and bathing suit gives the picture an inner calm. The bare feet on sand washed by the sea, the far horizon: Model succeeded here in visualizing an effervescent *joie de vivre* by using the tools offered by black-and-white photography.

In her overall creative work, Model demonstrated an interest in people in the street, whether these were idlers on the Promenade des Anglais in Nice (1934) or passersby on the Lower East Side (1939–45), many of whom are social outcasts. Although *Coney Island Bather* is a masterfully composed image—comparable in its type with Henri Cartier-Bresson's most successful snapshots—Model avoided an overly strong degree of aesthetization, resulting in the impression of great truth to life in her photos. She showed people as they were, not as they wished to be seen. This was one of the reasons why she did not ultimately succeed in making the breakthrough as a magazine photographer.

Also dating from her early New York period is the series *Running Legs*, one example of which is shown here. The formalization that dominates in this case contrasts with the verism of many of her milieu depictions. The picture from the upper-class financial district showing an elegantly clad lady's leg combines American emblems such as the Ford and the flag from a surprisingly novel perspective, making this a symbol of tempo and a worldly way of life. P.S.

Running Legs, Fifth Avenue, 1940–41

1901 Born Elise Felicie (Lisette) Amelie Stern (later Seybert) in Vienna. **1920–25** Studies music with Arnold Schönberg in Vienna. **1926-33** Studies singing with Marya Freund in Paris. **1933** Discovers photography through her sister Olga. After a conversation with Hanns Eisler, decides to become a professional photographer. **1936** Marries the painter Evsa Model. **1937** Emigrates to the U.S.A.; self-taught in photography. **1940–41** Photographer, under Ralph Steiner, for the magazine *PM*. **1941–53** Freelance photographer, working among others for *Harper's Bazaar* (until 1955), *Look*, and *Ladies Home Journal*. From **1951** Lecturer in photography at the New School for Social Research, New York. **1955–59** Meets Diane Arbus, who becomes one of her students. **1960** Takes over Berenice Abbott's class. Numerous workshops and seminars at other institutes, including in Vienna, Arles (1978), Seattle Art Museum (1979), and Haverford College (1983). **1967** Participates in Alexey Brodovich's Design Laboratory, an experimental workshop and conference for photography and design. **1968** Honorary member of the American Association of Magazine Photographers. **1981** Honorary doctorate from the New School for Social Research, New York. **1982** Retrospective at the Museum Folkwang, Essen. **1983** Dies in New York.

Further Reading: *Lisette Model*. Exh. cat., National Gallery of Canada, etc. Ottawa, 1990.

Helen Levitt

New York is a world of children—this is what is conveyed by the photographs of Helen Levitt, born in Brooklyn, herself only in her mid-twenties when she began to take these pictures of a city that at the time already had a population of seven million. But it is not the sunny world of well-to-do children into which she takes us, but the everyday life of neighborhoods such as the Lower East Side, where children literally grow up on the street, their playgrounds located between the gutter and the fire escapes, in a no-man's-land of empty building lots and backyards. The toys of middle-class children are replaced by what is available on the street: trash and motor vehicles. The lounge is replaced by sidewalks in front of laundries, shoe repair shops, and scrap-metal dealers. But this world can be transformed in an instant into a paradise for children when, for instance, the water hydrants are turned on in the summer and become fountains in an aquatic park.

These pictures are not concerned with social criticism. Levitt recorded scenes without sentimentality, as they were presented to her on the street. She used an angled lens so her subjects would not notice they were being photographed. The spontaneous liveliness and freshness of many of Levitt's pictures are due to this ability not to become involved in what is happening, not even indirectly becoming visible as the photographer. Levitt has been able to capture games of "cops and robbers," childish fights, dressing up at Halloween, or scenes of tenderness between children, as though through the eyes of a child.

In this photo Levitt shows three children on a derelict piece of land. Although each of them is armed with a stick, there does not appear to be anything too dangerous about their game. The boys' springy movements have something almost dance-like about them. The beauty of this moment is encapsulated in the sadness of the surroundings, a background of an area strewn with rubbish, a fire-wall with white graffiti and—indicated on the right—an empty street. Children's pleasure in playing and using their imagination appears to overcome even the desolation of the city; that could be the message of this photo. Or, in the words that preface Levitt's and James Agee's short film *In the Street*, produced in 1944: "The streets of the poor quarters of great cities are, above all, a theater and a battleground. There, unaware and unnoticed, every human being is a poet, a masker, a warrior, a dancer and in his innocent artistry he projects, against the turmoil of the street, an image of human existence." P.S.

1913 Born in Bensonhurst, Brooklyn. **1931** Works for a portrait photographer. Attends Photo League. **1935** Contact with Henri Cartier-Bresson in New York. **1936** First street photographs taken with a Leica. **1937** Teaches children for the Federal Art Project. First photographs of children playing. **1941** Cutting assistant with Luis Buñuel. **1943** Solo exhibition at the Museum of Modern Art, New York: *Photographs of Children*. **1944** Short film *In the Street* with James Agee. **1944–45** Editorial assistant in the film department of the Office of War Information. **1946–47** Film *The Quiet One* with James Agee and Janice Loeb. **1959** Returns to photography, especially color. From **mid-1970s** Teaches at the Pratt Institute in Brooklyn. **1980s** Returns to black-and-white. **1991–92** Major traveling exhibition. **1997** Participates in "documenta X," Kassel. Lives in New York.

Further Reading: Weiermair, Peter (ed.). *Helen Levitt*, Munich/New York, 1998.

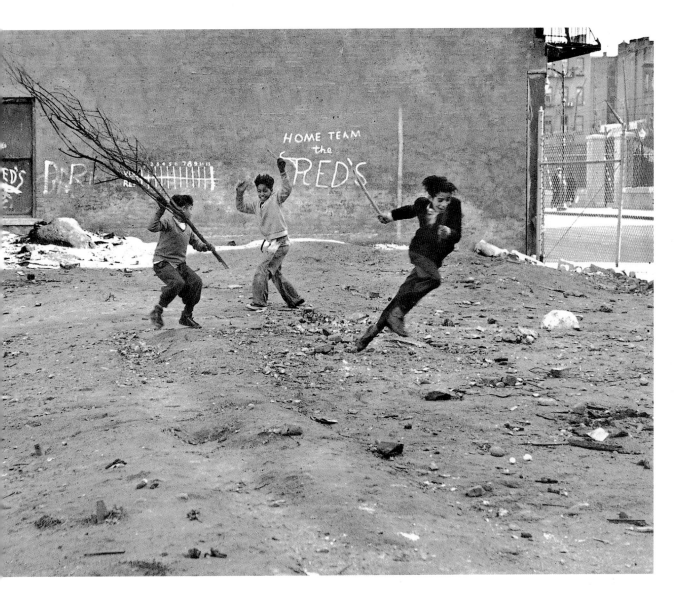

Andreas Feininger

"For me photography is a mirror of life, and every photo that is even worth looking at must be a reflection of life—of reality, nature, man and his activity, from art to war." Behind such a declaration, one would tend to assume, there must be a photographer of the type who delves deep into life, who creates photographs full of emotion. One would not think of Andreas Feininger, the rather cool photographer who composed his views of New York with great precision. However closely he approached his clams and shells with the camera, however much he concentrated on the surface of sculptures in close-up, he remained more the passive observer recording events from a certain distance, and especially so when he found himself amid the bustle of the city, when he delved into the streets of New York and watched people going about their daily business. He probably considered this distance necessary to prevent a situation where the photographer suddenly becomes part of the action and may influence events through his presence.

In order to describe a situation, the ambience—the loving recording of details in the vicinity—was always just as important to Feininger as the people who were active within it. There is no doubt that form played an important role in his photos, supplied an "architectural" order in the picture that was both framework and support for its content.

This is evident in Feininger's photographs of New York, his views of Brooklyn Bridge and the Manhattan skyline, which could also be read as abstract patterns of verticals and horizontals, of black, white, and grays. Moreover, through the use of a telephoto lens, the depth of the space is compressed within the picture plane. The photo opposite is particularly remarkable in the graphic contrasts of its composition. Thus, the thick smoke from the ship, which has just passed through the picture, still visible on the right, creates an almost calligraphic structure in front of the skyscrapers of Midtown Manhattan. This is paralleled by the ship's wake in the lower half of the picture. It is the clarity of the composition that makes this such a suggestive photograph.

This, ultimately, is where Feininger's great skill lies: to overlay the coolly calculated visual construction with an aura, a veneer of atmosphere, which makes one forget what a rational mind it was that distilled such an image from reality. R.M.

1906 Born in Paris, son of the artist Lyonel Feininger. **1922–25** Studies at the Bauhaus in Weimar under Walter Gropius and at the Bauschule, Weimar. **1926–28** Studies at the Staatliche Bauschule in Zerbst. Self-taught in photography. **1928–31** Architect in Dessau and Hamburg. **1932–33** Assistant to Le Corbusier in Paris. **1933–39** Architectural and industrial photography in Stockholm. **1940–41** Freelance photojournalist for the photo agency Black Star, New York.

1941–42 War correspondent and photographer for the Office of War Information. **1943–62** Staff photographer at *Life*, New York. From **1962** Freelance photographer in New York and Connecticut. **1972** Teaches creative photocommunications at New York University. **1999** Dies in New York.

Further Reading: *Andreas Feininger: Photographs 1928–1988.* Exh. cat., Institut für Kulturaustausch, Schaffhausen

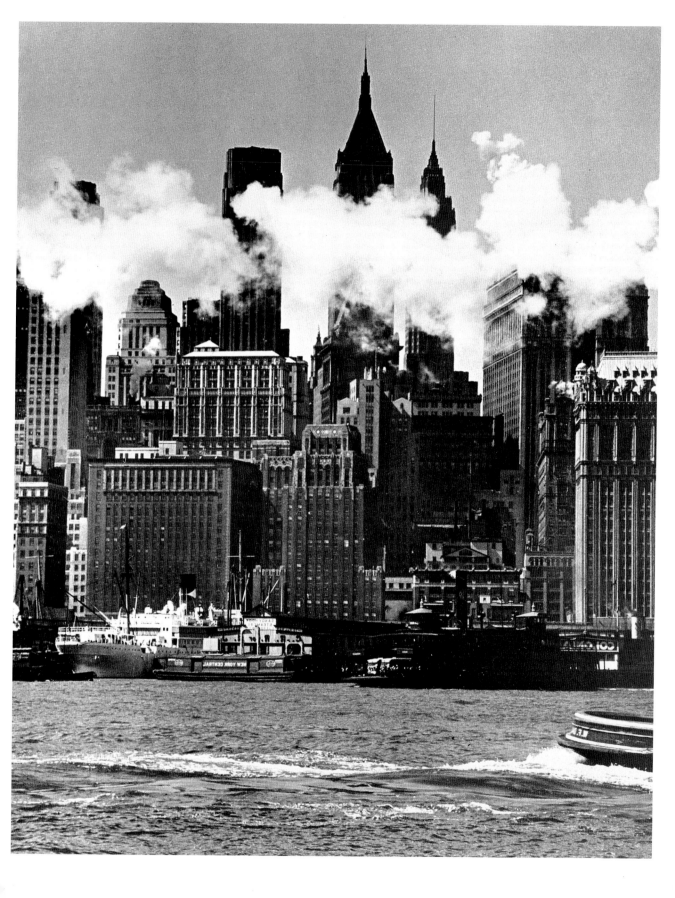

This portrait has become so synonymous with the writer that nobody can now imagine that Virginia Woolf might have looked any different: the oval, rather long face, the melancholy gaze, the hair combed back severely, the pointed nose, full mouth gently pulled downwards. A soft strand of hair, drawn backwards, matches the undulating lines on the furrowed brow.

Gisèle Freund took this photograph of Virginia Woolf in the same year that Germany invaded Poland and triggered World War II. The photographer had had to leave Germany before this, a few weeks after Hitler was appointed Chancellor. She was doubly threatened: as a critical student of sociology in Frankfurt, and as a Jew. She would soon have to emigrate even further, from Paris, where she had found refuge and written the very first dissertation in history on a photographic theme, to Mexico. Her passionate interest in literature and the socio-critical involvement of intellectuals brought her into contact with the leading writers and artists of the era. At the same time, she turned her hobby, photography, into her profession. She quickly became a highly sought-after photojournalist, with regular commissions for *Life* and other magazines. But her remarkable portraits of literati, painters, and poets, usually in a 35 mm format and in color, long before color photography was common, remained largely unknown. They belonged more to the private sphere. This intimate quality is in fact Freund's most striking characteristic. *Virginia Woolf*—like *André Gide under Leopardi's Death Mask in his Apartment at Rue Vanneau* and other portraits—was taken by the photographer at a moment when the subject apparently felt herself to be unobserved. The majority of the portraits were taken in the subjects' domestic surroundings. The camera functions as an invisible onlooker, yet never gives the impression of being indiscreet; convincing evidence of the high quality of Gisèle Freund's photographic skills. K.H.

André Gide under Leopardi's Death Mask in his Apartment at Rue Vanneau, Paris, 1939

1912 Born in Schöneberg near Berlin. **1920** First camera (Voigtländer, 6 x 9 cm). **1929** First Leica. **1929** Studies sociology, economics, and art history at the University of Freiburg. **1930** Moves to Frankfurt; continues sociology studies at the University of Frankfurt. **1931** Begins dissertation on the history of photography; one semester at the Sorbonne in Paris. Becomes acquainted with Surrealists in Louis Aragon's circle. **1933** Moves to Paris, where she continues her studies. **1936** Publishes dissertation. Reportages for *Life*. **1937** Photographic series on libraries commissioned for the World Fair in Paris. **1938** Works with first color films. **1939** Stays in London. **1942** Reporter in South America; camera assistant. **1947–54** Member of the photo agency Magnum. Reportages for *Time* and *Life*. **1950–52** Stays in Mexico, returning to Paris in 1952. **1963** First photo exhibition in Paris. Reporter in Southeast Asia. **1974** Publication of *Fotografie und Gesellschaft*. **1977** Participates in "documenta 6," Kassel. **2000** Dies in Paris.

Further Reading: *Gisèle Freund: Photographer*. New York, 1985. *Gisèle Freund: Photographien und Erinnerungen*. Munich/Paris/London, 1998.

Arnold Newman

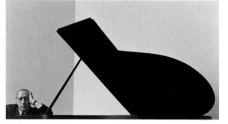

Igor Stravinsky, 1946

Arnold Newman is a legend in the history of photography. The native New Yorker can look back over a career that spans sixty years, as well as an incomparable body of work. At the age of twenty he was already working in a portrait studio in Philadelphia, an activity that was to mark his later life and his creative output. Alfred Stieglitz (see p. 14) and Beaumont Newhall were impressed by his work and encouraged him, in the course of various meetings in 1941, to continue along the path on which he had already set out. Newman then successfully ran a portrait studio in Miami Beach until he moved back to New York in 1946, where he opened a studio on the West Side. He received commissions from *Life* and *Harper's Bazaar*, whose director, Alexey Brodovich, fostered his subsequent career.

Newman developed a specific portrait style that made him internationally famous. He broke with the classical tradition, based on painting, in which the picture concentrates on the face, and the surroundings are usually included only as a background. According to Newman, the social, professional, or private surroundings of a portrait's subject are integral to and part of that person, and so he always incorporated them into his portraits as a basic component.

Newman's picture of Max Ernst shows an interior with pictures on the wall and a sculpture on a side table. The first thing we notice, however, is the huge chair with a neo-baroque backrest in which the painter is seated in a haze of cigarette smoke. Besides the American Indian kachina figure, the smoking becomes more than merely enjoyment of nicotine and allows us to interpret the haze as a tool for expanding the consciousness, as is entirely appropriate in the case of a Surrealist such as Max Ernst. The subject of the portrait only takes up a modest portion of the picture, which primarily depicts pieces from a private art collection. It is, in fact, that of Peggy Guggenheim, whom Ernst had married the year before in New York, and the paintings shown are by Kandinsky, Picasso, Braque (*Tondo*), and Duchamp (top left). Only the kachina figure belonged to Ernst. In Newman's work, the surroundings are not just a backdrop but a context. This is similar to a medieval depiction of a saint, where the associated story is what makes the saint figure convey what it is intended to represent in the picture. This was a brilliant visual concept that Newman developed and varied for every single individual of whom he made a portrait, and it was repeatedly successful precisely because of its variety. Art critics called Newman's pictures "environmental portraits," which is certainly suitable as a term with respect to the history of photography, but nevertheless falls somewhat short as a valid description. Newton was not concerned with including his subject's surroundings purely as "decor," but with the interaction between the social surroundings and the person, and with the interpretation of personality via these elements. In the case of Max Ernst, this meant that the ambivalent identity of an artist living in exile was expressed through paintings that were not by his own hand. R.M.

1918 Born in New York. 1936–38 Studies art at the University of Miami, Florida. 1938–39 Assistant portrait photographer with Leon Perskie, Philadelphia. 1939–41 Manager of the Tooley-Myron Photo Studios, West Palm Beach, Florida. 1942–45 Proprietor of Newman Portrait Studios, Miami Beach. From 1946 Arnold Newman Studios Inc., New York. From 1965 Photography consultant to the Israel Museum, Jerusalem. From 1975 Guest professor in photography at Cooper Union for the Advancement of Science and Art, New York. Lives in New York.
Further Reading: *Arnold Newman's Americans.* Boston, 1992.

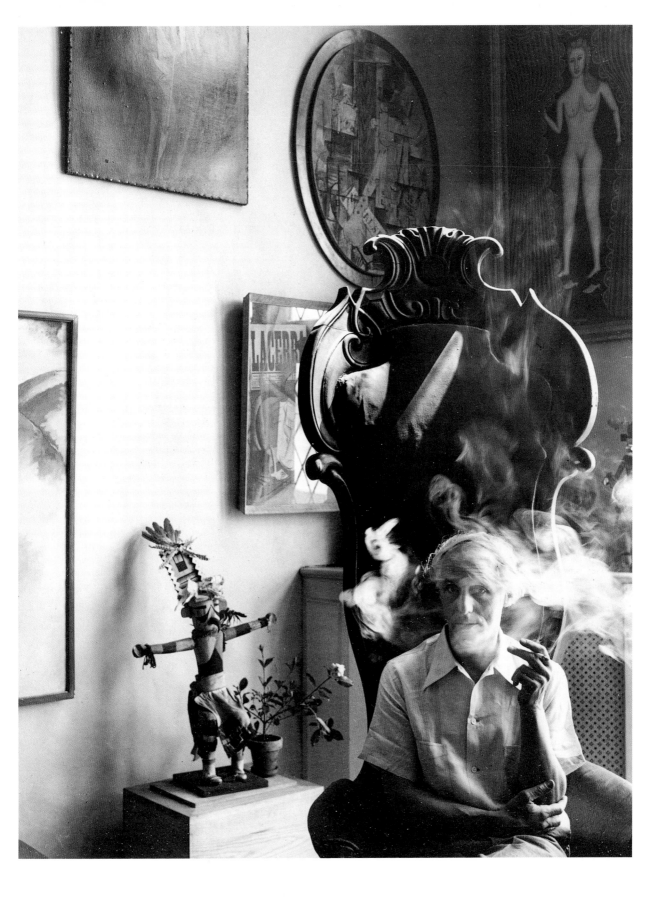

It would be no surprise if Weegee recognized himself in the form of the young man on the right in his famous picture *The Critic*. The "critic" is making venomous comments about the two ladies in elaborate evening garb who are advancing with stereotyped, persistent smiles, distorted into a grimace, plastered on their faces. The discrepancy between the outfits of the ladies, who left their youth behind some time ago, and that of their tormentor is immediately obvious. The photographer has set the tense encounter in an appropriate light by using a strong flash which makes the ladies' faces look like masks.

Weegee acquired a great reputation in New York as a sort of police photographer. Usually he was out and about at night, and the shadowy sides of existence, everything that shunned the light, were his domain. Crime fascinated him, but so did hidden pleasures. In the cinema he would watch necking couples—*Lovers at the Movies*—and photograph them using infrared

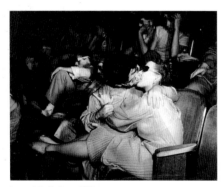

Lovers at the Movies, c. 1940

film. He was on the scene of a crime faster than the guardians of the law, because he listened in on police radio. He witnessed many fires in the city before the fire brigade arrived. He kept no distance from human misfortune, the victims of which were his preferred, if involuntary, heroes. He was a voyeur with a penetrating gaze, and as a voyeur he uncovered exhibitionism—at the time still concealed—during the gradually developing era of mass media. His searching gaze penetrated the carefully tended surface appearance, exposed the blatant contradictions of a materialistic society with mendacious morals. His best pictures have a decidedly sarcastic tone. In these, it was not realism that he was striving to achieve but the kind of projection that defamiliarizes reality, like a distorting mirror, until it becomes recognizable.

Behind social relationships, with their gaping conflicts, he also tracked down the human desires which from time to time disrupt the beauty of the surface appearance with primal force. The driver involved in a car crash continues to grasp the steering wheel, even in death—one of Weegee's most depressing photographs. And yet he was no stranger to irony. He did not even spare himself. On one occasion he photographed himself as a rotund, piggy-eyed king in fake ermine with a crown and scepter made from junk. It was a long time before he was acknowledged as one of the greats in his field. K . H .

1899 Born Arthur H. Fellig in Zioczew, Poland. **1910** Emigrates to the U.S.A. **1914–24** Assistant to studio and street photographers. **1924–28** Violinist for silent film performances. **1924–35** Works as photo lab technician. Employed by Acme New Pictures, New York (United Press International Photos); unofficial news photographer. **1938** Freelance press photographer. First photographer permitted to install police radio in his car. Adopts the name "Weegee" (derived from Ouija board). Works for various daily papers. **1940–45** Regular photographer for *PM*, New York. **1945** Publication of the book *Naked City*; filmed in Hollywood in 1947. **1953–58** Film consultant and actor in Hollywood. The book *Naked Hollywood* appears. **1958** Returns to New York. Travels through Europe and Russia; active for the *Daily Mirror*. **1968** Dies in New York.

Further Reading: Weegee. *Weegee's World*. Boston: 1997.

Ansel Adams became famous as a result of his super-lative landscape photography. He photographed land-scapes with razor-sharp precision and an incomparable eye for the structure and detail of his chosen subject matter. There are never people in his pictures. The canyons, mountains, and plains of the American West lie before us, pure and unsullied, as though on the first day of creation. Adams had a particular love of canyons. Immovable and majestic, they rise, disturbed by not the slightest spontaneous movement. All that changes here is the light, which Adams incorporates into his pictures with a touch of genius. It is light that he uses to convey atmosphere and to give the pictures their magical content. Every photo of a canyon reflects an overwhelming natural experience. Edward Weston, Paul Strand, Imogen Cunningham—friends of Adams—all photographed with an almost subservient respect for their subject. Adams himself elevated the act of photography to a religious experience. He realized in

his pictures what Walt Whitman celebrated in his po-etry: the uniqueness of American landscape and nature.

The Canyon de Chelly is photographed from a per-spective that brings out superbly the monumentality of the sheer drop in the canyon walls. The surface struc-ture is emphasized by the light falling on to it, which transforms it into a pattern of fine stripes of light and shade that become rays. The stone ruins lie within a dark cavern; the protective character is emphasized. Light, shadow, and silence make this a sacred place, a naturally created site, set outside time and space.

The second of the photos illustrated, *Moonrise Over Hernandez*, has become a veritable photographic icon. Never before has such magical light been captured in a photograph. The light that the moon casts over the landscape and the Pueblo has a cosmic quality. The world is acquiring something of the supernatural under the black sky, which takes up half the picture and is marked only by the moon. Every bush, every cross in the small cemetery is perfectly visible.

Adams exercised precise control—to a degree achieved by few other photographers—over the ex-posure and development of a photograph, so that he obtained the exact tonal scale that he had intended. With this mastery of the photographic medium, he succeeded in his personal interpretation of nature, although he altered nothing in its actual appearance. His aim was to show the "grandiose beauty of the world," and he knew that his photography was suc-cessful in doing this. E.B.

Moonrise Over Hernandez, New Mexico, c. 1941

1902 Born in San Francisco. 1914–27 Trains as a pianist. 1916–17 Trains as a photographer with Frank Dittmann. 1930 Meets Paul Strand, through whom he discovers photography as his true, expressive medium. 1931 Correspondent for the *Fort-nightly Review*, San Francisco. 1932 Co-founder of the "f-64" group with Imogen Cunningham, John Paul Edwards, Sonya Noskowiak, Henry Swift, Willard van Dyke, and Edward Weston. 1933–34 Director of the Ansel Adams Photography and Art Gallery, San Francisco. 1937–62 Lives and works in Yosemite Valley, California. 1940 Together with David McAlpin and Beaumont Newhall establishes a photography department at the Museum of Modern Art,

New York. From 1941 Teaches photography at various universities, schools, and institutes in the U.S.A.; founds and initiates countless photographic clubs, among other things. 1942–44 Photographic consultant for the Office of War Information, Los Angeles. From 1949 Technical consultant for the Polaroid Corporation, Cambridge, Massachusetts. From 1978 Honorary vice-president of the Sierra Club, San Francisco. 1962 Moves to Carmel, California. 1984 Dies in Monterey, California.

Further reading: Adams, Ansel. *The American Wilderness*. Philadelphia, 1997. Spaulding, Jonathan. *Ansel Adams and the American Landscape*. Berkeley, 1995.

Yevgeny A. Tschaldey

The Sea of War, Arctic Ocean, 1941

The photographer Yevgeny A. Tschaldey often told the story of how the young Red Army soldier with the Soviet flag pulled him up on to the pinnacles of the ruins of the Reichstag in Berlin. There the soldier hoisted the red flag, probably a more dangerous undertaking than the capture of the building, which had burned down in 1933, while Tschaldey, in a series of quickly taken photos, condensed the scene into a symbolic image. Another version of the story is less dramatic. According to it, the photographer was flown in after the conquest of Berlin, meaning of course that the whole picture was, in fact, a staged event. The most striking photo of the series, *The Reichstag*, became a symbol of victory, a triumphal fanfare. And yet the soldier and his reporter seem to have fallen prey to confusion; the Reichstag was in no way a symbol of Nazi terror but rather of the earliest German attempt

at democracy, and when the building went up in flames, the Brownshirts profited from this as a signal to complete their seizure of power.

The picture taken by the experienced agency photographer has a further story attached to it. While developing it, Tschaldey discovered that the Red Army soldier was wearing looted watches on his wrist, so he had to touch up the photo before it could be published. Tschaldey experienced the war from the very beginning. He photographed people in Moscow as they heard Molotov, the Soviet prime minister at that time, announcing over the loudspeakers in Red Square that German troops had invaded the Soviet Union. He described the "great war of the fatherland" as an epic of heroic battle against an implacable foe: *The Sea of War* depicts a line of determined fighters in helmets and long overcoats silhouetted against a bright sky. The atmosphere of the photo is ambivalent. Is the sky getting dark, or is this a new dawn breaking? Like all Soviet war photographers, Tschaldey was both a photographer and a soldier, usually to be found at the front. His pictures and those of his colleagues—many of whom, unlike Tschaldey, were either representatives or decided opponents of revolutionary photography—had a definite aim: to mobilize the feelings of the population, to increase the fighting spirit among the troops, to give an added solemnity to death in combat, and, finally, to demonstrate the superiority of the system. In the meantime, such images have become divorced from their original context, and even the historical substance is recalled more in terms of aesthetic quality than in the evidential nature of the photographs. K . H .

1917 Born. From 1936 Photo-reporter for the Soviet news agency TASS. 1941–45 Documents the events of the war from the North to the Black Sea. 1945 Photo-reporter at the Potsdam Conference, where he meets Robert Capa. 1946 Picture reportage of the Nuremberg Trials. Until the mid-1970s Works for TASS and *Pravda*, with interruptions. Loses his job because of anti-Semitic bias. Until early 1990s Freelance photographers. 1998 Dies in Moscow.

Further Reading: *Von Moskau nach Berlin: Bilder des russischen Fotografen Jewgeni Chaldej*, Berlin, 1994.

Ernst Haas

New York, 1966

Ernst Haas studied painting as a young man in Vienna, then turned to photography, taking it up as a profession after the liberation of Vienna in 1945. The emotionally complex image, *Homecoming Prisoners, Vienna,* one of the very first he ever published, contains a picture within a picture: a portrait of an unidentified soldier held up by an anxious mother, hoping for some comrade's recognition and any news of his fate.

It is an act that has become emblematic of this century in which warfare and civil repression have ripped so many families apart. From Holocaust survivors to the families of the "disappeared" in Argentina and

Chile, people have searched for their relatives, using photographs as this small, determined woman does here, to serve as both visual evidence and a token of hope. So it is also a picture about a picture, and a particularly heart-wrenching one at that, for no one in Haas' photograph—not the repatriated veteran, not the onlookers, not even the young man's mother—is actually paying attention to this portrait of the missing man. The only one looking at him is the viewer.

Haas' extensive reportage on Vienna's postwar traumas and the drama of returning prisoners of war — some of them published in *Life* magazine—made his reputation in Europe and the United States. But he had sickened of his homeland during the war, so he left. "I would have become lazy in Vienna," he wrote decades later, "so I went to New York, the city which makes you work and presses everything out of you.... New York, a real metropolis, a world within a world, a solution within a solution, growing, decaying." Many of his images of that city, like the one of reflected skyscrapers inset here, became defining representations of Manhattan at mid-century.

Due perhaps to his early training in the arts, Haas experimented diversely within his medium of choice, eventually abandoning black and white for color and becoming one of the first to push color photography into the realm of the poetic. Yet he consistently hewed closely to many of the traditions of small-camera photography of his day, which are manifested in both these pictures.

A.D.C.

1921 Born in Vienna. **1942–44** Studies medicine in Vienna, as well as photography at the Graphische Lehr- und Versuchsanstalt, Vienna. **1946** Acquaintance with Werner Bischof; works for the agency Black Star. **1947** Photographer for *Heute*. **1948–50** Freelance photographer in Paris. From **1949–1961** Member of the Magnum photo agency. **1948–51** Moves to New York. Work for, among others, *Life, Paris Match, Esquire, Look, Vogue,* and *Holiday*. First attempts with color film. **1950** Stills photographer for sundry films such as *The Bible* (1966), *Little Big Man* (1970), and *Hello Dolly!* (1969). **1971** First publication: *The Creation*. From **1975** Lecturer at the Maine Photographic Workshop, Rockport, and the Anderson Ranch Foundation, Aspen, Colorado. **1976** Opens the Space Gallery for Color Photography with Jay Maisel and Peter Turner. **1986** Dies in New York.

Further Reading: Hughes, Jim (ed.). *Ernst Haas: In Black and White*. Boston, 1992.

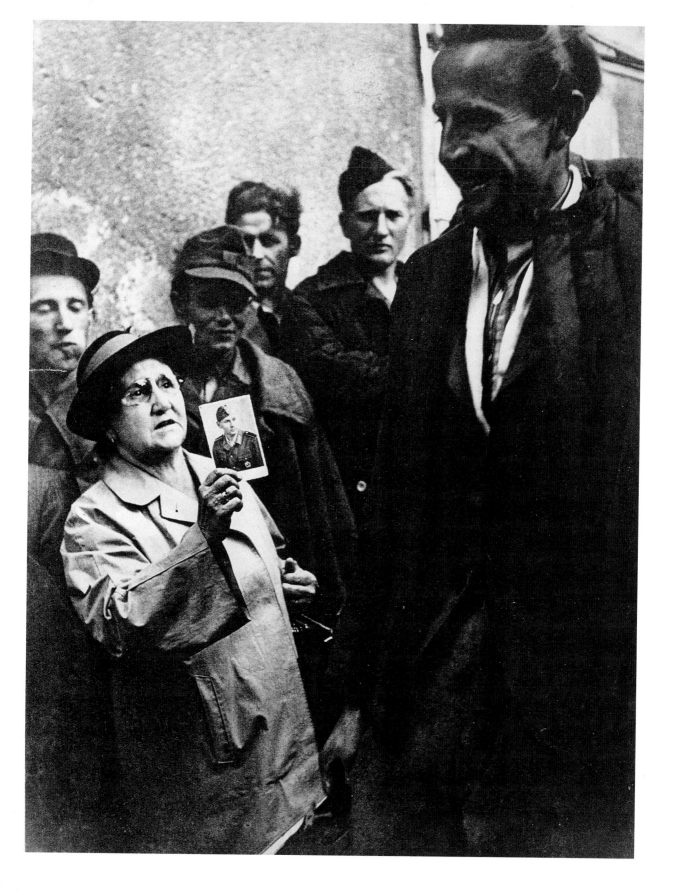

Margaret Bourke-White

She was almost always the first, and she set all her ambitions on also being the best. Margaret Bourke-White was famous as a fearless photojournalist who took decisive pictures on the forefront of world events. She favored subjects that had previously been reserved for her male colleagues: she shot industrial reportages in factories, reported on natural catastrophes, and eventually became a photographer for the United States Air Force during World War II. Her work for *Life* started with the photograph of a dam in Montana which appeared on the cover of the magazine's first issue. Thereafter she was "*Life*'s Bourke-White."

In March 1946, Wilson Hicks, head of the photography department at *Life*, sent her to India to document the end of British colonial rule. Immediately after her arrival Bourke-White tried to obtain an interview with the leader of the Indian independence movement, Mahatma Gandhi. Only after a lecture on the significance of the spinning wheel for the country's self-sufficiency, accompanied by practical demonstrations, was she allowed into Gandhi's room, but on that particular day Gandhi was sworn to silence so she was unable to speak with him. She was only permitted to take three flash photos, to minimize any disturbance to his reading. After two failed attempts, she succeeded in obtaining the photograph illustrated here, which still stamps our image of Ghandi to the present day. He is sitting on a cushion, legs crossed, clad in nothing but a handwoven loincloth, immersed in his reading of newspaper clips. His spinning wheel takes up almost the entire left half of the photograph; the symbolic power of the archaic piece of equipment and its strong graphic effect force the elderly man somewhat into the background. Yet Gandhi's concentrated bearing—accentuated by the light streaming through a window, creating a halo-like effect—seems to fill the simply furnished room. A weak flash provided the necessary light, yet the prevailing impression is of a completely natural situation. No picture expresses more vividly Ghandi's ideals: simplicity and lack of violence, but also intransigence in the face of injustice and oppression. L. D.

1904 Born in New York City. **1922–27** Studies at various universities: Rutgers University, New Brunswick, New Jersey (1922); University of Michigan (1923); Purdue University, Lafayette, Indiana (1924); Western Reserve University, Cleveland, Ohio (1925); Cornell University, Ithaca, New York (1926–27). **1927** Bachelor of Arts degree awarded. **1928** Freelance photographer in Cleveland. **1929–35** Regular contributor to the magazine *Fortune* in New York, plus freelance work for sundry advertising agencies in New York. From **1931** Own photo studio in the Chrysler Building, New York. **1936** Founding member of *Life*; staff photographer. **1942–45** Official photographer for the U.S. Army Air Forces. From **1957** Semi-retirement due to illness. Numerous publications of her reportages. **1971** Dies in Stamford, Connecticut.

Further Reading: Goldberg, Vicki. *Margaret Bourke-White: A Biography*. New York, 1986. Callahan, Sean. *Margaret Bourke-White: Photographer*. London, 1998.

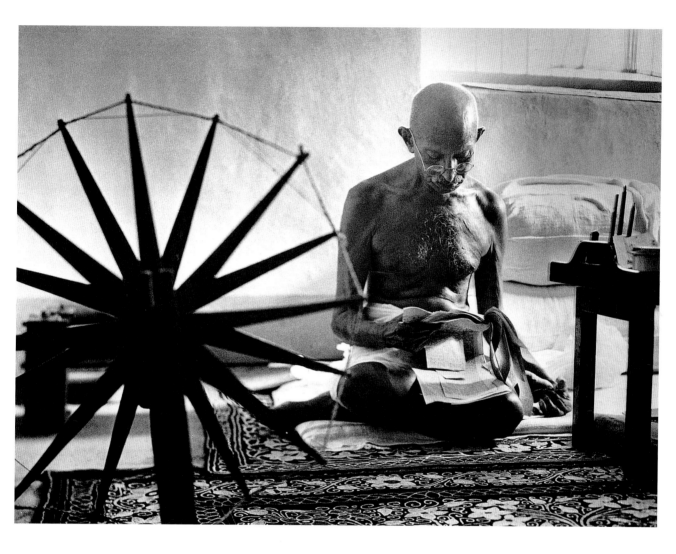

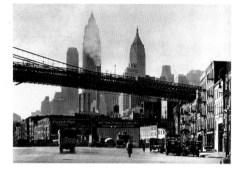

Lower East Side, Waterfront, South Street, 1935

first, that documentation of shopwindow displays reveals a great deal about the cultural *zeitgeist*; second, that these mercantile constructions often contain wonderfully surreal juxtapositions; third, that the attentive photographer can make strategic use of the reflections omnipresent in the urban envronment to indicate the visual density of the metropolitan milieu.

So, in the complacent Gotham of the post-World War II years, she generated an image that functions at one and the same time as sociological evidence and child's tranquil, expectant "night before Christmas" dream. The column on the left, and the apartment-building windows reflected in the storefront window's plate glass, place us immediately in the urban context; the reversed neon sign centered near the top of the image, "Village Bowling," allows anyone who knows the city to identify precisely the Greenwich Village spot; and there, in the midst of all that, floats one of Santa's reindeer, aglow, astride in mid-air, a magical vision in the midst of the mundane.

At the time she made this image Abbott was almost two decades into her project, which by then had turned into one of the most comprehensive one-person photographic interpretations of any major metropolis ever undertaken, and remains a distinctive interpretation of New York as well as a priceless document thereof. A.D.C.

Berenice Abbott learned her craft in Paris in the 1920s, apprenticing there to the surrealist Man Ray, befriending Eugène Atget (whose documentation of historic Paris—a landmark in the evolution of photography—she subsequently salvaged and preserved for posterity, almost single-handedly). She later claimed that she did not really consider New York a worthy subject for her imagery until she returned to it in 1929 with fresh eyes. By that time she had concluded that realism was her chosen medium's greatest strength. Seeing the city's rapid renovation, the new structures replacing the old, and inspired perhaps by Atget's archive which captured the City of Light in its transition to modernity, she set out to depict in precise detail, and at great length, what one of her many books called "changing New York."

In this image, *Designer's Window, Bleecker Street, New York*, she applies to New York several of the lessons she had learned from Atget and Man Ray:

1898 Born in Springfield, Ohio. **1917–18** Studies at Ohio State University, Columbus, followed by study of journalism at Columbia University, New York. **1918–21** Independent studies in drawing and sculpture in New York and from 1921–23 in Paris (under Antoine Bourdelle). **1923** Studies at the Kunstschule in Berlin. **1923–25** Assistant to Man Ray in Paris. **1925** Introduced to the work of Eugène Atget, Paris. Buys the Atget archive and promotes his work. **1926–29** Freelance portrait photographer with her own studio in Paris. **1929–68** Freelance portrait and documentation photographer in New York. Work from 1930 to 1939 for,

among others, the magazine *Fortune* and the W.P.A. Federal Art Project. **1935–58** Teaches photography at the New School for Social Research, New York. **1958–61** Active for the Physical Science Study Committee of Educational Services Inc., New York. **1968** Moves to Abbot Village, Maine. **1972** Teaches at Smith College, Northampton, Massachusetts. **1981** Teaches at the New School for Social Research, New York. Dies in **1991**.

Further Reading: *Berenice Abbott: Changing New York.* The Museum of the City of New York/Munich/Paris/London, 1997. Yochelson, Bonnie. *Berenice Abbott at Work.* New York, 1997.

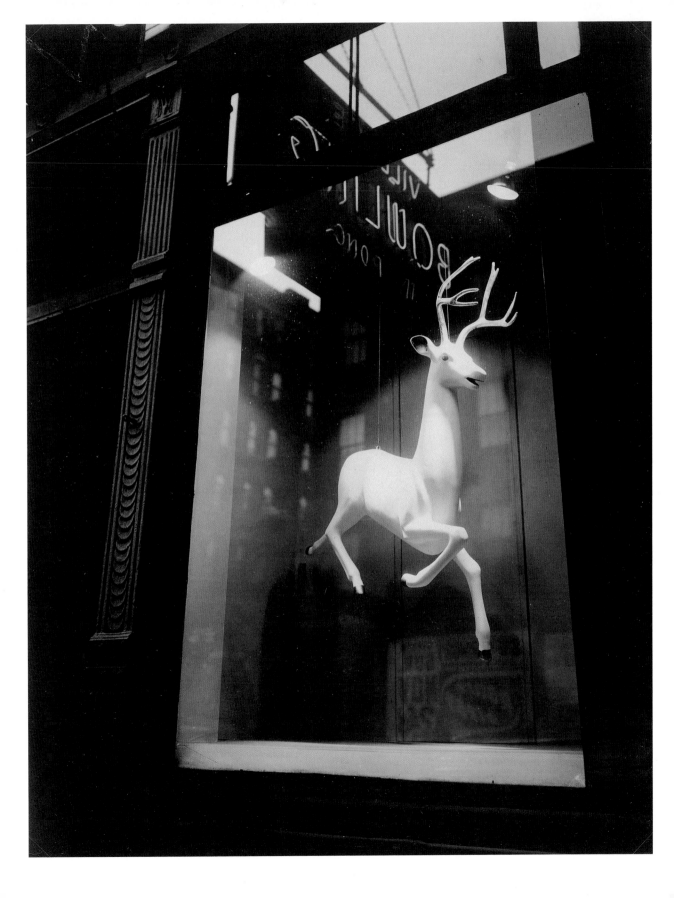

Robert Doisneau

Robert Doisneau was the great chronicler of the Parisian suburbs, the *banlieue*. There he found the appropriate images to express his unflagging love for "ordinary people": the wedding couple, all alone, heading for a bar; the tired worker in the Renault factory; the fisherman on the Seine hoping in vain for a catch. Doisneau observed people, he felt empathy with their lives, and tried to compress this sentiment into a single photograph.

In early 1950, the great American magazine *Life* requested photo agencies for pictures on a not very original theme: springtime romance in Paris. Doisneau had already developed a project on this very subject: he had been hunting out lovers. He was able to get a double-spread of his pictures published in *Life*. All portray the happiness of young couples kissing at picturesque locations in the capital of love—oblivious to their surroundings and unnoticed by passersby. Even in the supposedly easygoing Paris of the postwar years such a reportage was rather *risqué*. Doisneau therefore used young actors to re-enact the scenes he had observed.

One of the pictures, not even given a particularly prominent position in *Life*, shows a couple near the Hôtel de Ville (the city hall of Paris), which is recognizable in the background. The scene is observed from a café table by a crowded sidewalk: still walking along, the two snatch a quick, brief kiss. This tender moment of affection is noticed only by us, looking at it through the photographer's camera lens. It is this gesture, caught in the picture as though by accident, that sets us, along with the whole of Paris, dreaming of love.

The photo became famous in the mid-eighties when a poster of it was produced by a Parisian publisher. The picture soon became regarded as a symbol of romance as much as a nostalgic symbol of young love. It was used in advertising campaigns and sold throughout the world as a pirated postcard. At the same time, several couples tried to cash in on the photograph's late success, claiming to be the lovers caught by the photo-reporter. It was only in 1994 that Doisneau was able to provide evidence in court of his mode of working, an invoice from one of his models. The lawsuit embittered the photographer's last year of life, but it did little to harm the picture's popularity. L.D.

1912 Born in Gentilly-sur-Seine, France. 1926–29 Studies lithography in Paris. 1929–31 Works as an engraver and lithographer. 1931–33 Photo assistant to André Vigneau in Paris. 1934–39 Industrial photographer for the Renault works in Billancourt, Paris. 1939–40 Military service. 1940–45 Involved in the Resistance.

From 1945 Member of the photo agency Alliance (Adep), Paris. From 1946 Active for the agency Rapho, Paris. 1949–52 Photojournalist for, among others, *Excelsior, Point de Vue, Life, Fortune, Vogue, Paris Match.* 1995 Dies in Paris.

Further Reading: Hamilton, Peter. *Robert Doisneau: A Photographer's Life.* New York, 1995.

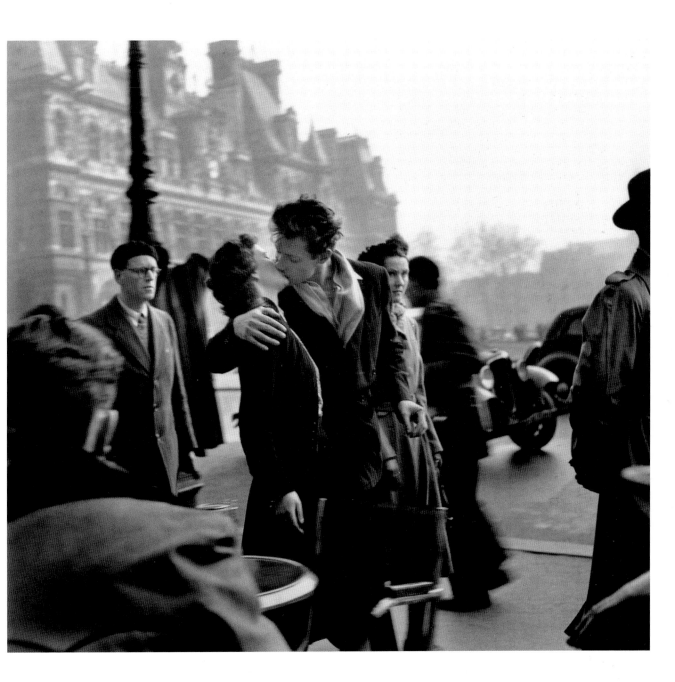

Strike at Citroën, Paris, 1938

Not much bigger than the baguette, this little boy
with his mother came by as Willy Ronis was on the
lookout for new motifs in Paris. He asked the woman
for permission to photograph her son. She agreed
and the lad ran off again. The picture might just as
easily be called "La joie de vivre" or perhaps even
"Looking forward to lunch," for the sun is already
at its height.

Ronis' photograph of the running boy was taken
all of six years before Cartier-Bresson's famous shot

of a young boy with two bottles of wine (*Rue Mouffe-
tard, Paris,* 1958). Yet this baguette-toting youngster
with the face of an angel has more charm and grace
than any of his age in the history of art and photo-
graphy. Children often crop up in Ronis' photographs:
holding their mothers' hand, swimming in a harbor
basin, playing with a model plane, or as little gangs
about to terrorize their neighborhood. Children are
part of that wholeness of life that Ronis celebrated
throughout his oeuvre. His finest photographs of
them are to be found in *Quand je serai grand,* 1993.

Ronis was interested neither in sophisticated
formalism nor in any thematic restriction, but above
all in the unspectacular and the everyday. He felt
a sense of solidarity, even love, toward all the people
he photographed, from the striking car workers at
Citroën in 1938 to the miners in Lens and the day
trippers on the banks of the Marne. "A good picture
is geometry modeled by the heart," he once said.
As such, the light-heartedness in many of his photo-
graphs is not just unmistakably French, but also his
ability to unite aestheticism with a membership of
the Communist Party.

Ronis' mother taught him to play the piano, and by
the age of six he was playing the violin and dreaming
of becoming a composer. Though he took a different
path in the end, many of his photographs betray a real
sense of polyphony and tonal structures. All his life,
Ronis revered Bach and Mozart. In spring 1926, he
was given his first camera, and Ronis did not put it
down again until 2002. He is the creator of one of the
greatest bodies of work in the history of photography,
but is also one of the most important witnesses of the
twentieth century. P.S.

Born in Paris in **1910**. Took up photography in **1926**. Dropped out
of law school to help his ailing father in his laboratory. Worked
as a photojournalist. Spent **1941-44** in the south of France in
various jobs, returning to photojournalism after the war. His work
was commissioned by *Points de vue, Regards* and *Le Monde
illustré* from **1945-50**. Married in **1946**. Included in the **1953** *Five French Pho-
tographers* exhibition at the Museum of Modern Art, New York (incl. Brassaï,
Doisneau and Izis). *Belleville – Ménilmontant* published in **1954**. Awarded
a gold medal at the **1957** Venice Biennale. Member of Rapho agency **1946-58**
and again from **1972**. Fashion, advertising and industrial photography commis-

sions. Involved in the **1960** *Interpress* in East Berlin. Ronis lived in
the south of France with his wife and son from **1972-83**, teaching in Avignon,
Aix-en-Provence and Marseille. In **1978** the French state took over his archives.
Awarded the Grand Prix des Arts et des Lettres in **1979**. Awarded the Prix
Nadar in **1981** for *Sur le fil du hasard.* Major retrospective exhibition in Paris,
New York, Moscow and Bologna in **1985**. In **1989** Ronis was made a Chevalier
de la Légion d'Honneur.

Further Reading: S. Böhmer, M. Harder, N. Neumann, *Willy Ronis – La vie en passant,*
Munich/Berlin/London/New York 2004

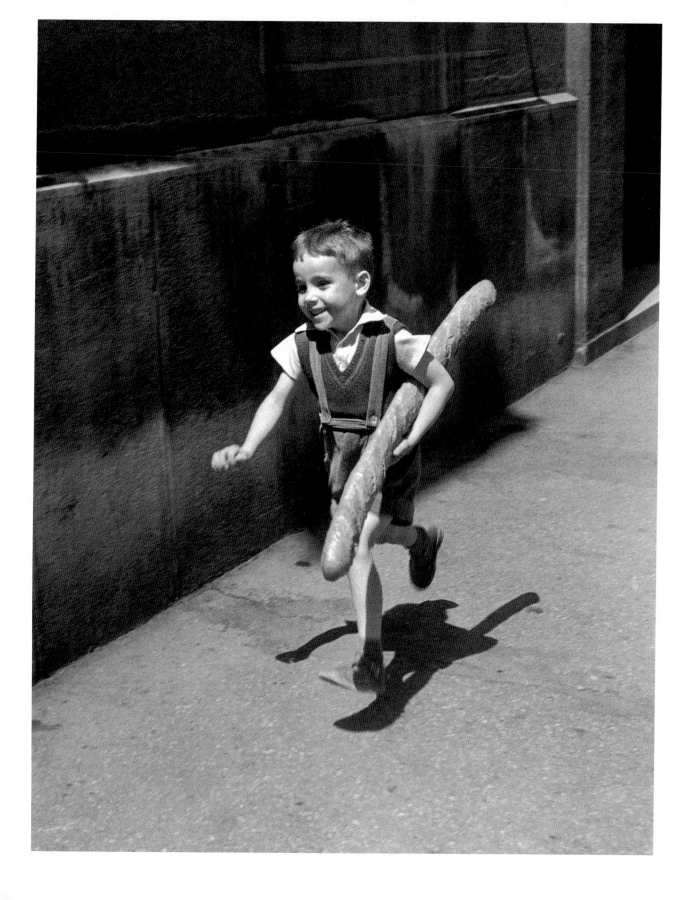

Otto Steinert

Otto Steinert was the most influential mentor of West German photography after 1945. As a teacher of photography at the Kunstschule in Saarbrücken, and later at the Folkwangschule in Essen, he trained a number of people who later became major photographers. As the organizer of the three major exhibitions in 1951, 1954, and 1958, which featured "subjective photography" and that were preceded by the foundation of the group "fotoform" in 1949, he ensured that German photography was tied into the international context. "Subjective photography" filled the artistic vacuum that the dark years of Nazi dictatorship had left in Germany. Stylistically it was inspired by the tradition of the Neues Sehen, and by experimental photography prior to 1933. Steinert also experimented with the technique of the photogram, negative prints, solarization,

and long exposures in order to give form to visual concepts displaying formal affinities to the Tachist painting of the fifties. Emphasis on the autonomous tools of photography, derived from optics and chemistry, formed the basis for his creative work—a creed that sounds almost scientific and was articulated in pictures that sometimes seem rather sterile but at the same time are marked by an enormous formal tightness. In addition, Steinert insisted on the highest technical standards.

Steinert's *Pedestrian's Foot* is not a photomontage but one of several motion studies that the photographer took from his Paris apartment. We can see the shadowy trace of movement of a passerby, with only one shoe and lower trouser leg actually. Although this phenomenon of the photographic phantom, resulting from long exposure times, was already known in the nineteenth century, Steinert's photo charms us with its contrast between the hard focus of the sidewalk with the protective iron grille and the soft, amorphous trace of human movement.

Here we have a human image recorded with a distanced eye, which, in its dissolving of concrete physicality, may represent a play on the transience of identity of the modern big-city dweller. Steinert's other photographs are on the classic themes of architecture, still life, nature, portraits, and industrial landscapes; they often emanate an aura of sadness and in their enigmatic nature come close to Magic Realism. U.P.

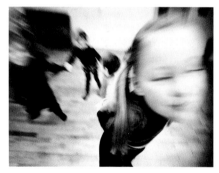

Children's Carnival, 1971

1915 Born in Saarbrücken. **1934–39** Studies medicine at the universities of Munich, Marburg, Rostock, and Heidelberg and at the Charité, Berlin. Self-taught in photography. **1939–45** Serves as a health officer in Germany. **1945–47** Intern at the Universitätsklinik in Kiel, in 1947 at the Universitätsklinik des Saarlandes in Homburg. **1948–52** Director of the photography class at the Staatliche Schule für Kunst und Handwerk, Saarbrücken. **1949–55** Together with Peter Keetman, Ludwig Windstosser, and others, founds the group "fotoform." **1951** Organizes the exhibition *subjective fotografie* at the Staatliche Schule für Kunst und Handwerk, Saarbrücken. Founding member of the Deutsche Gesellschaft für Photographie (DGPh). **1952–78** Director, and from 1954–78 professor, of the photography department at the Staatliche Werkkunstschule, Saarbrücken. Member **1958–65**, and in 1969, president of the entrance committee of the Gesellschaft Deutscher Lichtbildner (GDL). **1959–78** Director and professor of photography at the Folkwangschule, Essen; founding curator of the photography collection at the Museum Folkwang. **1963–74** President of the GDL. **1978** Dies in Essen.

Further Reading: *Sammlung Otto Steinert: Fotografien.* Essen, 1981

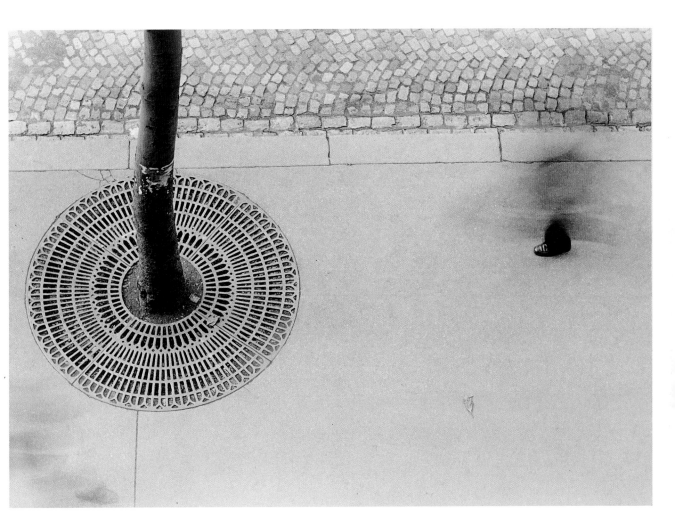

Screws on a table top, crumbled sugar cubes, a rag in a bucket—these subjects could hardly be more ordinary. Yet these are precisely the objects which ignited Wols' visual imagination. "Where the beautiful and the ugly become one," as he stated in one of his many aphorisms, that was the border zone where he sought and found his subjects. He disabled their hierarchy of value. Nothing seemed to him to be useless—and nothing useful—when he arranged parts of a dismembered rabbit together with a button, a harmonica, a comb, and cigarette ash to form a still life. Most of his models were taken from the daily menu: vegetables, mushrooms, meat, sardines, and so on. Radio tubes, burning-glasses, or—as in the photograph here—electric light bulbs were rarely used props. He portrayed these groups of things without the aid of sophisticated lighting techniques. The food ingredients are not stylized as delicacies, but equated to screws and tubes as

mere objects. In reducing them to their naked materiality, the painter-photographer Wols was trying to "see right to the bottom of a thing."

He placed the light bulb on a mirror, something he normally did not do, thereby producing a contrast between the black background and the milky sheen of the glass. The edge of the mirror can still just be identified on the right, whereas on the left it is partly lost in the glare of the flood lamp illuminating the picture. The bulb gives the effect of being "isolated": it has been unscrewed from its socket, is deprived of electricity, and is not lit. This icon of technology, Thomas Alva Edison's genial invention, lies before us, having become a twin through its reflection—without any technical pathos whatsoever. Wols was not interested in forcing his subjects into a compositional framework, in the sense—for instance—of the constructive aesthetic of the Bauhaus, nor in exposing them to our unconscious projections as ambiguous, obsessive constructs of the type that the Surrealists loved. He let things simply be, allowing them to come to an awareness of themselves.

Another major group of Wols' photographs are portraits of friends, but also of himself. Wols saw himself as laconic and unpretentious—sometimes pictured in a vest, or, as in this *Self-Portrait*, with a cigarette hanging from the corner of his mouth. He always placed particular emphasis on the gaze of the subject in the portrait, intensifying it almost into the realms of the hallucinatory. If he deliberately photographed friends with their eyes closed—a strategy of denying sight—it is also testimony to his knowledge about the power of the gaze. The eyes in *Self-Portrait* have a particular magic, since only the temples and cheeks can be seen, while the face itself is shrouded in darkness. P.S.

Self-Portrait, n.d.

1913 Born Alfred Otto Wolfgang Schulze in Berlin. **1920–22** Studies violin with Jan Dahruen at the Staatsoper in Dresden. **1932** Brief training at the Bauhaus in Berlin, then work as a freelance photographer in Paris, followed by occasional work in Barcelona and on Ibiza until 1935. **1936** Returns to Paris; resumes activity as freelance photographer. **1937** Adopts the pseudonym "Wols." Official photographer in the Pavillon de l'Elégance at the World Fair in Paris. **1939–40** Imprisoned in various war camps in southern France. Works mainly as an illustrator and painter. Settles in Cassis, near Marseilles. **1942** Escapes from the National Socialists to Dieulefit near Montélimar, together with Gréty Dabija. Meets the poet Henri-Pierre Roche, who buys a few works and, in 1945 and 1947, organizes exhibitions in Paris of Wols' watercolors and drawings. **1946** Moves to Paris. **1951** Moves to Champigny-sur-Marne. Dies in Paris.

Further Reading: Glozer, Laszlo. *Wols Photograph*. Munich, 1988.

The work of the painter and photographer John Deakin, one of the most enigmatic figures of the English art scene, was only rediscovered a few years ago. Successful as a painter, Deakin attempted a second career as a fashion photographer and worked for the French and English editions of *Vogue* between 1947 and 1954. Yet, despite his enormous productivity, to which such superlative portraits as those of Dylan Thomas, Maria Callas, Simone Signoret, Pablo Picasso, and Joy Parker

Joy Parker, Actress, 1953

(pictured here) bear witness, he suffered throughout his life from a lack of professional success and crippling poverty as a result of his unsettled way of life and alcohol consumption.

Deakin's (psycho)analytical look at his models was one of unsparing, often brutal, directness and of a psychological intensity that terrified as much as it fascinated. "My sitters turn into my victims. But I would like to add that it is only those with a demon, however small and of whatever kind, whose faces lend themselves to being victimized at all," Deakin said. Francis Bacon was so fascinated by the energy of Deakin's photos that he commissioned him to make portraits of his friends George Dyer, Henrietta Moraes, Muriel Belcher, Isabel Rawthorne, Lucian Freud, and Peter Lacy. It is known that Bacon greatly disliked painting from a live model, and thus he would fall back on photographs as the basis for his paintings. Apart from Deakin's photographs, Bacon mainly used press photos and Eadweard Muybridge's motion studies of animals and people, the realistic representation of which he converted and, at the same time, distorted in his paintings.

Around forty of Deakin's photographs, mostly with the color smudged and in parlous condition, are preserved in the London studio of Bacon, who judged his friend's work to be "the best since Nadar and Julia Margaret Cameron." Though the poor state of these photos may not be up to present-day museum curators' standards, we can observe a rare phenomenon in that the traces of material decay of Deakin's pictures do not detract from their effect. Rather, it seems to increase still further the degree of psychological discomfort that emanates from these photographs. U.P.

1912 Born in Bebington, Cheshire. **1928** Leaves school. **1930** Travels to Ireland (jobs include work as window-dresser) and to Spain, in order to paint. Early **1930s** Settles in London. Supported by the rich American art collector Arthur Jeffress; they travel together to the U.S., Mexico, and the South Seas, where Deakin continues to paint. **1938** First exhibition of his paintings at the Mayor Gallery, London. **1939** Commences photography. Lives in Paris and photographs the city and its inhabitants, especially social outsiders. When war breaks out, joins the army as a sergeant in the film and photography corps. **1947** Trial contract at *Vogue*, London; contract soon terminated. **1948** Sets up his own studio. Pub-lishes *London Today* with sixty-three photos of the city at twilight. **1950** Portraits for the short-lived American magazine *Flair*. **1951** Freelance portraiture work for *Vogue*. From **1952** Employed by *Vogue*. Experiments with large formats (60 x 55 cm). **1954** Fired from *Vogue* for the second time. Years of contact with Francis Bacon. **1956** Exhibitions *John Deakin's Paris* and *John Deakin's Rome* in David Archer's bookshop. Gives up photography, spends his time traveling. **1972** Dies of heart failure in Brighton. **1984** Posthumous exhibition *The Salvage of a Photographer* in London's Victoria and Albert Museum.

Further Reading: Muir, Robin (ed.). *John Deakin: Photographs*. Munich, 1996.

Encouraged early in his career by Alfred Stieglitz, Eliot Porter committed himself to what seemed in the 1940s to be constricting, unpromising areas of exploration: nature as subject and color photography as medium. Neither was taken particularly seriously then. Nature photography was thought of, at best, as a minor, quasi-scientific offshoot of landscape photography, more concerned with data regarding flora and fauna than with formal issues or poetics. Color was too closely associated with advertising,

Sculptured Rock, Grand Canyon, Arizona, 1967

editorial, and applied photography; those who saw themselves as "creative" photographers mostly eschewed it on principle, considering black and white more pure and abstractive than color.

As a printmaker, Porter began utilizing the dye-transfer process, which offered superior stability and greater control over the print's color palette, and also a less intrusive surface than the few glossy, commercially produced papers then available for color printing. As a picture-maker, he avoided the sensational and grandiose, working with delicate nuances of muted hues and emphasizing a close-up, intimate relationship with small patches of the natural world. In effect, he composed chamber music instead of symphonies, as in this joyous study of autumn leaves floating on the surface of a pond: a rich mix of diverse textures, surfaces and reflections therein, pinks, oranges, and blues, all of which keep the eye engaged in a continuous dance.

Following the example of Edward Weston and Ansel Adams, Porter began in the 1950s to generate a series of superbly reproduced monographs that brought his photographs—and the intricate beauty they described—before a much wider audience. That color photography is now taken for granted as an option by fine-art photographers is in part attributable to the determination of Porter and a few others in his generation, who persistently demonstrated through their exhibits and publications that color not only had a key role to play in photography's documentary function but also could be used for expressive and highly creative ends. And the fact that ecological issues have taken center stage in global awareness is surely creditable in part to Porter and to those who came after him, whose explorations of nature around the world immersed us in the visual glories of what remains of untouched wilderness and persuaded us to begin its preservation. A.D.C.

1901 Born in Winnetka, Illinois. Before 1913 First photos in Maine with a Kodak box camera. 1920–24 Studies chemistry at Harvard University, Cambridge, Massachusetts, then at Harvard Engineering School. 1924 Bachelor of Science degree; starts studying medicine. 1929 Doctor of Medicine degree from Harvard Medical School. 1930 Acquires a Leica; self-taught in photography. 1929–39 Teaches biochemistry and bacteriology at Harvard University and at Radcliffe College. 1937 First photographs of birds. From 1939 Career as photographer. 1939–42 Freelance photographer in Cambridge. 1942–44 Works on radar development in radiation laboratory at Massachusetts Institute of Technology, Cambridge. 1944–46 Freelance landscape and wildlife photographer in Winnetka, from 1946 in Santa Fe, New Mexico. 1955–56 Journey through Mexico with Ellen Auerbach, photographing church architecture. 1962–68 Member and chairman of the Sierra Club, San Francisco. 1969 Honorary doctorate from Colby College, Waterville, Maine. 1990 Dies in Santa Fe.

Further Reading: *Eliot Porter: Intimate Landscapes*. Exh. cat., The Museum of Modern Art, New York, 1979–80.

Paul Strand

While under self-imposed exile in Europe during the McCarthy era, the American Paul Strand turned his attention from his homeland to other nations and other peoples. He had already experimented along those lines with his 1940 publication, *Photographs of Mexico*, in which he manifested a stark, pared-down style that—along with the work of Walker Evans—defined documentary in still photography for the next three decades and continues to have its advocates even today.

From the 1950s through the mid-1970s, Strand produced book-length studies of five very different countries and cultures: Italy, France, Scotland's Outer Hebrides, Ghana, and Egypt. This is one of his Italian studies, from the 1953 project he titled *Un paese*, on which he collaborated with the distinguished filmmaker Cesare Zavattini. A formally posed family portrait, it gives us everything we sense we need to know to imagine these people's story. The working-class milieu is established by the missing stucco on the wall, the scruffy clothing, the rusted drainpipe, the household utensils on the lintel, and the ubiquitous bicycle, the poor man's taxicab. Here the matriarch stands, surrounded by five of her fifteen sons (four of whom,

according to her statement in the book, died in childhood). Whether by their own decision or Strand's, they demonstrate no sense of affection or connectedness, despite their close proximity. Yet the distinct personality of each seems registered in Strand's richly detailed description of them. As a result, the frame feels as densely packed and tense with their strong and not necessarily compatible energies as the house behind them must have been when they occupied it.

Strand worked with a view camera; although he had absorbed the compositional lessons of Cubism his images were poised, formally rigorous, and committed to the realist tradition. As a filmmaker, he had been involved in several projects (*Native Land,* most notably) that had strongly influenced filmic documentary style in the 1930s and 1940s; and that approach, in turn, especially in combination with the influence of his still photography, had been absorbed by the neorealist movement in post-World War II Italian film. Thus there is both an irony and a rightness in Strand's applying that approach to the Italians themselves in a magnum opus produced in partnership with one of the greatest of Italy's film directors. A.D.C.

1890 Born in New York. 1912—22 Freelance portrait photographer. 1923—29 Also active as filmmaker, primarily in New York and Mexico City. 1931—45 Mainly active in films, also in Mexico. 1943 Chairman of the Photography Committee, Independent Voters Committee of Arts and Science for Roosevelt. 1945—50 Freelance photographer, New York. 1963 Honorary member of the American Society of Magazine Photographers. 1973 Member of the American Academy of Arts and Science. 1976 Dies in Orgéval, France.

Further Reading: *Paul Strand circa 1916.* Exh. cat., The Metropolitan Museum of Art, New York, and San Francisco Museum of Modern Art, 1998.

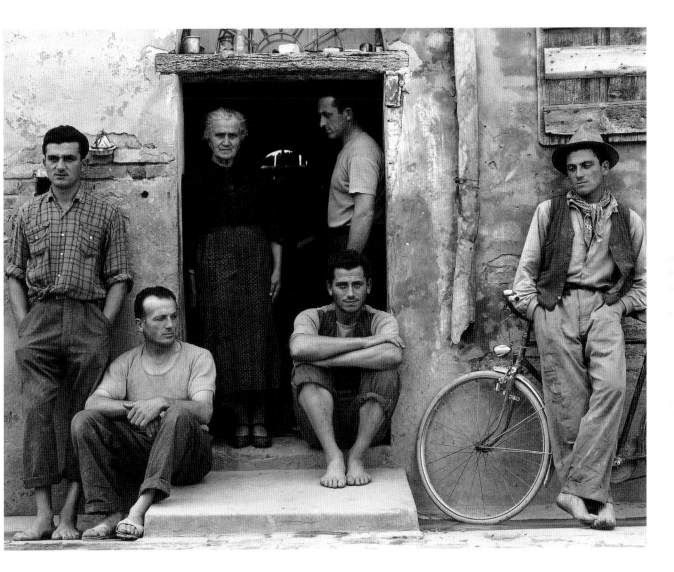

This photograph of the little flute-player walking be-tween the Andean village of Pisac and the town of Cuzco is probably Werner Bischof's best known picture. It has been published throughout the world and was one of the last photographs taken by Bischof, who died a few days later in a car crash in the Andes. There is a photographic quality about this image that is singular to the Swiss photographer. Bischof was a reporter-photographer and had come from the field of factual photography, which he had studied under Hans Fins-ler at the Kunstgewerbeschule in Zurich. His first years of photography were thus devoted entirely to making beautiful pictures of objects. Later, he discovered peo-ple in their environments, which fundamentally chan-ged his subject matter; he photographed man and the world in which he lived. For Bischof, the beauty of the image was always the basis of his vision.

It is not without interest to compare Bischof's flute-player with the one by Martín Chambi (see p. 61). In both cases we have the same motif, the same region.

Twenty years lie between the creation of the two pho-tos. Bischof arrived in South America as a foreigner and photographed as a foreigner. Chambi—a Peruvian—identified himself with the content of the picture. By setting the Indio at home in his landscape, Chambi was ultimately photographing himself. Bischof simply saw the Indian boy and spontaneously recognized the charm of the scene. This boy, too, is integrated into the land-scape, but he gives the impression of being an attrac-tive apparition. Identified as an Indio by his attire, he represents the beautiful young human being. Through the perfection of the image, Bischof elevates this Indio boy into a symbol of youth, happiness, and hope. And it is precisely because of these qualities, radiating from Bischof's photograph, that it was acclaimed by viewers throughout the world. Photography as a vehicle of hope—this was one of the moving statements that made Bischof's work unique. He was attempting to create a valid picture. He succeeded, and not just with the image of the Peruvian flute-player. E.B.

Rural Tavern, Puszta, Hungary, 1947

1916 Born in Zurich. **1930–32** Studies, among other things, teaching and drawing at the Evangelische Lehranstalt, Schiers (Grisons). **1932–36** Studies photography with Hans Finsler at the Kunstgewerbeschule in Zurich. **1936–38** Freelance photographer and graphic artist in Zurich. **1938–39** Photographer and designer for the Graphis Publishing House (Amstutz and Herdeg), Zurich. **1939** Military service in the Swiss Army. **1943–44** Works regularly as a fashion photographer for the magazine *Du*, Zurich. **1945** Travels through Europe, with photographic documentation of war damage. **1948** Freelance photographer for sundry magazines, especially *Life*. **1949** Photographer under contract to *Picture Post*, *Illustrated*, and *Observer*. Joins the Magnum photo agency, New York and Paris. **1949–54** Works for magazines, including *Life*, *Du*, *Epoca*, *Paris Match*, and *Fortune*, in India, Italy, Indochina, Mexico, South America, and the U.S.A. **1954** Fatal car crash in the Peruvian Andes.
Further Reading: Burri, René and Burri-Bischof, Rosellina (eds). *Werner Bischof 1916–1954*. New York, 1974.

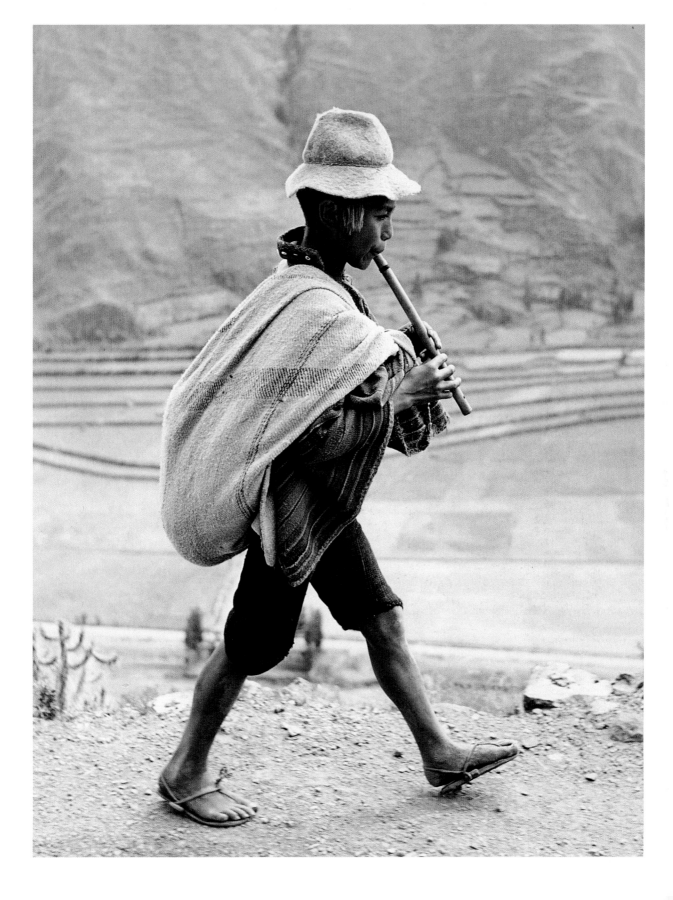

William Klein

William Klein's photographs of the metropolis of New York are passionate, political criticisms of the Establishment. They fend off the all too beautiful and elegant with a violence that today's viewer can still sense through his explosive, ecstatic images—a mixture of the nervy world of advertising and the hectic reality of street life. Klein's photos reflect a contradictory and unheroic impression of the big city. They are far removed from pictures of New York that give it monumentality, such as those by Edward Steichen or Alfred Stieglitz. As a native New Yorker who later moved to Paris, Klein's vision is governed by his love/hate relationship with North America, on the one hand clearly rejecting consumerism, on the other looking for African American "heroes," whom he found in the boxer Muhammad Ali and in Eldridge Cleaver, leader of the Black Panthers. Thus Klein shows us an image of America that, despite all its dynamism, radiates desolation, violence, and emptiness. It is hardly surprising that his photographic diary of New York, which appeared in 1956 in Paris under the title *Life is Good and Good for You in New York*, was unable to find a publisher in the United States, just like Robert Frank's *The Americans* (1954–58).

In the sphere of traditional photojournalism and life photography, Klein is a sort of outsider, a troublemaker, an "anti-Cartier Bresson," as one critic described him. Whereas the photo-reporters of the fifties and sixties were inspired by a humanistic vision, by "human interest," Klein's unsentimental view of the world found its expression in hard, high-contrast black-and-white prints. Spontaneity of observation is just as much a feature of his mode of working as the aggressive provocation of reactions. As filmmaker, book designer, and fashion photographer, he has always retained an ironic distance from the world of beauty, allowing his actions to be guided by the power of the subversive.

Without ever wanting to be a photojournalist himself, Klein undoubtedly had an enormous influence on modern picture reportage and fashion photography. Techniques, such as his use of excessive flash and wide angle lenses, leading to cropped compositions and close-ups, have been frequently imitated, as well as the extremely coarse grain of his prints. U.P.

1928 Born in New York. **1945–48** Serves in the U.S. Army; works as a cartoonist for the army magazine *Stars and Stripes* in Germany and France. **1948** Studies social sciences at City College, New York, and art at the Sorbonne, Paris. **1948–50** Studies painting with Fernand Léger. Self-taught in photography. **1950–54** Freelance painter in Paris. **1955–65** Photographer under contract to *Vogue*; later art director of *Vogue* in Paris and freelance work for, among others, *Domus*. **1965** Turns to film; less involvement with photography. Since **1980s** Reconsiders photography. Early work rediscovered and appreciated. **2002** Publication of *Paris + Klein*. Lives in Paris.

Further Reading: *William Klein: New York 1954–55.* Heidelberg, 1995. *William Klein. In & Out of Fashion.* Heidelberg, 1994.

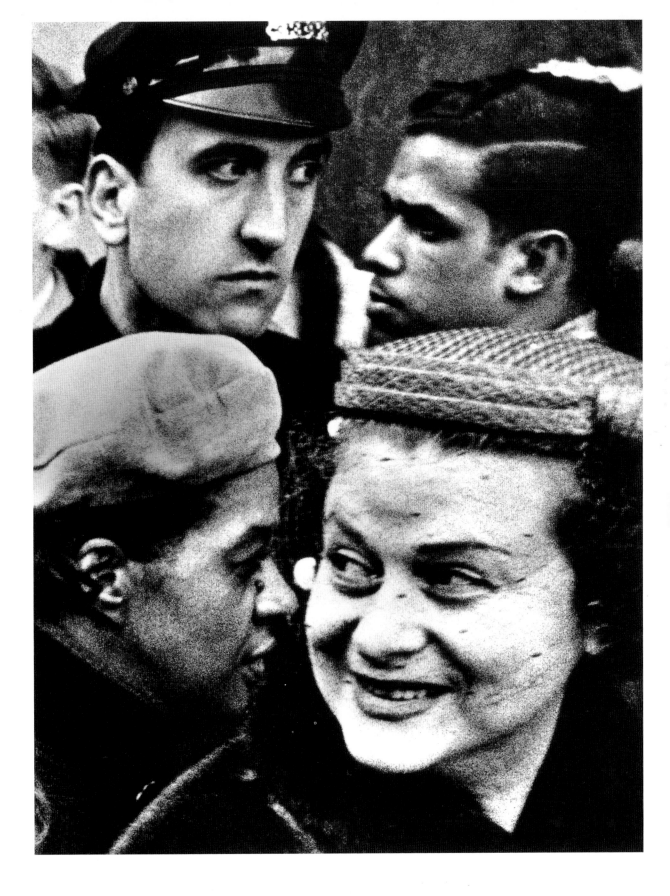

W. Eugene Smith

The word "heroic" is often used to describe W. Eugene Smith and his photographic career. Writers discuss his heroic struggles with *Life* magazine editors over the content of his photoessays, and over the time required to complete an essay. Biographers detail his courageous efforts to recover from on-the-job injuries that occurred during World War II, and again later, while making the *Minamata* series in Japan. They label as valiant his multi-year projects to chronicle life in Pittsburgh, and later, the life outside his window in New York. Analyses of Smith's life and work reveal a colorful, complex, self-destructive, and worthy character who made unforgettable single photographs as well as highly successful and moving photographic essays. Smith helped transform photojournalism at mid-century. *The Country Doctor* (1948), *Spanish Village* (1951), *Nurse Midwife* (1951), and *Man of Mercy* (1954), to mention only his most famous articles for *Life* magazine, were essays conceived and executed by Smith to be cohesive and revelatory. In each essay, dramatic single pictures, such as *The Wake*, build upon one another to establish the story that Smith wanted to tell and the positions he wanted to take. He was committed to the photoessay as a vehicle for social change. To maintain the integrity of his concepts, he fought to exercise control over the cropping, printing, selection, sequence, and layout of his photographs. As these decisions were the perogatives of the magazine's editors, Smith's success was fugitive. However, his examples have remained as the standards by which photoessays are still judged. Late in his life, Smith found two alternative venues for his work: books and museums. Unlike other great humanist photographers, including Jacob Riis, Dorothea Lange (see p. 70), and Brassaï (see p. 52)—all of whom Smith admired—he never produced a book in which the whole matched the power of its parts. Yet the publication of *Minamata* in 1975 elicited an extraordinary, worldwide response. Exhibitions gave him new opportunities to sequence his prints as well as to showcase their extraordinary richness. In all venues, he sought to evoke strong emotional responses from the viewers. That his pictures sustain power to reach subsequent generations is his lasting legacy.　　　　A.W.T.

1918 Born in Wichita, Kansas. 1930 First photographs; in 1933–35 under the guidance of the news photographer Frank Noel. 1935–36 Part-time press photographer for the *Wichita Eagle* and *Wichita Beacon*. 1936–37 Studies photography at the University of Notre Dame, Indiana. 1937–38 Photo-reporter for *Newsweek*. 1938–39 Works as freelance photographer for the agency Black Star, New York, for *Harper's Bazaar, New York Times*, and *Life*. 1939–41 Employed at *Life*; works for the magazine until 1977. 1942–44 Photographer and war reporter for the Ziff-Davis Publishing Company in the South Pacific. 1944–45 War reporter for *Life*. 1955–59 Member of the photo agency Magnum. 1958 Photography instructor at the New School for Social Research, New York. 1960 Teaches photojournalism to private classes. 1969 Teaches at the School of Visual Arts, New York, and in 1978 at the University of Arizona in Tucson. 1978 Dies in Tucson.

Further Reading: *William Eugene Smith: Master of the Photographic Essay*. Millerton, 1981.

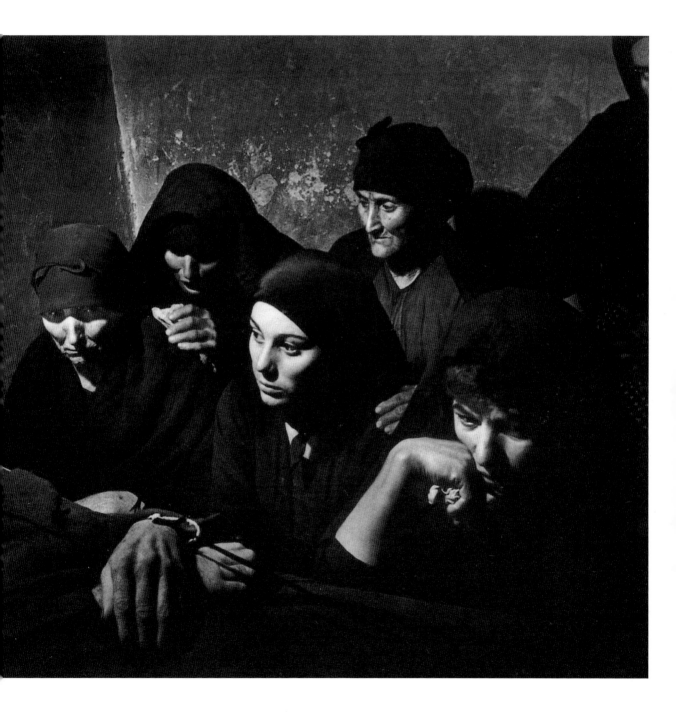

David Seymour (Chim) called him "the legendary Chargesheimer," an honorary title that remained thereafter. Chargesheimer's work of a lifetime stands in inverse proportion to the impetuous energy and lack of compromise of his creative activities. He started out as a sculptor shortly after the end of World War II, did gelatin silver paintings, produced a controversial work in 1949 on the ruins of Cologne, and then became famous with two picture books on life in that city. In the sixties, he again became active as a sculptor with kinetic objects and produced a further series of abstract, cameraless photographs; work as a set designer and producer followed.

Chargesheimer was a restless spirit, a provocateur. With his book on Germany's Ruhr District, he alienated city councillors from Castrop-Rauxel to Duisburg. He did not hesitate to reject a foreword for his 1970 book *Köln 5 Uhr 30* (Cologne 5:30 A.M.) written by the writer Heinrich Böll, because it did not correspond to his ideas; yet, at the same time, he felt at ease in Cologne among

the musicians of the group Can, in Cologne's jazz scene, and among the experimenters of the West German Radio (WDR) studio for new music.

In 1954, L. Fritz Gruber, who was preparing a book on Konrad Adenauer, arranged for Chargesheimer to take a portrait of the "old man," as Adenauer was known, but Chargesheimer initially met with scepticism from the venerable politician. Only when Gruber remarked that, in addition to the many ordinary photos in the book, he would also like to include some that captured Adenauer "like Lenbach painted Bismarck," did Adenauer become receptive to the idea. The resulting portrait was impressive indeed—a head that is more sculpture than photograph, probably the best portrait ever taken of the first West German Chancellor. But a scandal erupted when the weekly magazine *Der Spiegel* chose this photo of Adenauer for its cover during an election campaign (September 1957). Chargesheimer enjoyed good contacts with the magazine; in 1961 he published a book about it entitled *Des Spiegels Spiegel* (in German a neat play on words meaning "Mirror of *Der Spiegel*"—the magazine's name itself means "mirror"). There were massive protests about the cover picture, since the Christian Democratic Party accused *Der Spiegel* of wishing to portray Adenauer as an old man whom one could no longer be confident would survive a further period in office. This did no damage to Adenauer's campaign, as he won his last election battle. The headlines about the *Spiegel* cover, however, made Chargesheimer's picture popular. R.M.

Before the Procession, Cologne, 1950s

1924 Born Karl Heinz Hargesheimer in Cologne. **1942** Studies photography at the Werkschule in Cologne. Calls himself Carl Heinz Hargesheimer or signs himself "CHargesheimer," with the C and H linked. On the occasion of a reportage undertaken for *Stern* this becomes "Chargesheimer." **1943–44** Studies at the Bayerische Staatslehranstalt für Lichtbildwesen. Assistant to the cameraman and photographer Carl Lamb. From **1944** Back in Cologne. **1947–49** Freelance activity as a stage photographer at theaters in Hamburg, Hanover, Cologne, and Essen; first attempts as a set designer in Cologne and Hamburg. **1948** First exhibition, at a bookstore in Cologne. **1950–55** Lecturer at the Anneliese and Arthur Gewehrs Bi-Kla-Schule, Düsseldorf. Subsequent series of photos in Paris. From **1952** Freelance contributor to the *Neue Post*, Düsseldorf, and graphic artist at a firm in Cologne. First photocopies, which he also uses for stage sets. **1956** Advertisement photographer for Ford and Esso. **1960–66** Set designer and producer. **1967–71** Turns to creating kinetic objects; later returns to experimental photography. **1971** Dies in Cologne.

Further Reading: Misselbeck, Reinhold. *Chargesheimer: Photographien 1949–1970.* Exh. cat., Museum Ludwig. Cologne, 1983.

For over fifty years Irving Penn shaped the prevailing ideals of fashion and beauty through his photos for *Vogue* and other (fashion) magazines. But it was not just aesthetic appearance that he presented; he was also seeking to show the human side of his models, to turn anonymous images into portraits. His highly versatile career as a photographer has therefore not only been devoted to fashion but also to the artist's portrait, the ethnographic portrait, the nude, and the still life. Thus Penn is the author of an impressive and masterly gallery of memorable portraits that owe their existence to his preoccupation with strong, creative personalities. Between 1946 and 1949 he took portraits in his New York studio of artists such as George Grosz, Marcel Duchamp, and Georgia O'Keeffe, composers such as Igor Stravinsky and John Cage, and the writer Truman Capote. In these portraits he forces them into a niche of whitewashed partitions and, against this neutral, rather existentialistic background, tempts them out of the usual poses.

This late portrait of the Spanish artist Pablo Picasso is another icon of twentieth-century photography. The restriction of the picture to the face, while concentrating on the eye, is testimony to the photographer's captivating awareness of form and assured proficiency in reproducing the surface in all the richness of its black and white tones.

At the same time as he was carrying out commissions for portraits and fashion photography, Penn was also conducting initial experiments with nude photography in his New York studio, which would be presented to the public only thirty years later under the title *Earthly Bodies*. As soon as he completed the series of nudes, Penn hid them in a box, fearing a negative public opinion. The photographs portray female torsos, the statuesque nature of which arouses associations with the sculptures of Henry Moore or Aristide Maillol. Rosalind Krauss once described these nudes as a kind of voluntary kamikaze attack by Penn against his public identity as a fashion photographer, since the rounded female nudes seem the exact opposite of the slender, angular forms of fashion models. Today it is clear that Penn's nudes do not so much exemplify an anti-aesthetic of the ugly, but instead are directed by similar stylistic principles of beauty and simplicity of representation, and thus fit harmoniously and timelessly into his overall oeuvre. U.P.

1917 Born in Plainfield, New Jersey. **1934–38** Studies at the Philadelphia Museum School of Industrial Art. Trains as a designer with Alexey Brodovich. **1938–40** Work as freelance designer in New York. **1940–41** Works for a New York department store. **1941–46** Assistant to Alexander Libermann, the art director of *Vogue*, who encourages him to become a photographer. Series of portraits commissioned by *Vogue*. **1944** First fashion photography. **1944–45** War reporter in Italy and India. **1952** First promotional photos for American and international clients. **1960** Publication of *Moments Preserved*. **1961** Begins series of photo essays for *Look*.

1963 Begins series of photographic travel reports for *Vogue*; traveling exhibition through the U.S.A., commencing at the Museum of Modern Art, New York. **1964** First platinum prints, a technique he continues thereafter. **1969** Experiments with color prints on steel plates coated with porcelain. **1984** Major retrospective in the form of a traveling exhibition, again starting at the Museum of Modern Art, New York, followed by further stops in the U.S.A., Europe, and Asia. **1985** Resumes painting and drawing. Lives in New York.

Further Reading: *Irving Penn: A Career in Photography*. Boston, 1997.

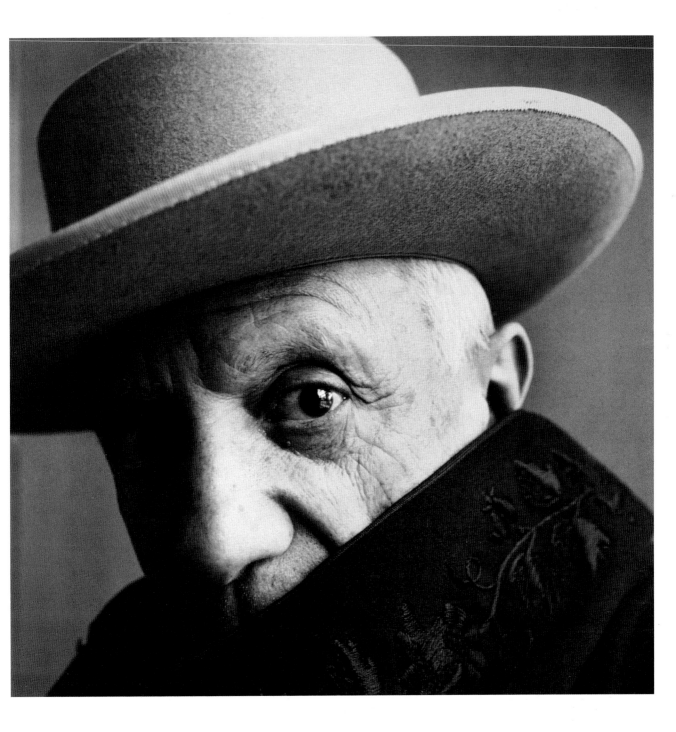

Imogen Cunningham

In the twenties, Imogen Cunningham became famous for her photographs of plants, to which she gave the German name *Blumenformen* (literally, flower forms), and with which she participated at the Werkbund Exhibition in Stuttgart in 1929. Later, it was her portraits and nude photographs which ensured her a place in the history of photography. A friend of Ansel Adams and Edward Weston (see pp. 94, 74), she was interested in photography in which reality and form were united and which led to a new experience of seeing. The transformation of the object from reality into an aesthetic object created by photography was an act of seeing, not of staging. The intention was to create a new aesthetic on the basis of the actual, natural event. Several versions of *Pregnant Nude* exist —the first

known nude photograph of a pregnant woman in the history of photography. Cunningham must therefore have had a lengthy session with her model, something she did quite frequently. The photographer was concerned with the physical presence of the woman, with the formal changes in her body, to which she gave something of the quality of a sculpture. She concentrated completely on the center of the body, the round belly and the breasts, ignoring the head and limbs. In the eye of the camera, this all merges together and results in a photograph in which truth and neolithic shamanism, reality and sculpture, correlate in a fascinating manner. The geography of the body is hinted at; is it to become an art object?

The photograph of the pregnant woman represents the fundamental break between our normal way of seeing and the way of seeing of a representative of "straight photography." Advocacy of the latter led to an aesthetization of the object that ultimately elevated it above pure reality. E.B.

Nude, 1932

1883 Born in Portland, Oregon. **1901** Begins to take photographs. **1907–09** Works in the studio of Edward S. Curtis, Seattle. **1909–10** Studies chemistry at the University of Washington, Seattle, and photochemistry at the Technische Hochschule in Dresden. **1909–11** Own studio in Seattle. **1912** First solo exhibition at the Brooklyn Institute of Arts and Science, New York. From **1917** Studio in San Francisco until 1976. **1918** First meets Dorothea Lange. **1922** Member of Pictorial Photographers of America. **1922–29** Series of plant studies. **1923** First double exposures. **1931–36** Freelance activities for *Vanity Fair*. **1932–35** Founding member of the "f-64" group with Willard van Dyke, Ansel Adams, Edward Weston, Sonya Noskowiak, John Paul Edwards, and Henry Swift. Guest lecturer in photography at the California College of Arts and Crafts, Oakland, and at the San Francisco Art Institute. **1946–47** Lecturer at the California School of Fine Arts, San Francisco (and again in 1950). **1958** Member of the Bay Area Photographers Group. **1964** Honorary member of the American Society of Magazine Photographers. **1967** Member of the National Academy of Arts and Science. **1968** Honorary doctorate in fine art from the California College of Arts and Crafts, Oakland. **1974** The Imogen Cunningham Trust is set up in San Francisco to preserve her photographs. **1975** Dies in San Francisco.

Further Reading: Lorenz, Richard: *Imogen Cunningham: Flora*. Boston, 1996.

On first seeing this photograph of children playing in the park in freshly fallen snow, Jacques Prévert exclaimed: "Ah! That's a Bruegel!" The association is immediately obvious. It is true that the rustic background of the Flemish painter's village pictures is missing, but the children, in multifarious patterns against the white snow, bring his winter scenes to mind. The stacked garden chairs act as a barrier separating the photographer from the children; the only visual contact is with the boy standing in the left foreground. Behind, frieze-like, the children's play unfolds in a strictly horizontal plane bordered by the zone of trees. We can see that the photo was the result of patient waiting. Only when everything was in place, when, as it were, a natural harmony had been established, was the release triggered and the moment frozen.

The Jardin du Luxembourg in the university quarter of Paris was one of Edouard Boubat's favorite locations. He liked to seek out squares and parks where nothing much ever happened and, through careful observation, exposed the surrealism hidden by their ordinary appearance. In 1982, he devoted an entire book to Parisian gardens and squares.

Boubat belongs to that generation of photographers who only began working professionally after World War II. Their "humanistic photography," which reached a peak in France at that time, had abandoned the photojournalism of the prewar years, with its pictorial narratives developing in series. Photographers now tried to condense life into a single decisive photograph. In these pictures, great feelings were formulated eloquently, as were quiet, contemplative moments. Parisian photographers were offered opportunities to present their work that went beyond sensationalist journalism—not just in the major magazines but also, increasingly, in galleries. Partly as a result of his training as a graphic artist, Boubat was more interested in the impressive visual formulation of an image than in photography's narrative qualities. In an interview he summarized it thus: "Whether you want it to or not, a photo reproduces an atmosphere." L.D.

1923 Born in Paris. 1938–42 Studies painting, typography, and design at the Ecole Estienne, Paris. 1942–45 Works as a photoengraving printer in Paris. 1946 First photographs in Paris. 1946–50 Freelance photographer, Paris. 1951–68 Regular photographic work for the magazine *Réalités*, Paris.

From 1968 Freelance photojournalist and portrait photographer in Paris. Numerous trips around the world. 1999 Dies in Paris.

Further Reading: *It's a Wonderful Life: Photographs by Edouard Boubat*. Paris. 1996.

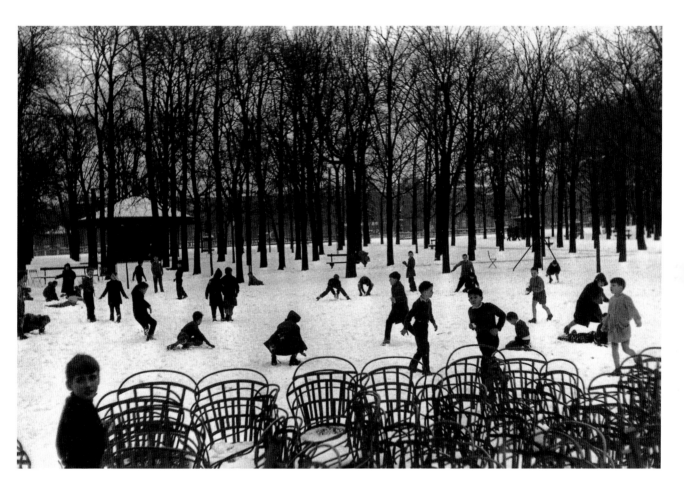

Mario Giacomelli is one of those photographers who, as artists, retire modestly behind their work. His series of 1961–63 on the dance-like rompings of young seminarians, entitled *I Have No Hands to Caress my Face*, achieved international acclaim—but fame never affected him personally or professionally. Giacomelli's oeuvre revolves around a handful of themes: the Italian landscape, primarily the hilly cultivated region of his birthplace and home, Senigallia, as well as the people who live and work in this landscape: farmers and day laborers, children, gypsies, and hospice inmates. If we disregard for a moment the emphasis that he places on his home, then, from the manner in which he depicts people, it becomes clear that the actual subject matter of his photography is the vision of the cycle of birth and death, work, celebrations, and illness. Even landscape

does not interest him as untouched nature, but first and foremost as a landscape that displays the traces of human endeavor. The land and the people of Senigallia, firmly anchored in tradition, present him with images of the daily struggle for existence.

For processing his photographs, Giacomelli prefers hard paper that suppresses the intermediate tones and accentuates black and white contrasts. Line is important to him; he moves photography closer to drawing and graphic art. He is not afraid to correct negatives or make double exposures in order to realize his ideas. Thus he creates landscape pictures that, over and above the visual work, ultimately exhibit conceptual qualities that correspond to those of Land Art. In addition, this association of realistic interest and an aesthetic of form produces images—such as that of the romping seminarians—that in their weightless rhythms of abstract shapes might remind us of Henri Matisse's dancing figures.

In his photographs, Giacomelli manages simultaneously to convey distance and closeness, the affecting and the metaphorical, commitment and graphic picture formation, emotion and conceptuality. His realism, far-reaching symbolism, and perceptible human involvement make him an outstanding personality among photographers. R.M.

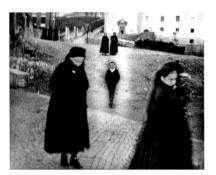

Scanno, 1957–59

1925 Born in Senigallia, Ancona, Italy. **1935** Begins to paint and write. **1938** Works for a typographer whose business he takes over in 1945. **1952** First photographs; founds the photo club Misa together with Cavalli. Thereafter numerous photo series. Works as freelance photographer, typographer, and illustrator in Senigallia. **1958** First solo exhibition at the Galleria il Naviglio, Milan. **1961** His photograph

Puglia, dating from 1958, appears on the cover of the English edition of the book *Conversation in Sicily* by Elio Vittorini. **1963** Participates in "photokina," Cologne. **1971** Participates in the Venice Biennale (again in **1993** and **1995**). **2000** Dies in Ancona.

Further Reading: Carli, Enzo. *Giacomelli: La forma dentro. Fotografie 1952-1995.* Milan, 1995.

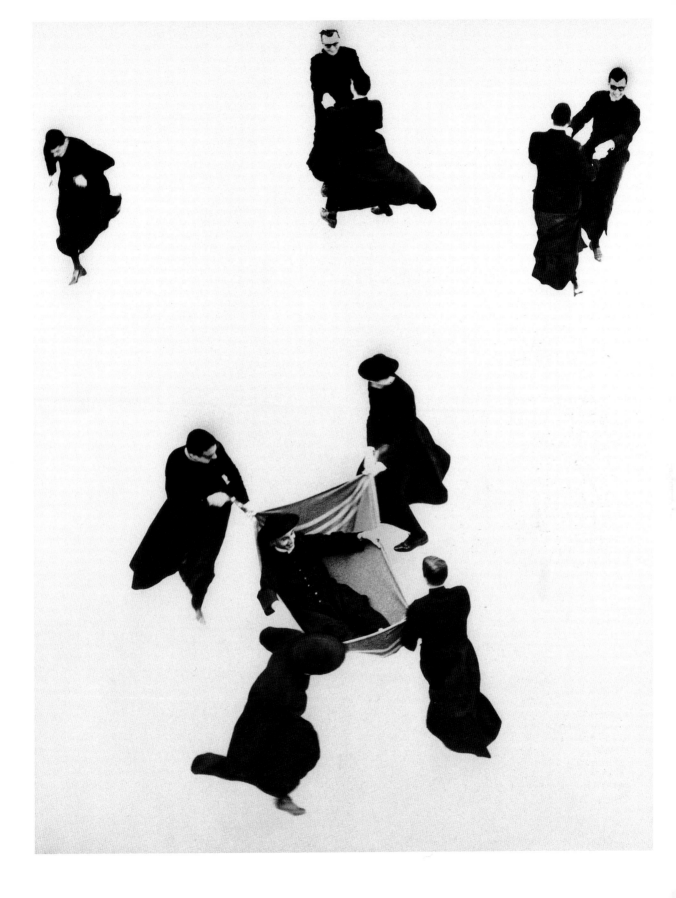

Garry Winograd

In his later years Garry Winograd would cast an increasingly jaundiced and sardonic eye on the public behavior of his fellow citizens. Early in his career, however, though not exactly uncritical, he appears to have felt himself more often in a celebratory mood, as manifested in this photograph.

The occasion for this image appears to have been a parade, possibly New York City's traditional Thanksgiving Day extravaganza. Winograd positioned himself directly in front of or behind an elevated rolling float, as indicated by the foil decoration that runs along the bottom edge of the picture and the silhouette of a man holding a bunch of balloons at the far left. The float incorporates a trampoline; one can glimpse its support struts along the bottom right. Counterbalancing the figure on the left, we see three men in band uniforms on the right, watching with amusement as the central figure—clad, incongruously, in a suit and tie, and, even more improbably, holding a cigarette between his lips—performs a somersault in mid-air.

Winograd has caught him in mid-turn, almost exactly upside down, limbs outthrust in this ecstatic moment of gravity-defying, controlled abandon. It is a classic rendering of a classic street photographer's trope, straight out of the tradition established by Robert Doisneau, Ruth Orkin, and others. And it includes few of the visual devices that would become the notable and much-imitated hallmarks of this influential photographer's mature style: skewed horizon lines, more abrupt and seemingly random framing, and less differentiation between the eventful and the incidental.

Yet, though Winograd was still some years away from finding his own voice, we can note here clues to the complex picture maker he would eventually become: that fringed border running along the bottom like an aluminum mountain range, its texture and highlights pulling the eye away from the image's center and ostensible main subject, and the out-of-focus billboard in the upper right corner, whose winged logo echoes the gesture of the acrobat's legs, and which reads "Flamingo/frozen," evoking the apropos image of a bird arrested in flight. Finally, it is a small miracle of precise timing, the suspended animation of that central event and the contributory incidents surrounding it exemplary of photographic seeing. A.D.C.

1928 Born in New York. **1947–48** Studies painting at City College of New York, and from 1948 to 1951 at Columbia University, New York. **1948** Starts taking photographs and working in the darkroom. **1949** Studies photography with Alexey Brodovich at the New School for Social Research, New York. **1951** Contract with Pix Inc., New York. First commission for *Harper's Bazaar*. **1952** Links with the American Society of Magazine Photographers, of which he is a member from 1963. **1954–55** Photographer under contract to Henrietta Brackman Associates, New York. **1967** Teaches at the Parsons School of Design, New York. **1968–71** Teaches at the School of Visual Arts, New York. **1971–72** Workshops at the Center of the Eye, Aspen, Colorado, and Phoenix College, Arizona, followed by numerous teaching assignments in the U.S.A. and Europe, as well as numerous exhibitions. **1984** Dies in Mexico.

Further Reading: *Winograd: Fragments From the Real World.* Exh. cat., The Museum of Modern Art. New York, 1988.

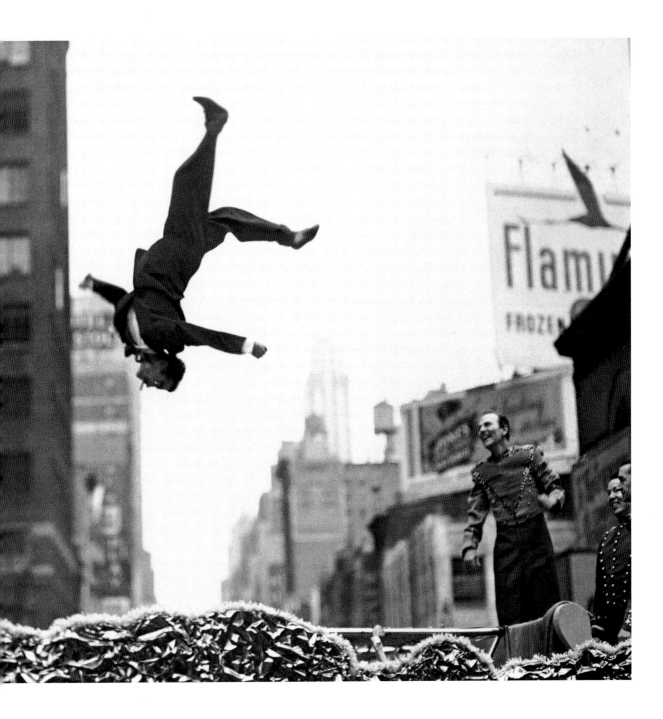

René Burri

It has never been the idyllic places of our world that have interested René Burri, the widely traveled photojournalist from the photo agency Magnum, but rather the places where stark social rifts are apparent. When, at the end of the fifties, he began his major work, the series *Die Deutschen* (The Germans), published in 1962, he preferred this divided country to the delights of France or Italy. Similar motives must have guided him, in 1959, when he traveled for the first time to Brazil, already a country subject to acute social and political tensions, with irreconcilable differences between rich and poor, where extreme corruption—still continuing today—was part of ordinary political life.

São Paulo is a prime example of Burri's multilayered approach to reality. His aerial view of the city provides us with something like the stratigraphy of a society. The clear structure of the picture, with vertical breaks defining the canyon of the street, multistoried facades, and a roof terrace, seems to correspond to the social division; below, the anonymous mass of people in motorized vehicles, with a few pedestrians looking like ants, as opposed to the few above. Yet it remains questionable if the group of "faceless" men on the roof are members of the oligarchy, the state apparatus, or just a shift of watchmen. Overall it is a panorama as though seen through a prism, dramatized in its proportions, which would make an ideal backdrop for a spy film. Compared to this, Berenice Abbott's views of New York (see p. 102) seem almost welcoming.

In his film *Metropolis,* Fritz Lang conjured up the big city as Juggernaut, an inhumanity that is also discernible in Burri's picture. The genre, rich in tradition, of the streetscape—with people strolling, shopwindows, vehicles, and so on—is here transformed into an allegory of the inhospitable: the city as a scenario of anonymity and alienation.

Although Burri, with his photographic overview *Die Deutschen*, fits into the tradition of Henri Cartier-Bresson (*The Europeans*, 1950–55) and Robert Frank (*The Americans*, 1954–58), there are nevertheless very clear differences between his approach and that of the Frenchman and his Swiss compatriot. For him the reality of life in a particular country is no longer encapsulated in scenes of encounters with people expressed with charm, pithiness, and irony, nor in masterful arrangements of form, but in a kind of photographic sociology which, as it soberly dissects, looks social reality straight in the eye.

P.S.

1933 Born in Zurich. **1949–53** Studies photography with Hans Finsler. Mainly self-taught in photography, influenced by Werner Bischof. **1953–54** Studies film at the Kunstgewerbeschule in Zurich. **1953** Camera assistant to Ernest A. Heininger. **1954** Serves in the Swiss Army. From **1955** Freelance photojournalist for *Life, Look, Stern, Fortune, Epoca,* the *Sunday Times, Geo, Twen, Du*; since then also filmmaker. From **1959** Member of the Magnum photo agency, Paris and New York. **1962** Publication of *Die Deutschen/Les Allemands,* Zurich and Paris. **1965** Involved in setting up Magnum Films. **1982** Opening of the Galerie Magnum in Paris, together with Bruno Barbey. From **1988** Art director of the *Schweizer Illustrierte.* Lives in Zurich.

Further Reading: *René Burri: One World, Fotografien und Collagen 1950–1983.* Berne, 1984.

Ed van der Elsken

Hardly any other photographer in Europe understood as well as Ed van der Elsken how to capture the sensation of being alive that young people felt in the years after World War II. In a series of books, which he himself designed and produced, he traced the rebellion of adolescents against their parents' generation. His book *Love on the Left Bank* (1956) is structured like a documentary photo-novel about the young people who spent their days and nights in "existentialist" jazz cellars and in the hotels and cafés of Paris. He did not see himself as an aloof observer but as a participant, as his smudged, black-ground, yet romantically atmospheric photographs reveal. Van der Elsken, who had hitchhiked to Paris only a few years earlier, initially did occasional work for the Magnum photo agency, but he preferred to work without a client.

In 1959, he set out on a journey around the world which took him to all the continents, to South Africa, India, the Philippines, China, Japan, Mexico, and the United States. His resulting photos were published in 1966 in the book *Sweet Life*. This is a highly personal commentary on social and political realities throughout the world, which was readily comprehensible everywhere; the book appeared simultaneously in six countries. While he was in Durban, in South Africa, van der Elsken photographed this laconic scene on a promenade beside the sea. The four elderly women deep in conversation on the weathered concrete bench and the man passing them without a word are caught beneath a dark and threatening sky. Probably in the darkroom, van der Elsken lightened the area around the man's head to make it stand out against the coarse-grained background. The words on the back of the bench are what gives the photo its political significance, since they identify the women as white, as representatives of the apartheid system, beneficiaries of racial segregation.　　　　　　　　　　　　　　　　　　L.D.

1925 Born in Amsterdam, where he later studies art. Self-taught in photography. Attends courses at the Nederlandse Fotovakschool, The Hague. **1947–50** Freelance photographer in Amsterdam. **1950–53** Moves to Paris; training with a professional photographer. **1955** Returns to Holland. **1955–61** Produces the series *Jazz*. **1956** Publication of *Love on the Left Bank*. **1959** Embarks on a journey around the world; makes films and takes photographs. From **1959** Active as a documentary filmmaker. **1966** Publication of *Sweet Life*. **1990** Dies in Edam.

Further Reading: *Ed van der Elsken: Once Upon A Time*. Exh. cat., Stedelijk Museum Amsterdam, 1991.

Alberto Korda

During a memorial service in Havanna, at which Fidel Castro holds an address, members of the Cuban leadership are gathered on the podium, among them the president of the National Bank and future Minister of Industry, Che Guevara. Alberto Korda photographs the event for the newspaper *Revolución*.

Argentine-born Ernesto Guevara de la Serna, known as Che Guevara (1928–1967), did not seek out flashlights and publicity. Even at official events he would sometimes ask photographers to put away their cameras. As Alberto Korda later recalled, this photo was pure chance. Just days before this photo was taken, eighty people had been killed when a French cargo ship loaded with guns for Cuba was blown up. The burial service turned into a mass demonstration for the new government of Cuba, which had been formed only one year earlier under the leadership of

Fidel Castro. Korda stood some eight metres (25 feet) from the podium, taking pictures as Castro delivered his speech. The Cuban leader was surrounded by his ministers and other dignitaries; Jean-Paul Sartre and Simone de Beauvoir were also in attendance. Guevara stood in the background. Suddenly, he stepped forward and looked out over the crowd. Korda recalled being "fascinated by the intensity in his eyes." Before Guevara stepped back again, Korda had time to take two pictures: one in landscape and one in portrait format.

Spontaneous and natural, the portrait is a snapshot of the revolutionary as observer, unaware that he is being observed himself. The angle is slightly from below, with Guevara's eyes directed upward and into the distance. In keeping with the occasion, the commandante wears a formal military jacket; his face is framed by the star-adorned beret, his tousled hair, and full beard. Sensitivity and gentleness, determination and will power, dignity and a profound gravity emanate from Guevara's youthful figure in the portrait. The composition is reminiscent of images of saints with a "heavenward" gaze; perhaps its worldwide appeal is explained by this accidental reference to Catholic visual propaganda that has served the Church for centuries. Milan publisher Gian Giacomo Feltrinelli knocked on Korda's door in search of a Guevara portrait four months before Che's death and came away with two prints at no cost—he must have suspected the photograph's great visual potential. Feltrinelli selected the image cropped by Korda to show only Guevara's face and printed it as a poster in vast numbers.

As Korda said: "And the photo exploded all around the world." As a picture of a new messiah, it became the icon of the leftist protest against capitalism and the establishment. P.S.

Quixote Atop a Lamppost, Havana, 1959

1928 Born in Havana, Cuba. **1946–47** Studies economics at Candler College, Havana. **1947–50** At the Havana Business Academy. **1956–69** Founds the Estudios Korda in Havana together with Luis A. Pierce. **1959–62** Photographer for the magazine *Revolución*, Havana. **1959–69** Fidel Castro's photographer. **1961** Founding member of the photography branch of the Unión de Escritores y Artistas de Cuba (UNEAC) in Havana. **1968–80** Photographer at the Academia de Ciencias de Cuba, Havana. **1980** Active as freelance photographer, including fashion photography. **1980–82** Photo director at Opina. **2001** Dies in Paris.

Further Reading: *Alberto Korda: Momenti della Storia*. Exh. cat., Centro Culturale Editoriale Pier Paolo Pasolini. Italy, 1982.

Lee Friedlander

Lee Friedlander loves anomalies, quirks, and examples of our "best intentions" that have gone astray. He enjoys visual puns and conundrums. His pictures are witty and, sometimes, unkind. He works quickly. Like a star athlete, he senses in advance where the "play" will happen, and lifts his camera at that moment. Being a photographer, he said, was "all I ever wanted to do since I was a kid. Always." He has produced one of the richest and most inventive bodies of work in photography. Each of Friedlander's many series has a distinctive character. With equal skill, he can make tauntingly complex and eloquently simple pictures. His images are most likely to be direct and without asides when he is photographing children or plants. Urban environments evoke him to create the most visually complex compositions. In the 1960s, he worked with mirrors, reflections, signs, and movie screens to capture images-within-images. He also recorded the ubiquitous televisions in his motel rooms as he crossed the country on assignment. City streets and highways were the richest sources of these amply layered pictures about the visual cacophony of urban life. In the 1970s, he photographed parties and chronicled the rote gestures of greetings and of disinterested acquaintance. Another Friedlander series elucidated the types of memorial statues that have been erected in American cities, and where they are usually situated. Often, he noticed that an intention to honor had been subverted by changing environments and values. In the 1980s, Friedlander investigated how people look when they are working, mirroring the inverted gazes captured by Walker Evans when Evans photographed subway riders in the 1940s (see p. 72). Friedlander is also a searing portraitist and has published four books of photographic portraits. He began his career in the 1950s photographing for record companies. The portraits of jazz and blues musicians that he made for himself, rather than for clients, are both intimate and, at times, unflattering. He is hardest on himself in the self-portraits made "on the road" in the 1960s. Sometimes he portrays himself as a stalking shadow lying across the views and people before him. For decades, he also photographed his wife Maria and his children, Eric and Anna, as well as his friends and colleagues. The pictures are informal; the subjects are often "at home," "at ease," and touchingly vulnerable. A.W.T.

1934 Born in Aberdeen, Washington. **1948** Begins to take photographs. **1953–55** Studies photography with Edward Kaminski at the Art Center School, Los Angeles. From **1955** Freelance photographer working for, among others, *Esquire*, *McCall's*, *Collier's*, and *Art in America*. **1966** Chair of the Artist in Residence program at the University of Minnesota, Minneapolis. **1970** Guest lecturer at the University of California, Los Angeles. **1977** Chair at Rice University, Houston. Lives in New York.

Further Reading: *Lee Friedlander: The Desert Seen*. New York, 1996.

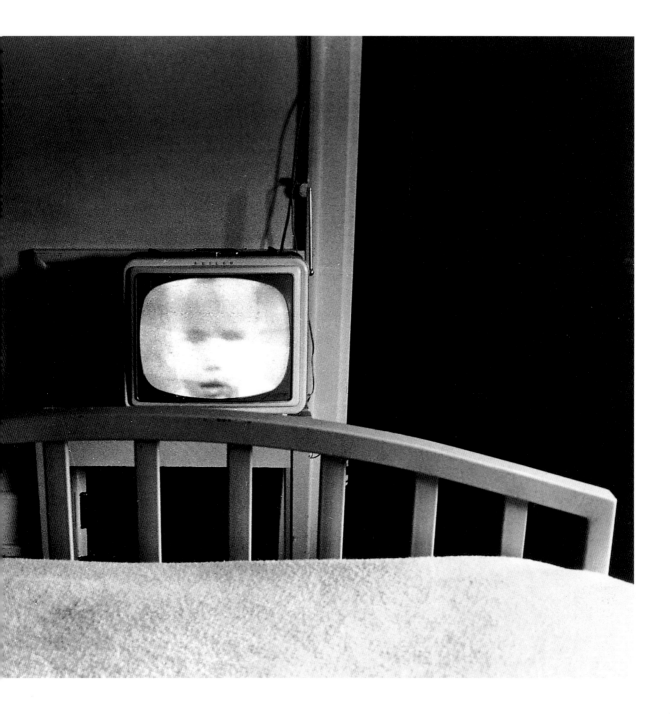

Cecil Beaton was perhaps one of the last baroque artists in England. He understood how to present people of rank—and he almost only made portraits of members of the nobility and the social circles in which he himself moved—in such a way that clothing, figure, accessories, backdrop, and material qualities were combined into an enchanting extravaganza. He spoke of himself as a "fanatical aesthete." As set designer, costume designer, and portraitist, he ridiculed the modern principle "less is more" with his sumptuous arrangements, unlike any other of the great figures of twentieth-century photography. His pictures are homages to luxury and to a feudal—English—cult of hedonism that allowed a smooth transition from the Victorian to the postmodern age. However, from the fifties in particular, alongside the entertaining unreality of his portraits (which reached their apogee in the portraits of the British royal family), Beaton understood how to project a cool objectivity, which is particularly evident in his portraits of artists and intellectuals.

Edith Sitwell, the English writer of noble birth, is seated wearing a white garment—more drapery than dress or coat—in front of a chair back swathed in white fabric near a light-colored wall. Her aristocratic profile stands out prominently against the white ground, richly modeled, owing to the folds of fabric. Her bearing is given an additional, rather blasé, refinement by the studied pose of her hands. The scarf, tied diadem-like into a turban, and the rings on her fingers are the few, if eloquent, attributes of the ageing poetess, whose face is mercilessly exposed, although she turns her gaze away in a distinguished manner. At the time of this portrait Edith Sitwell, made a Dame (DBE) in 1954, was seventy-five years old. She continued to give public readings, and the free rhythm of her lyric poetry was still found liberating by the youth of the period. The pioneer of literary modernism died two years later. Beaton, who had been making portraits of her since the 1920s and with whom she was friends, succeeded here in creating a portrait which is a masterpiece of psychology, its carefully calculated theatricality allied with sophistication and a high level of artistic sensitivity. P.S.

1904 Born in London. **1922–25** Studies history and architecture at St. John's College, Cambridge. Teaches himself photography. **1925–70** Set designer, and **1941–70** film outfitter in London and Hollywood. **1926** First exhibition in a London gallery. **1926–30** Freelance portrait and fashion photographer. **1928–50** Court photographer to the British royal family. **1939–45** Photographer for the Ministry of Information in London. **1930–c. 55** Employed as fashion photographer at Condé Nast publications, mainly for *Vogue* in New York and London. Thereafter freelance until his death. **1964** Member of the Royal Photographic Society. **1980** Dies in Broadchalke near Salisbury, Wiltshire.

Further Reading: Garner, Ph. and Mellor, D.A. *Cecil Beaton: Photographs 1920–1970.* New York, 1996.

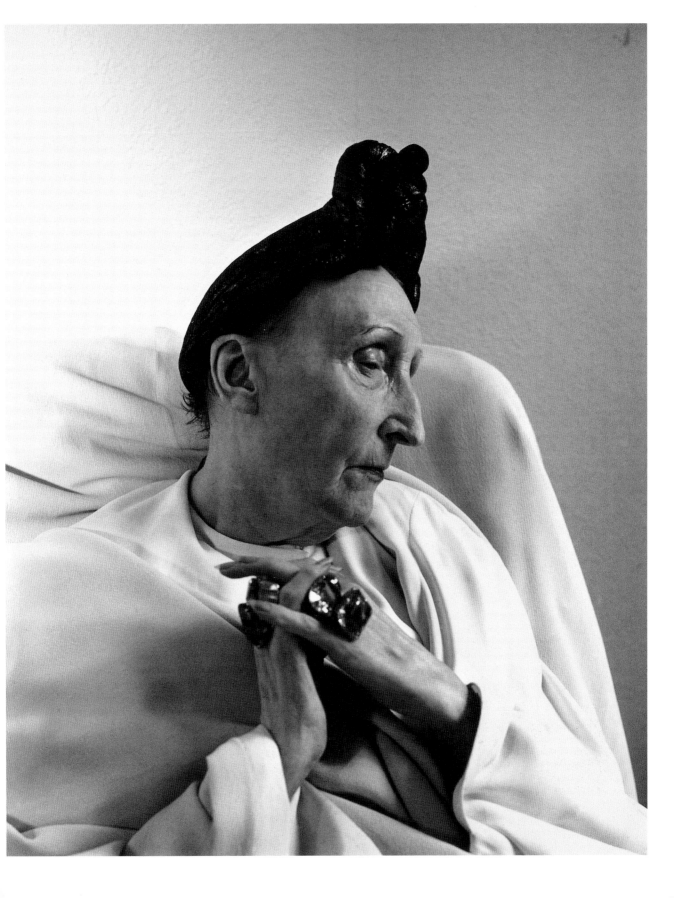

Richard Avedon

This is a picture that fascinates. If one examines the ladies' clothes, it can be seen to be an official photograph. All eleven of them are of mature years, definitely "upper class," and decked out in evening gowns and sashes as indications of their function. Some of them are even wearing medals on their chest. They are all representatives of an organization called "The Daughters of the American Revolution," which obviously awards its officers military rank. These eleven leaders have the status and title of generals. With this photo, Richard Avedon created a group picture that follows a genre, rich in tradition, one that can trace its origins back to the guild portraits of the Netherlands. Certainly, the reference to guild portraits in Avedon's photo is particularly instructive, especially if we compare it with the most famous work of this genre, Rembrandt's *Night Watch*. Rembrandt exploded the then prevailing norms of group portraiture by not painting the heads of the members of the watch lined up next to one another; instead he turned the group portrait into a story and gave it dramatic lighting.

Avedon's photograph interests us, like Rembrandt's *Night Watch*, because of its unconventionality. The generals are part of the group, and yet each of them is isolated. None of them is looking at another of her colleagues, none of them is looking at the photographer, and there is no visual contact with the viewer. The group is alone with itself; a diverse network of intersecting, but never touching, glances develops. In addition, the main person in the center is standing with her back to the viewer, thereby cutting off the group even more from the photographer, producing a certain privacy, and making the viewer an intruder, despite all the official get-up. The contradiction is obvious. Based on their attire, these are officials who are portrayed, yet, based on their facial gestures and their conduct, they are private individuals.

The inner conflict of the group composition is not only the expression of a formal experiment but also a mirror of Avedon's ambivalent relationship to the subjects of this picture. In a lecture he once said, "These are the Generals of the DAR, the Daughters of the American Revolution. That means that every one of their ancestors came over on the Mayflower. They turned into the most reactionary of organizations. They're the ones who would not permit Marian Anderson to sing in Constitution Hall because she was black." R.M.

1923 Born in New York. **1941–42** Studies philosophy at Columbia University, New York. **1942–44** Work in the photography department of the U.S. Merchant Navy. **1944–50** Photography studies with Alexey Brodovich in the Design Lab of the New School for Social Research, New York. **1945–47** Regular photographer for *Junior Bazaar*. **1946** Sets up own photo studio in New York. **1945–65** Editor and photographer at *Harper's Bazaar* under Brodovich and Carmel Snow. From **1950** Freelance work for, among others, *Life* and *Look*. **1959** First publication: *Observations*. From **1966** Regular contributor to *Vogue*. **1980** Appointed Chancellor of the University of California at Berkeley. **2004** Dies in San Antonio.

Further Reading: *Richard Avedon. Evidence 1944–1994*. Munich, 1994.

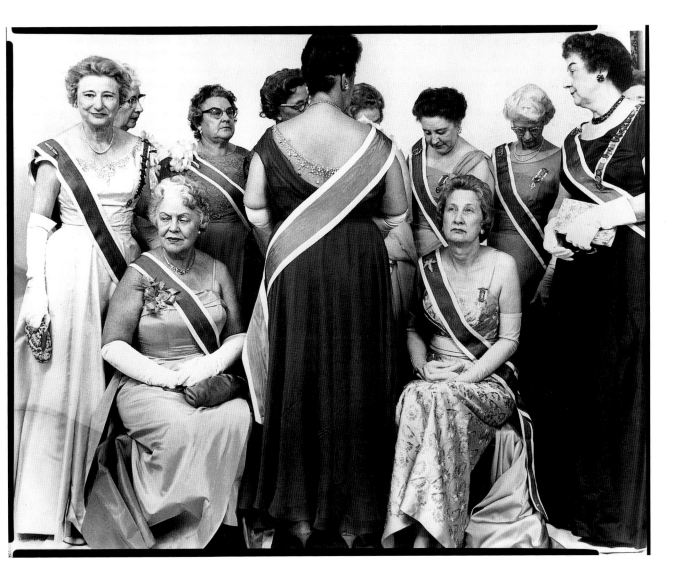

For more than three decades Stefan Moses, who, together with Thomas Höpker, Robert Lebeck, and Max Scheler, is among the top-notch photographers of the magazine *Stern*, has been preoccupied with the theme of his life—to depict the Germans. At the head of his various cycles of portraits is the series *Self in the Mirror*: self-portraits of German intellectuals such as the writer Ernst Jünger and the philosopher Theodor Adorno, or Ernst Bloch and Hans Mayer, taken with a delayed-action release, making the very act of photographing the theme.

We know how difficult, how impossible, it is to grasp the essence of a person within a picture, but at the same time we have high expectations about the general validity of pictures of people. In order to get closer to the identity of a person, it is important first of all to clarify the field of tension between the mask-like transfigurations and the essential. Moses deliberately

assists by means of stage management and animation when, for instance, he uses a pale gray felt cloth as a background for his West or East German portraits or, for another series, takes prominent witnesses of contemporary German history such as Golo Mann, Willy Brandt, and Max Schmeling into the forest and photographs them there. In other portraits, politicians pose with a wooden dumbbell or artists, such as Otto Dix, Hans Richter, and Ernst Wilhelm Nay, with a homemade mask.

Characteristic is Moses' psychological feel for a situation, for the concealed and the cryptic, for tragedy and irony. Whereas classic portrait photography in the style of Hugo Erfurth (see p. 40) concentrates in a static manner on the facial features, whose "landscape" becomes, so to speak, a mirror of the personality, Moses' portraits are lively *mises en scène*. This is also demonstrated in his picture essays on his son Manuel, in which he depicts his son's childhood poetically, making visible the world of childish games and dreams, the dressings up and transformations. As a result of his break with customary studio aesthetics Moses constantly reinvents the pictures; the classic relationship between photographer and model is liberated from the static approach, the essence of personality is playfully exposed. These are photos of artistic, highly contemporary value which continue the tradition of August Sander's encyclopedic work on people in the twentieth century (see p. 20). U.P.

Child and Cat with Chinese Animal Masks, 1965

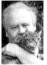

1928 Born in Liegnitz, Silesia. **1943** Photographic training with the children's photographer Grete Bodlée in Breslau and Erfurt. **1946–49** Stage photographer at the Nationaltheater in Weimar. **1950** Moves to Munich. **1950–60** Photojournalist in Munich, working among others for the *Neue Zeitung*, *Revue*, and *Quick*. **1960–67** Employed at *Stern*. From **1965** Freelance photographer. Photos of artists, writers, and politicians. **1990** Awarded the David Octavius Hill Medal by the Fotografische Gesellschaft Deutscher Lichtbildner (GDL). **1992–94** Traveling exhibition *Ostdeutsche Porträts–1989/90*, including stops in the U.S.A. and Canada. **1998–99** Exhibition *Jeder Mensch ist eine kleine Gesellschaft*, in Munich. **2002–03** Retrospective in Stadtmuseum Munich. Lives in Munich.

Further Reading: *Abschied und Anfang: Ostdeutsche Porträts 1989–1990 von Stefan Moses. Ostfildern, 1991. Stefan Moses: Jeder Mensch ist eine kleine Gesellschaft.* Exh. cat. Munich, 1998.

As a film director, Gordon Parks broke the color barrier against African Americans behind the camera in Hollywood with *The Learning Tree* (1969) and *Shaft* (1971). A composer whose orchestral music has been performed internationally, he is also an autobiographer and novelist. And, of course, a photographer, best known for the classic black-and-white documentary and photojournalistic images he produced for the Farm Security Administration and later for *Life* magazine.

This image comes from his extensive *Life* feature story on the Black Muslims, produced when the late

Muhammad Ali, 1970

Malcolm X still spearheaded its organizational activities and served as the fiery spokesman for its adversarial, separatist policies in relation to white America. Parks himself was not a Muslim, and disagreed with

many of their practices and principles, but he understood them as a necessary force in the United States at that time, and a logical outgrowth of the country's racist history. His coverage of the organization and its members treated them as forces to be reckoned with—as in this study of ranks of Muslim women, which uses selective focus to personalize the one in the foreground, suggesting the individuality of each of those behind her while symbolizing their collective strength and determination. (The boxer Muhammad Ali, portrayed in the inset image, was then a recent, controversial convert to Islam.)

Parks has never lost his love for still photography—the medium that served as his ticket out of poverty, the one which, he acknowledges fondly, "made all the other things possible. My main thrust was the documentary approach—which I learned from Roy Stryker and the F.S.A. [Farm Security Administration] group. That shaped my whole attitude toward life." That project gave him the opportunity to depict (among other things) the African American experience as perceived by a member of that minority, and thereby to have a significant voice in determining how his people were visually represented to the world.

This was a major breakthrough in that era, and Parks used the opportunity well, not only then but consistently thereafter. When he later started working for *Life* magazine, he covered many subjects, from Hollywood to fashion, but much of his strongest work from that period addressed issues of race, prejudice, and the politics surrounding those matters. A.D.C.

1912 Born in Fort Scott, Kansas, grows up in impoverished circumstances. **1916** Moves to St. Paul, Minnesota. **Early 1930s** Starts composing. **1937** First camera. **1941** Julius Rosenwald Award for Photography, Chicago. **1942** Works under Roy Striker in the photographic department of the Farm Security Administration. **1945–49** Photographer for Standard Oil of New York. Publication of the books *Flash Photography* and *Camera Portraits*, among others. **1949–70** First black photographer at *Life*. Also successfully active during this time as a writer and as a director of his own film projects. **1960** Chosen as the American Society of

Magazine Photographers' "photographer of the year." **1966** Exhibition of his pictures at "photokina" in Cologne, with a great response. **1970s–80s** Further films and books (prose and poetry). Numerous honorary doctorates. Several photo exhibitions, mainly in the U.S.A. **1988** Receives the National Medal of Arts from the President of the United States. **1989** Large-scale retrospective *40 Jahre Fotografie* in Tübingen. **1990** Honored for his life's work by the International Center of Photography. Publishes his autobiography *Voices in the Mirror*. Lives in New York.

Further Reading: *Half Past Autumn: A Retrospective–Gordon Parks*. Boston, 1997.

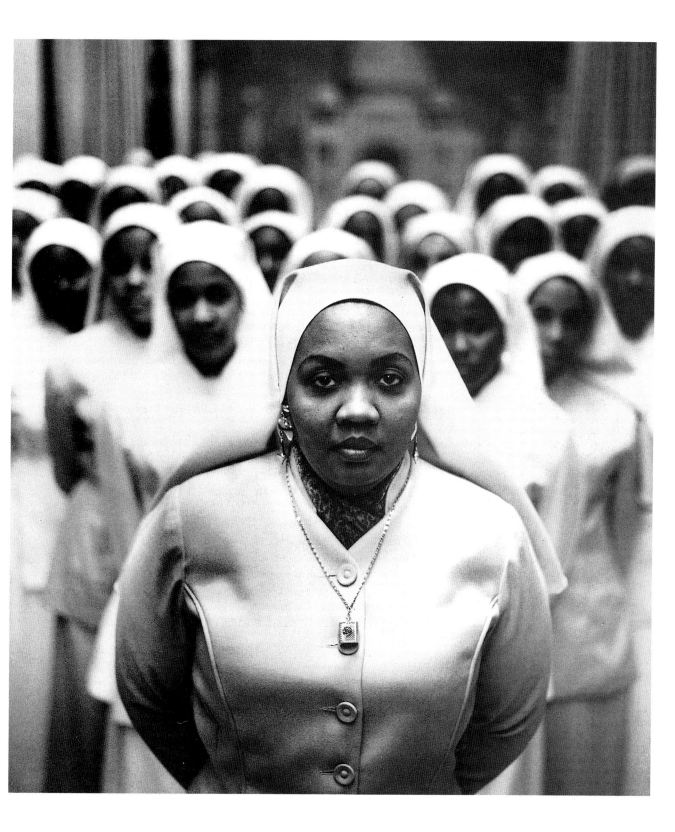

Malick Sidibé

Dance Party, 1972

Malick Sidibé, of Mali in West Africa, is representative of the large number of indigenous African photographers who, although they received their training from white photographers, became independent and since then have produced photographs "by blacks for blacks." The greater part of their work consists of portraits. In this field Seydou Keita and Abdourahmane Sakaly (Mali), Cornelius Y.A. Augustt (Ivory Coast), James K. Bruce-Vanderpuye (Ghana), and Narayandas V. Parekh (Kenya) have produced exceptional work.

Sidibé expanded the parameters of portrait photography and made it dynamic. Every evening he would leave his studio and laboratory to attend young people's celebrations in Bamako and record their boisterous

meetings. In this he was the opposite of Sakaly, whose clientele was drawn from the upper class. In the decades of Twist and Cha Cha Cha, and later Rock 'n' Roll and Beat, Sidibé photographed the new, self-assured generation at their private dances and parties, and in their clubs, bathing in the Niger, at weddings, baptismal ceremonies, or sports events. With a distinctive spontaneity, freshness, and immediacy, he captured the zest for life of teenagers and people in their twenties following Mali's independence.

Sidibé's oeuvre is not just unique in Africa; in the West, too, there was hardly another photographer who documented the youth culture of the sixties and seventies with such passion and over such a long period of time. *Twist* is one of the few "classic" pictures by Sidibé. Young Malians in elegant evening garb have put a record on and are dancing to the latest hits. The figure of the male dancer filling the foreground, seen from behind, directs our gaze on to the pleasant, concentrated face of his partner—both of them in the crouched posture typical of this dance. The young, modern townspeople have abandoned the tribal dances of the rural regions and are enjoying dancing socially in couples in the Western fashion, but in a way that again displays almost ritualistic form. Through the emergence of amateur and color photography on a massive scale, such sophisticated portrait and observational art has now been consigned to history in Africa—and not just there.

P.S.

1936 Born in Soloba, in what was then the French Sudan (now Mali). **1952** Graduates from school. Until **1955** Attended the Ecole des Artisans Soudanais in Bamako, where he studied goldsmithing, followed by training in the Photo Service studio of the French photographer Gérard Guillat (known as Gégé).

1956 First camera. **1962** Sets up own photographic studio. Becomes favorite photographer of the youth of Mali, concentrating on photographing them at ceremonies, parties, and dances. **2003** Hasselblad Prize, Göteborg (Sweden). Lives and works in Bamako, the capital of Mali.
Further Reading: Magnin, André (ed.). *Malick Sidibé*. Zurich, 1998.

Typology of Half-Timbered Houses, 1959–74

At the beginning of the century, Karl Blossfeldt embarked on his large-format photographs of details of plants (see p. 24), survey photographers collected architectural data in German cities and recorded them photographically, and August Sander began his encyclopedia on people in the twentieth century (p. 20). In these contexts, photography was primarily considered a means of compiling visual material in a comparable manner and thus of preserving it for science and for interested posterity.

When Bernd and Hilla Becher took photographs of cooling towers and half-timbered houses in the sixties,

they did so because they had discovered that such monuments were being torn down more rapidly than they themselves could photograph. However, photography also turned out to be extremely useful because it provided objectively better comparable data. The art scene then discovered these works as photographic parallels to sculptures and other plastic works, so to speak as "found," "anonymous sculptures." According to this way of thinking, a photograph was still a document that recorded the sculptures as such. "The 'artist'—to use a term that is not really admissible here—retreats completely behind what he is depicting. He remains anonymous like the built 'sculptures' that he reproduces." Today Bernd and Hilla Becher would definitely be seen in a different light, but this shows how far photography has come since 1981, how much our understanding of documentary photography has changed. In the meantime, it is apparent that it is the concept that makes the Bechers artists, and that their documentation is no detriment to this. The reversal in evaluation that led to Blossfeldt, Sander, Albert Renger-Patzsch, and other factual and documentary photographers also being honored as artists retrospectively has moved the Bechers into the rank of German artists of highest international renown. Basically, we should not see the Bechers' photos as individual pictures. It is only when they are put in rows, compiled into series, that the essence of these works, their concept, can be recognized. R.M.

Hilla Becher: **1934** Born Hilla Wobeser in Potsdam. Trains as a photographer, then works as a commercial photographer in Hamburg and Düsseldorf. **1957** Moves to Düsseldorf. **1958–61** Studies, followed by the establishment of a photography department at the Staatliche Kunstakademie in Düsseldorf. From **1959** Collaboration with Bernd Becher.

Further Reading: *Becher, Mapplethorpe, Sherman.* Monterrey, 1992. Grigoteit, Ariane (ed.). *Bernd & Hilla Becher.* Deutsche Bank AG, Frankfurt am Main, 1998.

Bernd Becher: **1931** Born in Siegen. **1947–50** Trains as an interior decorator in Siegen. **1953–56** Studies at the Staatliche Kunstakademie in Stuttgart. **1957** First photographs of industrial buildings. **1957–61** Studies typography at the Staatliche Kunstakademie in Düsseldorf. **1959** Begins collaborating with Hilla Wobeser, whom he marries in 1961. **1972–73** Guest lecturer at the Hochschule für Bildende Künste, Hamburg. From **1976** Professor at the Staatliche Kunstakademie, Düsseldorf. **1990** German contribution to the Venice Biennale, with Hilla Becher. Bernd and Hilla Becher have lived in Düsseldorf and in Munich since 1989. **2004** Large retrospective in Düsseldorf and Munich.

Diane Arbus

Boy with a Straw Hat Waiting to March
in a Pro-War Parade, N.Y.C. 1967

Less a street photographer than a transactional, environmental portraitist who often used the street as a setting for her work, Diane Arbus faced her subjects head on, usually at close range, and always asked their permission before photographing. Thus these are not surreptitious, "candid" sketches but collaborations reflecting the conscious relationship between photographer, camera, and subject.

Arbus frequently photographed children and adolescents, with a keen eye for their awkward and painful efforts to anticipate adulthood and fit themselves into its often constricting roles. This boy, with his fixed, adamant, and angry stare through the lens at us, seems curiously time-displaced. He is an American teenager, after all, in 1967—the heyday of "sex, drugs, and rock 'n' roll," the historical moment of the international hippie movement, the Summer of Love, and widespread opposition by members of his generation to the ill-conceived and increasingly unpopular war in Vietnam.

Yet he has not only decorated himself with symbols declaring his opposition to all that but has gone further, to garb himself as a defiant throwback to another era: the straw boater, the white shirt and jacket, the bow tie, the short-cropped hair, all speak of an earlier day and a previous war, when mindless flag-waving and naïve patriotism were all the rage. Everything seems slightly too large for him; he has yet to grow into it all. It is as if he is wearing his father's clothing, and his father's attitudes and politics as well.

Though he was undoubtedly surrounded by others, part of the crowd watching the parade or even a marcher in it, Arbus has photographed him as if no one else was around, isolating him from his immediate context—just as he has cut himself off from the behaviors and tendencies of his cohort. Her use of on-camera flash freezes his hostile glare at her—while also registering every detail of of his face, clothing, and accoutrements. This has the effect of emphasizing his protruding ears, which remind us poignantly of his immaturity, becoming what Roland Barthes dubbed the "punctum," the telling detail, of the image.

A.D.C.

1923 Born Diane Nemerov in New York. 1941 Marries photographer Allan Arbus. Initially works as his assistant, then until 1971 photographer for *Harper's Bazaar*, *Show*, *Esquire*, *Glamour*, and *The New York Times*. 1955–59 Studies under Lisette Model at the New School for Social Research, New York. 1965–71 Teaches photography at Parsons School of Design, New York, in 1968–69 at Cooper Union for the Advancement of Science and Art, New York, and 1970–71 at the Rhode Island School of Design, Providence. 1971 Dies in New York.

Further Reading: *Diane Arbus. An Aperture Monograph*. New York, 1972.

Will McBride

1968 was a year unlike any other. In West Germany, the genera-
tional conflict that had already been simmering for ages was
vented in violent clashes with the organs of the state. In France,
students and workers became allies in protest against the conser-
vative regime of an authoritarian general. At the same time, in
Prague, Soviet tanks plowed down budding hopes for a socialist
"spring" following the cold winter of Stalinism. One of the sym-
pathetic photographers of the events of that year was Will
McBride, trained as a painter, a student of the precise "realist"
Norman Rockwell. In February 1953, McBride arrived in Ger-
many as a GI and was fascinated by the country's "gray tones …
which I had never seen in my thoroughly glittering homeland."
He was immediately successful as a photographer in the magazine
trade. Yet his aesthetic interest lay neither in documentation nor
in reportage. He introduced a new tone to photography, and his
photos are more strongly colored by personal experience than
by the objective appearance of his subjects. McBride restricted
himself to interior views of a German reality in which the con-
flict between the generations was gradually taking shape, seek-
ing its expression in unconventional clothing, existentialist
affectations, and rebelliousness against the bigoted suppression
of sexual pleasure. His pictures convey atmospheres and feelings
rather than facts. His strength lay in sequences of pictures,
subtle photographic essays which unfolded through individual
stages. In 1968, he photographed the cast of the successful Mu-
nich production of the musical *Hair,* in cardboard boxes. Several
versions of the central image of the sequence exist. Usually it is
cropped on the right and left, reducing the distance between the
sixteen male and female actors (including two children) and the
viewer. In the cardboard boxes, which are open at the front,
piled two or three stories high, representing something like the
cross-section of a profit-greedy apartment house, the naked
actors sit, crouch, and huddle, either alone or in twos. The photo-
graph reduces the myth of 1968 to an optical metaphor of a contra-
dictory nature: on the one hand, the demonstrative proclamation
of freedom and independence, but on the other, a depressing
testimony of homelessness, separation, and physical confinement.
Perhaps the decisive experience lies in the failure of the high-
spirited dreams of the past. K.H.

1931 Born in St. Louis, Missouri. **1948–50** Studies English at the University of Vermont; private
student of Norman Rockwell. **1950–51** Studies painting at the National Academy of Design, New
York. **1951–53** Studies art history, painting, and illustration at Syracuse University, New York.
1953–54 Serves in the U.S. Army, stationed in Würzburg; first photographic works. **1955–58**
Moves to Munich, then Berlin. Studies philosophy, painting, and photography. **1959–61** Free-
lance photographer in Berlin, from 1961 in Munich. Picture essays and reportages for *Twen,
Quick, Geo, Stern, Life, Look,* and *Paris Match.* **1965** Guest lecturer at the Hochschule für
Gestaltung in Ulm. **1972** Moves to Casoli, Italy. **1983** Returns to Germany. Establishes photo
studio in Frankfurt am Main. Lives in Frankfurt.

Further Reading: Weiermair, Peter (ed.). *Will McBride. 40 Jahre Fotografie.* Schaffhausen / Zurich /
Frankfurt / Düsseldorf, 1992.

Robert Häusser was the first postwar photographer who received recognition in artistic circles as early as the 1960s. He rapidly became aware of the danger that photography in Germany might become isolated and sought ways of eliminating the separation between art and artistic photography. Thus he turned away from thematic orientation and more toward artistic techniques.

Bicyclist, 1953

The constant factor in his work was the magic of things. Typical of this is *J.R. 5–9–70*, which shows a cult object, the racing car, brought out through hard contrasts as a simple form, a fetish of the twentieth century. The fact that this object is wrapped increases the intensity of the impression. However, it also demonstrates the ambivalent feelings towards the event to which the enigmatic title of the photo refers: the death of the Austrian race-car driver Jochen Rindt on September 5, 1970, in Monza.

Through camera positioning and lighting, Häusser succeeded in seeing simple things in a new way, isolating individual objects within a picture and, so to speak, investing them with significance. Magic Realism has been mentioned in connection with Häusser's work, but his art could also characterized art as photographic symbolism in continuation of nineteenth-century tradition. Certainly, part of this comes from a share of the romantic, which in him—a former farmer—is not without an earthy foundation.

Whether from his "bright period" (1953-55) or from other phases, all his pictures are typified by a certain morbidity and, faced with his self-portrait, any doubt about his tendency to yearn for death vanishes. Häusser's interest in farm life was expressed in his early pictures of freshly plowed fields, but particularly in the series on home-slaughtering, a photographic narrative in six pictures. In later work he turned more frequently to the pictorial sequence, using it to document his interest in formal pictorial solutions, but also in conceptual work. He became increasingly interested in political themes and in borderline situations such as loneliness, desolation, doubt, and death. However, the politics of the day did not enter into Häusser's art. His pictures never arose out of the moment but from long observation, from analysis. As far as he was concerned, contemporary criticism was not a confrontation with the political and social realities of the day, but instead with people and situations. R.M.

1924 Born in Stuttgart. Trains as a press photographer, later apprentices as a photographer. **1942–46** War and prisoner of war. **1946–52** Works on his parents' farm in Mark Brandenburg, East Germany. Pictures of the rural world. **1950** Studies at the Kunstschule Weimar under Walter Hege. Exhibition at "photokina" in Cologne. Appointed to the refounded West German Gesellschaft Deutscher Lichtbildner. Particpates in many exhibitions in the West. **1952** Growing discrimination owing to his contacts with the West; gives up the farm, flees to West Germany and establishes business as photographer in Mannheim. Commissions from publishing houses and corporations, in many countries in Europe, South America, the U.S. and East Asia. Publishes several books of his pictures; many photos also appear in magazines and newspapers. **1980** Gives up studio and commercial photography for artistic, creative work. Solo exhibitions in over sixty museums and galleries in Germany and abroad. Numerous prizes and awards, including from the Hasselbad Foundation.

Further Reading: *Robert Häusser: Photographische Bilder, Werkübersicht der Jahre 1941-1987.* Exh. cat., Württembergischer Kunstverein. Stuttgart. 1988-89.

Roses, 1956

If ever a photographer succeeded in composing a poem with visual tools, Josef Sudek did. A glass of water, an egg, a stone—these were all he needed for what he called "a simple still life." Everything else was done by the light. Sudek's "poems" are modulations of light on simple and utterly commonplace themes; not over-ornate poetry, but prose using the shortest words. One German term for photographer—*Lichtbildner* (literally, sculptor of light)—is particularly appropriate as applied

to Sudek. All his work is permeated by a receptive-ness to the finest nuances of light which touches on the supernatural. "He wrestled with the light like Jacob with the angel," Jaroslav Seifert once noted.

Sudek's photographic oeuvre is a hermetic world, the creation not of a widely traveled person but of a man who found strength in restricting himself to a few places, ultimately to one place—Prague. Most of his pictures were, in fact, produced either in the studio or during walks not far away. He had a masterly under-standing of how to invest the apparently marginal with significance, of making the ordinary mysterious.

A Walk in the Magic Garden shows an apparently casual, but nevertheless carefully thought-out arrange-ment of garden furniture on a lawn. A white cup on the table and the discarded summer hat give the impres-sion that guests cannot be far away. At the same time, however, the arrangement of the chairs hints at some-thing out of the ordinary; a suggestion of a surreal situ-ation, the unreality of which is enhanced by the atmos-phere of the light, equivalent to either dawn or dusk. Sudek produced variations on the "magic garden" theme in several works taken in his architect friend Otto Rothmayer's garden. Characteristic in this picture, among other things, is the fact that Sudek dispenses with refined accessories such as sculptures or stone globes and limits himself to simple garden equipment in setting the scene. He has included a chair of the latest type (right rear) among somewhat older designs, a choice that makes a considerable contribution to the "romantic" character of the picture. P. S.

1896 Born in Kolín, Bohemia. **1908–10** Attends the Royal Technical College in Kutná Hora. Starts working in photography. **1910–13** Trains as a bookbinder. **1920–22** Amateur photographer, member of Czech Photo Amateur Club (CKFA), Prague. **1922–24** Classes with Prof. Karel Novák at State Graphic Arts College in Prague. **1922** Founding member of the Prague Photo Club; excluded in 1924. **1924** Founding member of the Czech Photographic Society. **1927** Opens a studio in the center of Prague. **1930s** Collaboration with the publisher Druzstevní Práce and on the art association Mánes' journal, *Volné směry*. Establishes the Sudek Gallery for Fine Artists. From **c. 1947** Works with panoramic camera (10 x 30 cm); book project *Prag als Panorama* (Prague as panorama). **1956** Publication of first monograph, with 232 intaglio reproductions. **1976** Dies in Prague.

Further Reading: Farova, Anna. *Josef Sudek: Poet of Prague.* New York, 1990.

One year before he recorded this scene, Josef Koudelka had decided to give up his career as an aircraft engineer and devote himself entirely to photography. Just thirty years old, he had been awarded a prize for his theater photographs by the Czechoslovakian Artists' Association. In that fateful year of 1968—the "Prague Spring," the occupation by Warsaw Pact troops—Koudelka was still living in his native land, but two years later he went into exile in England, then France, and after that was stateless for almost two decades.

The picture of the winged boy was included in 1988 in his volume *Exiles*, containing a total of sixty-one photos. Together with two pictures from Romania and a further one from Czechoslovakia, it was among the earliest works in this series. As a quote from Victor Hugo in it states: "Exile is not a material thing, it is a spiritual thing…. And anywhere one can dream is good, providing the place is obscure, and the horizon is vast."

In *Exiles,* Koudelka included pictures from almost every country that he had visited—England, Ireland, Scotland, southern Europe, Turkey, even one from the United States. At first glance, it looks almost as though he had intended, if only vaguely, to characterize the inhabitants of the countries of Europe in emulation of his colleague at Magnum, Henri Cartier-Bresson. Yet the creator of this picture had other things on his mind: optical and psychological irritations, the experiencing of almost Kafkaesque alienation, enigmatic moments, and phenomenal occurrences within the apparently ordinary. In view of all the associations invoked by the term, *Exiles* is a collection of experiences of the magical, of consciousness of another dimension. People, animals, and objects appear to be equally affected by it. Almost all the photographs take a turn toward the surreal. Koudelka's art could be characterized as "fotografia metafisica."

The unreal in the opposite picture is taking place in broad daylight in a village street, in the form of a white-robed cyclist wearing sneakers and wings. As far as we can see, it is not the right season for a Christmas nativity play. Has he perhaps dressed up for a masquerade party, or for a part in a school drama? He has come to a halt and is leaning apprehensively against a wooden wall, his eyes lowered before the figure of authority, with a horse-drawn cart beside him. The melancholy that overcasts this scene and which is prevalent in Koudelka's work is also partly due to the socialist dreariness that reigned for decades in the Eastern Bloc. Angels, denied by the official atheism of the Communist Party, would have seemed to be—in a double sense—messengers from another world. Koudelka deliberately did not provide the picture with any further explanation, other than indicating the country, in order to lend the viewer's imagination wings and let it soar all the more freely. P.S.

1938 Born in Boscovice, Moravia. **1952** Takes first photographs. **1956–61** Studies aircraft construction at the Technical University, Prague. **1961–67** Works as aeronautics engineer in Prague. **1961–65** Active as a freelance photographer for the theater magazine *Divadlo.* **1965–70** Official photographer for the Theatre za Branou, Prague. Member of the Society of Czechoslovakian Artists. **1968** Documents the occupation of Czechoslovakia by Soviet troops.

1970 Emigrates to London. **1971–80** Freelance photographer with the photo agency Magnum, Paris and New York; lives in London. **1975** Solo exhibition at the Museum of Modern Art, New York. **1977** Major traveling exhibition in Europe. Living in Paris since **1980**.

Further Reading: Koudelka, Josef. *Exiles.* New York. 1988/89.

Dying Bull, Nîmes, 1976

The *Nus de la mer*, nudes lapped by swirling surf on the beaches of the Camargue, that made the French photographer Lucien Clergue famous, were originally part of a series of photographs on the theme of flotsam and jetsam. On cold sandbanks and amid jumbled piles of driftwood, he photographed the skeletal remains of cats and fish, of flamingoes and other birds. Amid the debris and the salt encrusted sands he found a world of bizarre structures and textures that photography had not yet explored. Clergue portrayed the coast of Provence as a sea-fringed cemetery in which forms are at the mercy of the elements and the process of decay.

In 1960, the *Nus de la Mer* appeared in one of his early photo books, *Poesie Photographique*, among images of dead animals and the rock-hewn tombs of the Abbaye de Montmajour near Arles. These followed on from his series of *Saltimbanques*, photographs of young acrobats and theatre performers in the ruins of war-ravaged Arles, the facades of crumbling houses, the life of the gypsies, scrap-yards. His melancholy black-and-white world, redolent of Italian neorealismo films, echo the sadness of Clergue's personal life at the time, working in a factory and caring for his terminally ill mother.

The female nudes stretched out in the foaming waters were not sensual sea-goddesses or Aphrodites, but figures defiantly surviving the world of death. In Clergue's photographs of the bullfight, this treshold has already frequently been passed. Clergue had recently become part of the circle around Picasso and Jean Cocteau and, encouraged and inspired by his artist friends, he took an exacting approach to photography. The gloomy existentialism of his early work gave way to the impassioned pursuit of nude photography, a field in which he was to become a leading and influential figure. His photographs of young women were soon imbued with a new radiance, beauty and eroticism. Clergue's concession to French law was to protect the anonymity of his models by not showing their faces. In the resulting concentration of sheer physical presence, Clergue's Nereids become metaphors of *luxe et volupté*, of pure joy in the borderland between the world of water and terra firma. P.S.

Born in Arles in **1934**. First published photographs in the daily newspaper *Le provençal* in **1953**, the year he met his close lifelong friend Picasso, and also created his series of dead animals on the beach. *Nus de la Mer* begun in **1956**. Paul Eluard's *Corps mémorable* with photos by Clergue published in **1957**. Solo exhibition at Kunstgewerbemuseum Zürich in **1958**. Freelance photographer from **1959**. Exhibited at the Museum of Modern Art, New York (with Bill Brandt and Yashuhiro Ishimoto) in **1961** at the invitation of Steichen. *Toros muertos* with texts by J.Cocteau and J.-M.Magnan published in **1962**. *Naissance d'Aphrodite* published in Paris in **1963**. The film *Le Drame du taureau* was made in **1965**, followed in **1966** by the films *Picasso, Guerre, Amour et Paix, Née de la vague*. In **1969** he was co-founder of the Rencontres Internationales de la Photographie in Arles. In the **1970**s he began working with colour photography. In **1975** he created his first nudes in an urban setting. In **1979** he received a doctorate in photography from the University of Marseille. From **1981** he created his series of *Surimpressions* with superimposed reproductions of paintings and bullfight scenes etc. *Picasso. Mon ami* published in **1993**.

For further reading: Eva-Monika Turck, *Lucien Clergue – Poésie photographique*, Munich/Berlin/London/New York 2003

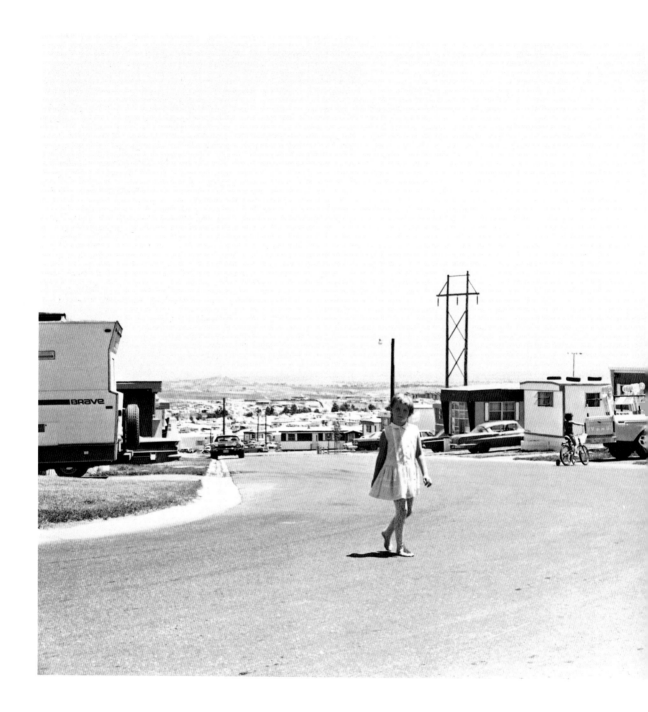

Robert Adams

Robert Adams's photography can be described as contemplative. Unlike photojournalism or editorial magazine photographs that must quickly grab a reader's attention, Adams' photographs are made for those willing to adjust to his considered pace. His pictures are quiet, unassuming, and utterly respectful of his subjects: urban and rural landscapes in the western United States. An ardent conservationist, he has been motivated, in part, by man's mismanagement of these vast lands. Yet his photographs neither preach nor reminisce. Avoiding the tradition of heroic landscapes, he has instead chosen more subtle, intimate, and human-scale views of mountains, prairies, and waterways, as well as of settlements and cities. He seeks to see with "normal vision." Adams began photographing in Colorado, where he lived for over forty years. His work came into prominence with the publication in 1974 of the book *The New West: Landscapes Along the Colorado Front Range*. Shortly thereafter, his work was included in the benchmark exhibition, *New Topographics: Photographs of Man—Altered Landscape*. Using the same large-format cameras as traditional landscape photographers, the artists in *New Topographics* explored instead the relationship between man and nature. Adams and the other photographers looked at the incessant construction on what used to be free and open spaces; their subjects included roadways, tract homes, shopping centers, and trailer parks. Often, the human-scale elements appear slight and fragile under the vast western skies. In the series *Photographs of the American West,* Adams poses the question of what would be if those skies were contaminated by nuclear fallout. More than the other New West photographers, Adams also notices the plants that persist, those that grow around the concrete and evade the bulldozer. In addition, he photographs well-crafted structures as often as the travesties of good design. He patiently locates beauty where others find only the banal. Beauty is a cause for reverence. He unabashedly admires its existence, and manifests his veneration in the quality of light that suffuses his pictures. Even photographs taken at night emit light, as if from within the print itself. Never overtly dramatic, the prints possess an even, eloquent, silver radiance. A. W. T.

1937 Born in Orange, New Jersey. **1955–59** Studies at the University of Redlands, California. **1959** Bachelor of Arts in English. **1965** Awarded doctorate in English from the University of Southern California, Los Angeles. **1962–70** Lecturer and assistant professor of English at Colorado College, Colorado Springs. From **1967** Freelance photographer and writer. **1971** First solo exhibition at the Colorado Springs Fine Arts Center. **1977** Publication of the series *Denver: A Photographic Survey of the Metropolitan Area*. Lives in Colorado.

Further Reading: Adams, Robert. *What We Bought: The New World, Scenes from the Denver Metropolitan Area 1970–1974.* Published by the Stiftung Niedersachsen. Exh. cat., Sprengel Museum, Hanover, 1995. Adams, Robert. *Beauty in Photography: Essays in Defense of Traditional Values.* 1981. Adams, Robert. *Why People Photograph.* 1994.

William Eggleston

If any photographer's work invited the naive response, "my kid could do that," it might be William Eggleston's photographs. His photograph of a tricycle that graced the cover of his first book, *William Eggleston's Guide* (1976), was taken from the eye level of a very small child. But it is not just the perspectives in his photographs that invite the comparison. Rather, the accessibility of the scenes in his pictures intimates that anyone, even a child, could have noticed the same views. Eggleston's pictures possess the seeming simplicity of snapshots. However, a child is unlikely to think to record something as ordinary as a kitchen table, complete with industrial-size condiment bottles, and a supply cupboard (opposite). Nor would a child catch the visual link between white bleach bottles discarded on a dusty road and puffy, summer clouds drifting over a flat horizon. No child would understand the shared-but-unequal lives implied in the identical hands-in-the-pocket stances of two men—one white, one black; one in a suit and one in a uniform. Anyone born in the rural South where Eggleston works is familiar with his subjects. However, no one else, adult or child, has thought to photograph this world, and not in this illuminating way. Eggleston does not attempt to varnish, polish, clean up, or otherwise beautify his world. He isolates the most basic components, including a meal, tracks in a dirt road, ordinary pets, a side porch, unpainted columns, an ancient truck, and an old-fashioned gas station. The unsentimental directness of Eggleston's gaze results in pictures that, in turn, invite us to gaze and to consider. We see details that we might otherwise have overlooked and whose importance we might have slighted. One can build a deep understanding of these places and of this culture with these distinct parts. His approach is literary without being narrative. He learned his style and refined his vision by reading Southern writers, such as William Faulkner and Eudora Welty, and by looking at the photographs of Walker Evans (see p. 72). Like his mentors, he respects what is daily and trusts the ordinary moments to reveal life's indecipherable complexities.

A.W.T.

1939 Born in Memphis, Tennessee. **1957** First camera (Canon rangefinder); in **1958** first Leica. From **1962** Freelance photographer in Washington and Memphis. **1965** First attempts with color slide film. **1967** Turns to color negative film. Moves to New York. Meets Garry Winogrand, Lee Friedlander, and Diane Arbus. **1974** Lecturer in visual and environmental studies at the Carpenter Center, Harvard University, Cambridge, Massachusetts. **1976** Solo exhibition at the Museum of Modern Art, New York, with accompanying publication, *William Eggleston's Guide*. Photo commission for *Rolling Stone*. **1978–79** Researches into color video at the Massachusetts Institute of Technology, Cambridge. Photography in the Gulf States on behalf of A.T.T. **1980–90** Journey to Kenya with Caldecot Chubb: *The Louisiana Project*. **1982** Takes photographs during the scene construction for John Huston's film *Annie*. **1983** Photographs the series *Kiss Me Kracow* in Berlin, Salzburg, and Graz. **1986** Commissioned to photograph shooting of the film *True Stories* by David Byrne. **1988** Trip to England, resulting in the series *English Rose*. **1989** Publication of *The Democratic Forest*, New York and London. **1990** Journey to Spain. **1998** Receives Hasselblad Prize, Göteborg (Sweden). Lives in Memphis, Tennessee.

Further Reading: *William Eggleston: Ancient and Modern*. New York, 1992.

Joel Meyerowitz

Even though mastering black and white has always demanded great proficiency from the photographer, color photography has turned out to be an even more difficult discipline. In the history of photography, color masterpieces are comparatively few in number. In more recent times, William Eggleston (see p. 170), Franco Fontana, and Joel Meyerowitz in particular have succeeded in getting a creative grip on color—Eggleston by confronting the lens with intensive color situations, Meyerowitz by careful selection of subjects whose "colorfulness" is naturally subdued. The coast, people on the beach, and objects in the shadows are among his preferred subjects, along with portraits. Waiting for dusk or "bad" weather also allows him to perceive the intrinsic value of colors, their "noise," ready filtered.

In *Vivian*, taken in Provincetown, Massachusetts, the main figure has her back turned to us and her arms folded behind her. She gazes out over the open sea. Her red bathing suit, highlighted by the sun's rays, complements the bluish-green of the middle ground, which merges into a silvery blue-gray in the upper half of the picture. The few boats—parallel to the lower edge—lie peacefully at anchor, furthering the contemplative atmosphere. The degree of consistency with which the photo is constructed is revealed in one detail: the top of Vivian's head, her impending departure, should she take a step forward, meets with the fine line of the horizon. The photograph was taken with a cumbersome, large-format (20 × 25 cm) camera, using a telephoto lens to foreshorten perspective.

Caspar David Friedrich's painting *Monk by the Sea* (1808–10) is the romantic prototype for this image: the solitary human figure immersed in contemplation of infinite nature. Meyerowitz has produced a kind of secularized photographic variation, modernized to take in the facts of international summer vacations and female equality. Even if it less charged with metaphysics, for the American photographer, too, the sea is an object of inner contemplation. The qualities of equilibrium and composure, as Vivian (Meyerowitz's wife at the time) may be experiencing them, are also imparted to the viewer of this photo via its austerity of form and coherence of structure. The ocean panorama becomes a psychological sounding-board.

The majority of Meyerowitz's pictures, especially those featuring many figures, are carefully staged and have greatly contributed to the popularity of *mise en scène* photography.

P.S.

1938 Born in New York. **1956–59** Studies painting and medical drawing at Ohio State University, Columbus. **1959** Bachelor of Fine Arts. Self-taught in photography. **1959–63** Works as art director in advertising. From **1963** Freelance photographer. **1966** Solo exhibition at the International Museum of Photography, George Eastman House, Rochester, New York. **1971–79** Lecturer in photography; **1977** Mellon Lecturer at Cooper Union for the Advancement of Science and Art, New York. From **1977** Extraordinary Professor of Photography at Princeton University, New Jersey.

Further Reading: Meyerowitz, Joel. *Cape Light: Color Photographs by Joel Meyerowitz*. Boston, 1991.

Cindy Sherman

The young woman, her hair cut short under the knit cap, looks out sceptically at the city skyscrapers, her mouth slightly open with astonishment. Behind her, the gigantic buildings tower into the sky, filling almost the entire background of the picture, taken from a markedly low angle. The open Byronic collar, indeed her clothing in general, as far as it is visible, seems unlike that of a city dweller and lend the model a certain vulnerability and sense of displacement. The angle of her eyes follows the camera perspective. They are directed upward and to our right, toward the vertiginous towers of urban architecture which surround her. The viewer's attention is thus drawn away from the model and toward the context in which she finds herself. The narrative crux of the picture is clear; there is no doubt that a story is being told here. The title explains it: *Untitled Film Still*. It refers not to a specific story but to a specific medium, cinema, which tells variations of the same stories over and over again.

Cindy Sherman made her debut on the art scene with the remarkable series *Untitled Film Stills*, of which this is number twenty-one. She herself plays the role of the young woman, as played by countless actresses in the American genre cinema. But the picture says little as a portrait, and still less as a self-portrait. This is no selected personality that is presented here but somebody playing a role, a role which, as always in the cinema, reflects a social pattern, a widespread perception of the role of women in society. It deals with the power of the modern mass media to influence perception and thus, simultaneously, social existence.

For many years, the images of women's roles past and present, as well as the subliminal influence they exert on the individual in a media society, have constituted the central theme in Cindy Sherman's work.

K.H.

1954 Born in Glen Ridge, New Jersey. **1972–76** Studies painting and photography at State University College of New York in Buffalo; Bachelor of Arts in 1976. **1974–77** Works at Hallwalls Gallery; first solo exhibition there in 1979. **1977** Moves to New York City. Up to 1980, first series of *Untitled Film Stills*. From **1980** Exhibitions at the Metro Pictures Gallery, New York. **1982** First European traveling exhibition mounted by the Stedelijk Museum, Amsterdam. Participation in "documenta 7," Kassel, and the Venice Biennale. **1983** First major traveling exhibition through the U.S.A. **1984** Participates in the 5th Biennale in Sydney. **1987** First retrospective in the form of a traveling exhibition, including Whitney Museum of American Art, New York. **1990** Publication of *Untitled Film Stills* in New York and Munich; also publication there in 1991 of the series *History Portraits*. **1991** *Vomit* and *Civil War Series* are the first series in which she herself does not appear. **1995** First Cibachrome prints and processing of negatives, influenced by early Surrealist photography. Lives in New York.

Further Reading: *Cindy Sherman*. New York/Chicago/Los Angeles: 1997. *Cindy Sherman: Photoarbeiten 1975–1995*. Exh. cat., Deichtorhallen Hamburg, Malmö Konsthall, Kunstmuseum Luzern. Munich/Paris/London. 1995.

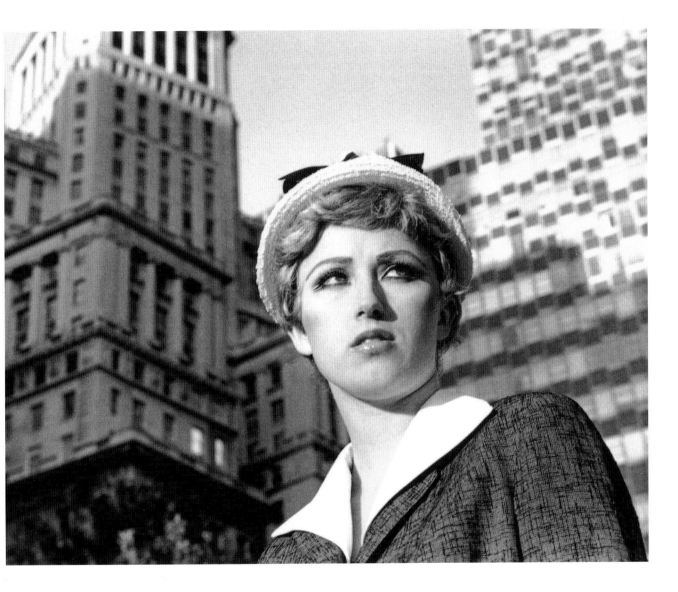

No other artist of the twentieth century has dealt so clearly with perception as David Hockney. Whatever influence Picasso and Cubism had on him in theory, Hockney remained a man of the eye, an artist for whom art has to do with pleasure in colors, shapes, and painting. At a time when it was considered chic in the art world to be aloof, incomprehensible, or ambiguous, his art was considered by critics to be superficial and "too beautiful." For many years, this hindered perception of the innovative approach of his work. Hockney wrested back themes for the visual arts that had long been considered the domain of photography, painters having relinquished them because they thought they were gaining freedom by giving up the obligation to reproduce reality.

In emulation of the Cubist Picasso, Hockney established a relationship between painted and photographed images and our manner of perception. Over the course of two decades, he developed new approaches to confronting reality and portraying its perception by exchanging his experiences with both media. He replaced the central perspective of photography by a collage-type composition made up of a multitude of moments recorded photographically. In place of the static landscape image, he put our experience of landscape in motion by driving through it in a car, as a composition of individual moments of memory. From the analysis of perception developed the representation of subjective memory, based not just on its contents but also on the act of remembering. Finally, Hockney included in his collages not only his own movement and the time that had simultaneously elapsed, but also the opposite movement. Photo-collage allowed him to record people not as lifeless, static, visual objects but as living beings moving through time. This processual perspective, already practiced in the Middle Ages, dissolves space as a static construct and rediscovers it as a field of action.

The Skater is the fourth collage (the others are Diver and the two portraits of Gregory Walking, once in the picture plane and once advancing toward the viewer) in which Hockney made movement itself the subject matter. In other collages, such as Serving Tea in the Garden, Henry Moore, or Photographing Annie Leibovitz While She Is Photographing Me, movement has indeed been recorded, since the people have moved during the long process of taking the photographs, but movement as such is not the theme. The Skater is the only collage in which the rotations of a human body are recorded so that all the details of movement appear as "facets," including the individual phases of motion of the arms and legs. The picture was used as a poster for the 1984 Olympic Winter Games in Sarajevo and has become one of Hockney's best known images. R.M.

1937 Born in Bradford, England. Representative of British Pop art. From 1953 Studies at Bradford College of Art. 1959–62 Studies at the Royal College of Art in London. Meets R.B. Kitaj, Allen Jones, and Peter Phillips. From 1961 Produces photographs as well as paintings and graphic art. 1962 Teaches at Maidstone School, London. 1963 First solo exhibition at the Kasmin Gallery, London. From 1963 numerous teaching activities at various universities in the U.S.A. 1964 Stays in the U.S.A. 1966 First stage sets and costumes for Alfred Jarry's opera Ubu Roi at the Royal Court Theatre, London. 1968 Studio in Santa Monica, California. Participates in "documenta 4," Kassel. 1969 Guest professor at the Hochschule für Bildende Künste, Hamburg. 1970 First retrospective, organized by the Whitechapel Art Gallery, London (traveling exhibition). 1972 Photography increasingly important. 1973–77 Lives in Paris. 1975 Stage sets and costumes for The Rake's Progress at Glyndebourne. Publication of autobiography David Hockney by David Hockney. 1981 Exhibition Looking at Pictures in a Room at the National Gallery, London, with accompanying publication. 1982–84 Photocollages and Polaroid collages. 1985–89 Experiments with color photocopier and colored computer graphics. 1985 Commission for French Vogue. 1988–89 Works produced with fax machine. 1990–91 Works with computer drawing, camera, and color laser printer; series L.A. Visitors. 1992 Honorary doctorate from the Royal College of Art, London. 1995 Honorary doctorate from the University of Oxford. Lives in London and Los Angeles.

Further Reading: Melia, Paul and Luckhardt, Ulrich. David Hockney. Paintings. Munich/New York, 1994. Misselbeck, Reinhold (ed.). David Hockney: Retrospective-Photoworks. Exh. cat., Museum Ludwig, Cologne. Heidelberg, 1998.

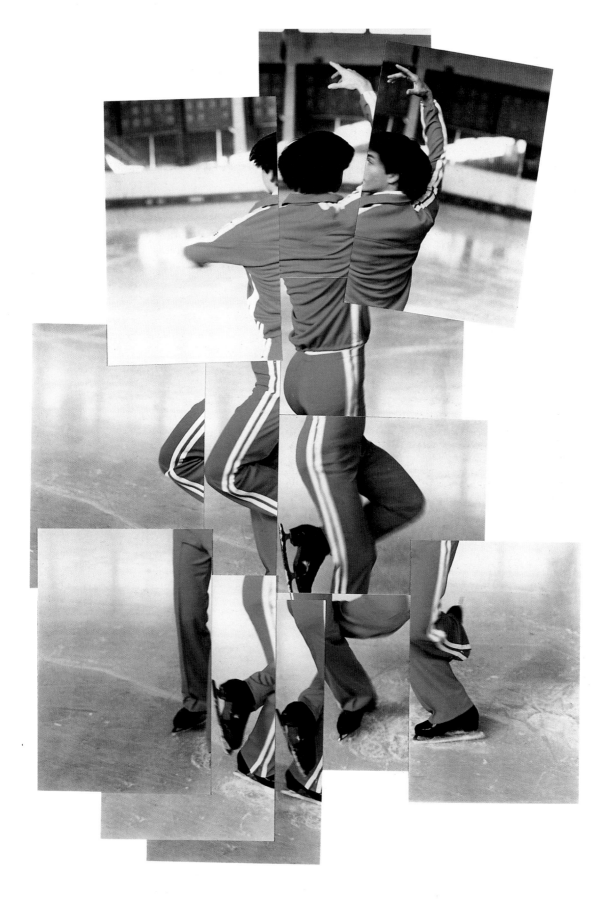

Helmut Newton

They're Coming! Four tall young women march in a phalanx formation from the back of the picture towards the front, obviously as unstoppable as they are self-aware and self-confident. Taken from a slightly low angle, they appear monumental, invested with irresistible power. Helmut Newton is the male photographic harbinger of women as the strong sex. Wearing nothing but high-heeled shoes, they advance in two rows, the ones in the back row with their hands casually propped on their hips. They look through, or past, the viewer, which serves only to increase the suggestive power that emanates from them; they appear to be completely unconcerned, and nothing can stop them. In a similar photo with identical choreography, the women wear elegant suits but, in a strange way, seem more powerful in the unclothed version.

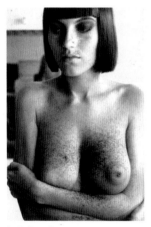

Arielle After a Haircut, 1982

In retrospect, the once highly controversial photographer turns out to have been a prophet. At least his claim to be a good observer has received triumphant confirmation. Earlier objections that he degraded women into objects of sexual desire have turned out to be short-sighted. His photos were never copies of the visible but evidence of an obsessive perception that fed on subjective experiences and observations, buried memories and erotic desires, collective repressions and taboo cravings, unspoken urges and fears. A world all its own is manifest in the polished poses of Newton's models, in his careful selection of locations and objects, in the contrast-rich lighting drawn from *pittura metafisica* and the American *film noir,* in his absolute control of staging. Fluctuating emotions, the interwoven patterns of social and psychological feelings, longings, and needs create an autonomous aesthetic reality.

Frequently, however, there is melancholy lurking below the glamour of Newton's photographic universe. A radiant beauty, eyes turned inward, displays herself with a hairy chest (opposite). Her arms—also hairy—are folded below her swelling bosom. Is she being presented to the curious public as an exotic oddity, as was commonly the case in earlier times at carnivals and circuses? Only the title of the picture, *Arielle After a Haircut*, provides an answer to the riddle. Hair is associated with the animal aspects of mankind; Georges Bataille interpreted eyes and hair as synonyms of sexuality, and Newton certainly touches on this here. He is the photographer who elevated the pleasure of seeing and of being seen into a subject for photography. K.H.

1920 Born in Berlin. **1932** Receives his first camera. **1937–38** Trains with the photographer Yva in Berlin. **1938–40** Works in a studio for fashion and theatrical photography in Berlin. **1940** Moves to Australia; freelance photographer in Sydney. **1942–45** War service in the Australian Army. **1954** Active for Australian *Vogue.* **1956** Moves to London, where he works for British *Vogue.*

1957 Works for *Jardin des Modes.* From **1958** Regular contributions to *Queen, Nova, Vogue, Elle, Marie Claire,* and *Linea Italiana.* Today primarily active for *Stern* and *Vogue.* Since **1981** Lived in Monte Carlo. **2004** Dies in Los Angeles. Opening of Helmut Newton Foundation in Berlin.

Further Reading: *The Best of Helmut Newton.* New York, 1996. Newton, Helmut. *Aus dem photographischen Werk.* Munich, 1993.

Even if in fragmentary form, the ideals of antiquity have always remained alive in Western culture, invoked time and again in movements of renaissance and classicism. This untitled nude by Robert Mapplethorpe provides eloquent testimony of this, as well as of the way in which such ideals continue to have echoes in the modern world of the media. The square photograph is divided up according to the "golden section": a naked male torso in profile, on the left with his forearm, turned in the plane, with hand open and fingers spread; on the right, light, rich in contrasts, falls on the genitals, thigh, and lower abdomen, with shimmering reflections that emphasize the surface of the skin, whereas the arm and hand on the other side have a silhouette-like effect and give the picture almost the character of a photogram. Although Mapplethorpe plays up the contrasts sharply, the photo does not fall apart; rather, there is a subtly balanced equilibrium between light and shade. Mapplethorpe was a master in the use of light. Sam Wagstaff, his mentor and friend, later a victim of the same pernicious disease that killed Mapplethorpe, said that the latter allowed himself only one trick: the "drama of light." This was the source from which he drew "tension bordering on the paradoxical" (Arthur C. Danto). Light blends into an aesthetic unity the extreme contrasts, the polarities of physical strength and clear spirituality, hardness and softness, beauty and transience, sexual lust and immaculate purity, aggression and restraint, the natural and the artificial.

Mapplethorpe was no innovator, either in photography or in art, more a classicist with manneristic tendencies—or perhaps a mannerist with a pronounced bias toward classicism. Thus his pictures display the resolve toward a visual style. He valued symmetry. The use of the "golden section" was an exception; usually his motifs are placed in the center on the pictorial axis, frequently turned to face the viewer. And yet, in his work, form is never an end in itself. What is shown is transcended in the aesthetic form, even when what is shown is "obscene." At times Mapplethorpe overstepped the limits—but he still preserved form. He threw light on the most animal element in human nature and spiritualized it in its aesthetic reflection through light. Eros and Thanatos are the themes around which his pictures revolve, regardless of genre, whether nudes, portraits, or still lifes with those beguiling flowers of barely veiled sexual intensity. K.H.

1946 Born in Queens, New York. **1963–69** Studies art and advertising design at the Pratt Institute, Brooklyn. Works on various underground films. **1967** Window-dresser in a children's store in New York. **1968–70** Experiments with collages (initially religious themes, later taken from pornographic magazines). **1969** Designs jewelry. **1971** Involved with photography, self-taught. Works with a Polaroid, favoring self-portraits, erotic scenes, flowers, and portraits. **1972** Collects old photographs. Meets Sam Wagstaff. **1973** Work with large-format Polaroid camera. First solo exhibition *Polaroids* at the Light Gallery, New York. Meets Andy Warhol. **1976** Photography with a Hasselblad; first color photos. Publications in *Interview*. **1977** Participates in "documenta 6," Kassel. **1978** Shoots the black-and-white film *still moving/patti smith*. **1980** Series of portraits and physical studies of the first female world body-building champion, Lisa Lyon. **1983** Publication of *Lady Lisa Lyon*. **1984** Makes the film *Lisa Lyon*. From **1985** Produces platinum prints. **1986** First platinum prints on linen, first photogravures on silk. **1988** Establishment of the Robert Mapplethorpe Foundation for AIDS medical research and support of photography as an art form through photographic institutions and museums. First retrospective at the Whitney Museum of American Art, New York. **1989** Dies from AIDS in New York.

Further Reading: Holborn, Mark and Levas, Dimitri (eds). *Mapplethorpe*. Munich/Paris/London, 1992.

Ralph Gibson learned photography in the United States Navy, studied at the San Francisco Art Institute, and apprenticed to the great documentary photographer Dorothea Lange before moving to New York in 1969. Once there, he began working as a cameraman for another of the key figures in mid-century documentary, the Swiss emigré photographer and filmmaker Robert Frank, while evolving his own distinctive vision in

In Situ, 1988

still photography. Though he worked with a Leica and Kodak Tri-X film, and often photographed in public venues, Gibson's work soon lost almost all traces of its early links to documentary and street photography.

Intensifying contrast and emphasizing the grain of the film in his prints, he began to concentrate on minute details: the edge of a café table, the arc of a hip, the glint of a fork, increasingly seen in extreme close-up—a form of visual microstudy.

This cryptic image, *Infanta*, represents well the surgical precision of Gibson's reductivist style. He gives us the exactly framed right brow, eye, and curved cheek of a woman—just enough to suggest gender and age, and to establish individuality, but hardly sufficient for a portrait: she is unrecognizable here to anyone save the photographer and perhaps would not even recognize herself from this slender piece of evidence.

Gibson's subject looks down and away from his gaze, in avoidance or introspection. She constitutes the only tangible solidity in an otherwise pitch-black void, appearing for all the world like the west coast of some continent photographed from the air or delineated in a cartographer's rendering, this bit of her visage a map to be read. Yet the space is compressed, the photographer's proximity is intimate; this is a lover's-eye view of the beloved, where the territory is intimately familiar and any part stands for the whole. Paradoxically, by isolating carefully selected fragments of the visual surround in this minimalist way, this photographer learned he could heighten both his own and the viewer's consciousness of the complex sign system that underpins contemporary life. Formally rigorous, the results also partake of the sometimes hallucinatory clarity of passages from dreams, with a consistent erotic energy. A.D.C.

1939 Born in Los Angeles. **1956–60** Studies photography during military service in the U.S. Navy. **1960–61** Studies at the San Francisco Art Institute. **1961–62** Assistant to the photographer Dorothea Lange. **1967–68** Assistant to Robert Frank, among other things, on the film *Me and My Brother* in New York. **1969** Moves to New York. Founds Lustrum Press, where he publishes all his own books as well as those of other photographers. **1970** First solo exhibition at the San Francisco Art Institute. **1975** DAAD grant in Berlin. From **1980** Turns to color photography. Lives in New York.

Further Reading: *Ralph Gibson: Women.* Exh. cat., The Boca Raton Museum of Art, 1993.

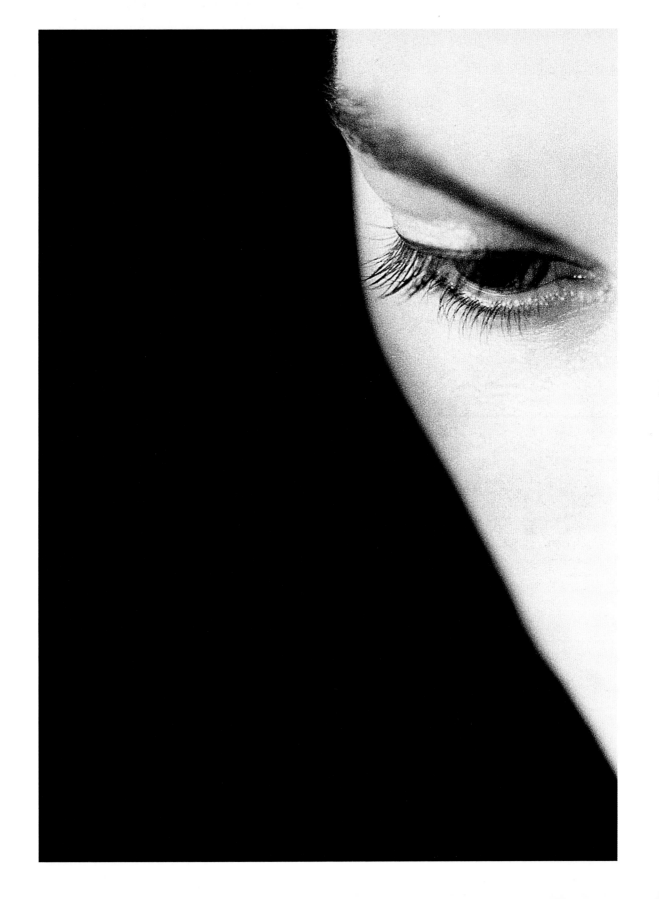

Touhami Ennadre

This photograph of a hand comes from the cycle *Hands, Back, Feet*, produced in Southeast Asia in 1978-82. Touhami Ennadre concentrated primarily on hands in these works, which he reproduced in his preferred large format of 1.5 x 1.3 meters. By isolating them

Trance, 1993–95

against a neutral black, he succeeded in making them monumental, giving the body parts an almost sculptural effect. Mainly, he depicted two hands of different people—old and young—in order to bring out the contrasts in skin texture. The hands of a child clasp the hand of an elderly person; young hands clasp an old hand. In other pictures, Ennadre shows pairs of hands

of old people whose skin has become leathery or papery, weathered by the experiences of a long life. Here it is the extended hand of a mother which is grasped by the tiny hands of her child. Sentimentality and charitable feelings play no role in these images, which are sober statements of fact, and yet considered supremely formal arrangements.

Anyone afraid of ageing or death will find no comfort in Ennadre's photographs. He fearlessly tackles "difficult" themes—from birth, depicted with brutal realism, and the dying process, which starts from this very point, to death itself: as archeologically discernible death in the ruins of Pompeii, as the death of animals in slaughterhouses or in the form of fossils, as the death of a suicide, and as the death of the deaths of the twentieth century—Auschwitz. Even photographic series on the Moroccan city of Fez, the Alhambra, or the paintings of bulls in the caves of Lascaux become, without warning, insights as though into tombs and mausoleums.

His series, *Trance*, of 1993-95, deals with a completely other world, that in-between world of consciousness in which Haitian devotees of Voodoo immerse themselves. The black void in which Ennadre embeds all his subjects corresponds directly with the theme of death, underlies all appearances like a bass note. To speak of morbidity in this context would be to misunderstand the photographer. Ennadre rejects the superficiality and arbitrariness of our visual culture and tunes the palette of his "colors" to a sonorous black, liberating a profusion of values within this asceticism. P.S.

1953 Born in Casablanca. **1961** Family moves to Paris, where he later becomes a French citizen. Receives camera from his mother, which proves decisive for his choice of career. **1976** Awarded the Prix de la critique de la photographie at the Rencontres internationales in Arles. Travels to Indonesia, Singapore, Malaysia, Thailand, Burma, Nepal, and India. **1978** Participates in the exhibition *Tendances actuelles de la photographie en France*, ARC, Musée d'Art Moderne de la Ville de Paris. **1978–82** Produces the series *Hands, Backs, Feet*. **1982–85** Travels to the U.S.A., Canada, Germany, Morocco, Italy, and Sicily. **1984** Annual grant for the Villa Arson, Nice. **1985–90** The series *Herculaneum*. **1986–93** Travels to Japan, Benin, Haiti, and Poland. **1990** Exhibition in the Institut du monde arabe, Paris. **1993–95** The series *Trance*. **1995** Participates

in the exhibition *Vital. Three Contemporary African Artists*, Tate Gallery, Liverpool. **1996** Participates in the exhibition *African Photography. A Triptych*, Solomon R. Guggenheim Museum, New York. **1997** Exhibition at the Havana Biennale and the Johannesburg Biennale. **1998** São Paulo Biennale. Participates in *The Edge of Awareness: Project Art of the World*, Geneva, PS1, New York, and *Art in Freedom*, Museum Boijmans van Beuningen, Rotterdam. **1998** Six-month grant from the AFAA (Association française pour l'action artistique) in the Villa Kujoyama, Kyoto, Japan. **1999** Exhibition at the Maison Européenne de la Photographie, Paris. **2002** Participates in "documenta XI," Kassel. **2004** Shanghai Biennale. Lives in Paris.

Further Reading: *Touhami Ennadre: Black Light–Lumière Noire–Schwarzes Licht*, with an essay by François Aubral. Munich/New York, 1996.

Sebastião Salgado

Fight Between a Serra Pelada Mineworker
and a Policeman, Para, Brazil 1986

This photograph is one of hundreds that Sebastião Salgado took in 1986 at the Serra Pelada goldmines. Many photographers had worked there before Salgado, but it was his pictures which first revealed to the world this inferno of the twentieth century, the hopelessness, brutality, and poverty in which people were forced to work to survive. With his photographic work, Salgado has become the advocate for the world's poorest. This photograph from the series on the Serra Pelada mineworkers is a representative example of his photographic commitment.

Salgado is a reporter, a documentary photographer, and yet at the same time a poet, even a lyric poet, in this field. He is a photographer of human pain and of the human dignity that nevertheless remains intact through all misfortune. What does the picture tell us about this? In the Serra Pelada mines huge masses of people—50,000, it is said—work in constant mud in the search for gold. Salgado has taken photos of this seething mass of humanity in such a way that one forgets these are people; one would think they were ants, or perhaps slaves building a pyramid. There are disruptions in the trudge up and down the muddy slope: one of the workers has grabbed a policeman's

gun. They face up to each other: the policeman in his uniform, the laborer clad only in a loincloth, his torso naked, his bare legs spread in an aggressive stance. Tension fills the air. What will happen? Will he manage to wrestle the weapon away? The dialogue as such is taking place on the faces of the two protagonists. The black worker is protesting. The white policeman is skeptical, uncertain. The situation is dangerous. The policeman is helpless without his weapon. This situation could escalate into rebellion.

All the questions in this photograph are touched on, and all the questions are open; this is what gives it its dynamism and tension. The pitiless rhythm of the mine is interrupted for a moment and disturbed by human "action." The laborer—the slave, although he is paid better than the overseer—has revolted against his fate. For an instant—that instant in which Salgado sees and takes the picture—he is a free man. Then the crowd will return to work and submit to their fate. Eduardo Galeano, the Uruguayan writer, has expressed this best: "These photographs will outlive their people and their author because they bear the legacy of the world regarding their naked truth and their hidden splendor." E.B.

 1944 Born in Aimores, Brazil. **1963** Study of law in Vitoria. **1967–68** Doctorate in economics from the University of São Paulo. **1969–71** Doctorate in agriculture from the Sorbonne, Paris. **1970** Acquires a Pentax. **1971–73** Works for an international coffee organization in London. **1973** Photojournalist in Paris; reports on the famine in Nigeria. **1974** Reports for *Sygma* on the revolutions in Portugal, Mozambique, and Angola . **1975–79** Works for the agency

Gamma. **1977–83** Regular travels and reportages in South America. **1979** Links with the photo agency Magnum; works for *Geo*. **1982–85** Collaboration with the organization Médecins sans Frontières. **1984** Full member of Magnum. **1986–92** Documentary project on ending physical labor. From **1994** Research into people's movements throughout the world.

Further Reading: Salgado, Sebastião. *Workers*. New York, 1993. *Salgado Sebastião: An Uncertain Grace*. New York, 1990.

For years, Sally Mann's children—two girls and a boy—posed for her as part of a relationship as consensual as any between child subject and artist parent, and far more so than most. (It is hard to stop your mother from writing a poem or short story about you, or painting you from memory, while comparatively easy to render the making of a photograph difficult if not impossible, or at least to impose your own personality on it.) Thus there is a significant element of collaboration to this project, even if final control of the imagery's messages ultimately rests with the photographer.

Untitled, Virginia, 1992

Superbly crafted as sumptuous, interpretive photographic prints in the classical tradition, these works—of which this group portrait is one example—are also consistently and extraordinarily affecting as images: intimate, startling, deeply emotional, devoid of sentiment, psychologically charged, often unsettling, revelatory. Intersecting, as they have, a time of hysteria over the representation of children's bodies and children's sexuality, they have stirred controversy and attracted a wide audience.

These pictures are not made furtively or casually. Mann uses a large-format camera, conspicuous and cumbersome; in all her images, even if not as obviously as this one, the children are aware of its presence, and of her examination of them through the lens. They are thereby made self-conscious, and must be understood as deliberately presenting themselves to their mother's scrutiny with the knowledge that total strangers will get to see the results.

Here they stand, clearly bonded, strong, defiant. Of whom? Of their mother? Or of a society that has problematized their cooperation with her? In any event, these facts remain: that, in their photographic incarnations, these children have grown into adolescence in front of the world's eyes; that their appearance at these stages of their growth are engraved on the memories of thousands of people; that what we know of them (or think we know) is only what they and their mother have chosen to tell us; and that, as Richard Avedon once said, "The moment an emotion or fact is transformed into a photograph it is no longer a fact but an opinion"—which is to say, an interpretation, a fiction. A.D.C.

1951 Born in Lexington, Virginia. From **1966** Studies at Bennington College, Vermont, and Friends World College. **1971** Learns photography at the Praestegaard Film School, the Aegean School of Fine Arts, and in the Ansel Adams Yosemite Workshop. **1974** Awarded Bachelor of Arts degree from Hollins College in Virginia. **1975** Additional Bachelor's degree in literature. Since then workshops and lectures. **1989** First solo exhibition at the Museum of Photographic Art, San Diego. **2003** Publication of *What remains*. Lives in Lexington, Virginia.

Further Reading: Mann, Sally. *Still Time*. New York, 1993.

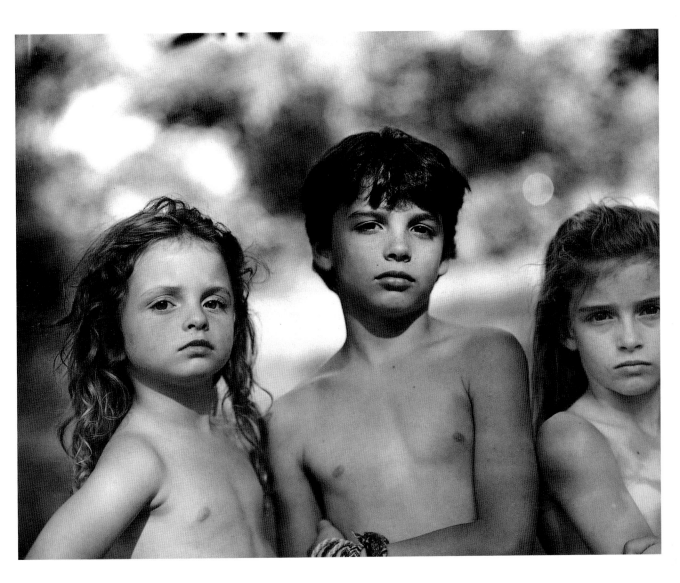

A Sudden Gust of Wind (after Hokusai) 1993

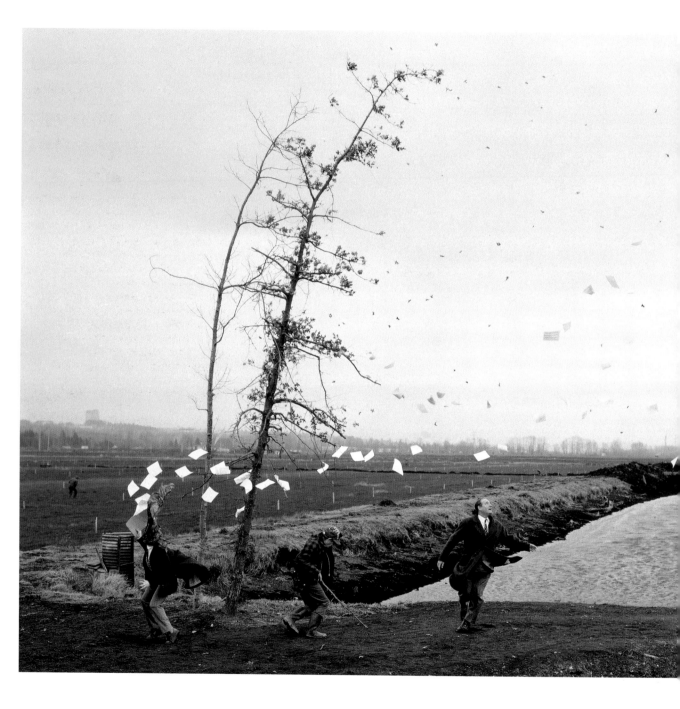

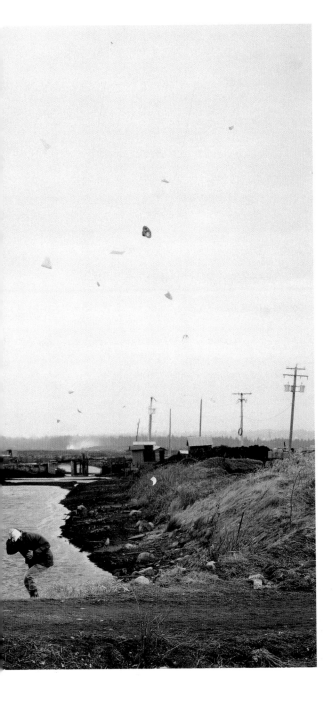

Jeff Wall

The Canadian photographer Jeff Wall began to work directorially in the 1970s, staging increasingly elaborate tableaux for the camera. He gravitated to the presentational form called the Duratrans, a backlit transparency most familiar to the average citizen in its frequent usage in airports, office buildings, and other architectural sites of the corporate state. Wall considers the Duratrans " a bureaucratic way of presenting information" because "[the] point of control, of projection … is inaccessible." These lightboxes of his, like their commercial counterparts, are large, glowing, imposing artifacts whose size—typically 8 ×16 feet—makes the settings of his images, and the figures within them, close to life-size.

Wall sees his work as operative in a charged space somewhere between conceptualism and realism, an effort to bring to the attention of his fellow citizens the power structures that underpin the global economy. Yet, for all his theoretical inclination, he deliberately produces images that are theatrically credible and consistently engaging to the eye, such as this elaborate reinterpretation of a classic work by the Japanese woodblock artist Hokusai.

This is more, however, than a mere updating of and homage to that source. The woodblock was to its day and its culture what the photograph is to ours—a comparatively affordable medium enabling the middle class to purchase and live with works of art. And Hokusai is known for his inclusion of everyday people from the working and middle class in his exquisitely rendered images. Thus Wall's citation of his precursor is highly political in its resonances.

Most of Wall's images are set in his home town of Vancouver, British Columbia, a comparatively new city (only 100 years old) with little history as such. Yet it is an economically vital international seaport with strong links to the Pacific Rim, and a population combining Native American, Asian, and European peoples. Staging this scenario in that place, replacing Hokusai's leaves and trees with paper and telephone poles, symbolizes those abrupt, transformative cultural and technological incursions, giving new meaning to the image's originally playful title. A.D.C.

1946 Born in Vancouver, Canada. **1970** Graduates from the Department of Fine Arts at the University of British Columbia, Vancouver. **1970–73** Research at the Courtauld Institute of Art, University of London. **1974–75** Lecturer in the Department of Art History at the Nova Scotia College of Art and Design in Halifax. **1976–87** Lecturer in the Centre for Arts, Simon Fraser University, Vancouver. **1978** First solo exhibition at the Nova Gallery, Vancouver. **1987** Participates in "documenta 8," Kassel. From **1987** Lecturer in the Department of Fine Arts, University of British Columbia, Vancouver. **1997** Participates in "documenta X," Kassel. Lives in Vancouver.

Further Reading: Brougher, Kerry. *Jeff Wall*. Exh. cat., The Museum of Contemporary Art, Los Angeles. Zurich/Berlin/New York, 1997.

Nan Goldin

Nan Goldin is best known for an often harsh and hard-edged first-person account of life among her own cohort, that culture of gender-bending, substance-abusing, club-going young people which constitutes a notable and notorious component of New York City's population. Goldin left home at age fourteen, began photographing at age fifteen, and attended school in Boston, where she met a number of kindred spirits. In 1978, she moved to New York, whose "downtown" scene provided her with both subject matter and showcases for her highly personal, often autobiographical commentaries on the experiences of one segment of her generation.

The gay transvestite and performance artist Stephen Tashjian, who calls himself Tabboo!, is one of those whose connection with Goldin was established in the Boston scene, and who, like her, made his way to the New York art and club scene upon graduation. Here Goldin portrays him "preparing," in T. S. Eliot's words, "a face to meet the faces that we meet." She seems to have caught him during a "backstage" moment, as if he were an actor in a dressing room, out of costume but in makeup. He has turned away momentarily from the mirror into which his partner still stares to present himself to Goldin's lens, and to our eyes, in all of his complexity. His body is clearly male, the gesture of his hand on his companion's shoulder feminine, his expression somewhere in between. He stands for this moment hidden behind his mask, yet confronting us with both himself and his adopted role before turning back to contemplate and perhaps improve on his projected image.

Coming of age in the first cohort of photographers to take color photography for granted as an option, Goldin began working in black and white but switched to color early on, and has used it exclusively ever since. Like Diane Arbus and Mary Ellen Mark, she works within the loose confines of documentary form but emphasizes transactional, environmental portraiture. Most of her early images were made in the relentless glare of on-camera flash. Yet there is a lyrical aspect to Goldin's project as well, which has become more obvious in her recent work. A.D.C.

 1953 Born in Washington, D.C.; raised in Boston. From 1969 Involved with photography. From 1973 Color photos. Attends evening classes with Henry Horenstein at the New England School of Photography. First solo exhibition at Project Inc. in Cambridge, Massachusetts. 1974 Meets Lisette Model. Begins studying at the School of the Museum of Fine Arts, Boston. 1978 Moves to New York. 1984 First publication, *The Ballad of Sexual Dependency*; parallel slide show consisting of c. 700 slides with music, constantly revised. In 1986 first presented at the Burden Gallery, Aperture Foundation, New York, as well as in cinemas, museums and at film festivals. 1991, 1992 DAAD grant in Berlin. 1992, 1994 Travels through Asia. 1995 Film *I'll Be Your Mirror*, together with Edmund Coulthard, made for the BBC. Lives in New York.

Further Reading: Sussman, Elisabeth and Armstrong, David (eds). *Nan Goldin: I'll Be Your Mirror*. Zurich/Berlin/New York, 1996.

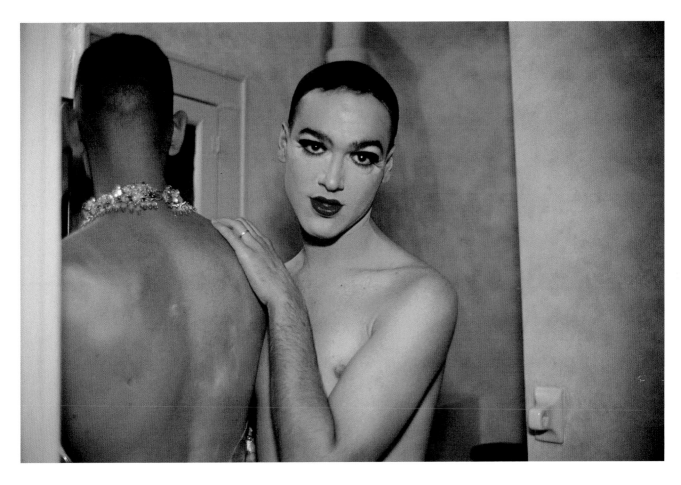

Weymouth, Dorset, from "Think of England," 1996-2000

Spirited wit is hardly the first thing that springs to mind as one of the great strengths of contemporary photography. Photographers eager to be taken seriously as artists, in particular, seem to have lost their sense of humor somewhere along the road to the art market. Thank goodness there's Martin Parr.

Whereas some of his colleagues tend to take themselves a little too seriously, Parr is able to laugh at photography and, with that, at himself. His very British form of sarcasm is all the more cutting, his use of color almost lurid. The colors make the sheer banality of the subject matter cringingly embarrassing and refreshingly tacky.

At the age of thirty, Parr abandoned black-and-white photography and embraced color. It was in the days when Margaret Thatcher was prime minister, and Parr had soon heard enough of her waxing lyrical about a national revival. He focused his lens on the very situations that showed the social veneer crumbling, such as his pictures of families on their weekend outings to the run-down, litter-strewn seaside resorts near Liverpool. Parr also tore away the mask by turning his attention to eating habits – jostling at the buffet, in the fast-food restaurant or at the supermarket. To get even closer to his subject matter, Parr made the change from medium to small format in 1995 and used a ring flash even in daylight conditions for a merciless, shadow-free portrayal. He sent cheap laser prints of his "ugly, colorful and bright" *Common Sense* series to dozens of exhibitions around the world simultaneously.

"I love England, but sometimes I get very annoyed by it," said Parr, referring to his *Think of England* series from the late 1990s. He shows his compatriots sunbathing with their UV shades and their pot bellies, eating their greasy breakfasts or, in this case, having picnics. Disrespectfully, he hangs a Union Jack like a curtain in front of a seated woman's face. Without differentiating between them, the lawn, the floral dress, the flag, and the folding chair all become part of a single decorative carpet of color. It is one of those wonderfully boring situations that have always fascinated Parr, without pointing a finger at anybody.

P.S.

Born in Epsom, Surrey, in **1952**. Studied at Manchester Polytechnic from **1970-73**. Initially worked in black and white, including his series on non-conformist chapels. Has worked entirely in color since **1982**. In the mid-**1980**s he took photographs of cross-channel shoppers in the hypermarkets of Boulogne, made a series about the relationship between man and his automobile, and another about bored couples. Apart from his own photographs, Parr also compiled a collection of *Boring Postcards* from the 1930s and 1940s. He took 468 photos of all the streets, houses and shops in the small town of Boring, Oregon.

He created a series on tourism. He had his own photo taken in studios throughout the world. In **1994** he became a full member of Magnum. In **1995** he changed from middle format to small format. He laser-printed his *Common Sense* series. The series *Think of England* was produced in the late **1990**s. In **2002** he had a major retrospective exhibition at the Barbican Art Gallery and National Museum, London. Parr has also curated successfully, e.g. in **2004** for the Rencontres International de la Photographie in Arles, and was appointed Professor of Photography at The University of Wales in Newport. Further Reading: *Exh. cat. Martin Parr*, London 2002

List of Illustrations

LUCIEN CLERGUE
Nude with Stars, 1971, gelatin silver,
collection of the photographer
Dying Bull, Nîmes, 1976, gelatin silver,
collection of the photographer

IMOGEN CUNNINGHAM
Pregnant Nude, 1959, gelatin silver, 81.3 x 66
cm, Imogen Cunningham Trust, Berkeley
Nude, 1932, gelatin silver
Self-Portrait (1933)

JOHN DEAKIN
Francis Bacon, 1952, gelatin silver,
48.3 x 57 cm, Condé Nast Publications, Vogue
Archives, London
Joy Parker, Actress, 1953, gelatin silver,
38 x 30.5 cm, Condé Nast Publications, Vogue
Archives, London
Portrait (probably by Frank Auerbach)

ROBERT DOISNEAU
Kiss in front of the Hôtel de Ville, Paris, 1950
(*Le baiser de l'hôtel de ville*), gelatin silver,
18 x 24 cm, Rapho Agency/Focus
Portrait (private)

WILLIAM EGGLESTON
Untitled, 1980, dye-transfer print, 40.6 x 51
cm, collection of the artist
Portrait by Winston Eggleston

ALFRED EISENSTAEDT
*The Dirigible Graf Zeppelin Being Repaired
Over the South Atlantic on a Flight to Rio de
Janeiro*, 1934 (*Das Luftschiff "Graf Zeppelin"
wird auf dem Flug nach Rio de Janeiro über den
Südatlantik repariert*), gelatin silver, 28 x 35.2
cm, Rheinisches Landesmuseum, Bonn
Portrait (London, 1932, anonymous)

ED VAN DER ELSKEN
Durban; South Africa, 1959–60, gelatin silver
(vintage), 23.9 x 30.2 cm, Museum Ludwig,
Cologne, ML/F 1977/255, Gruber Collection
Portrait (1990) by Paul Levitton

TOUHAMI ENNADRE
Hands, 1978, gelatin silver, 150 x 130 cm,
collection of the artist
Trance, 1993–95, gelatin silver, 150 x 150 cm,
collection of the artist
Portrait (private)

HUGO ERFURTH
Otto Dix with Brush, 1929 (*Otto Dix mit
Pinsel*), oil pigment print, 47 x 37.5 cm,
Rheinisches Landesmuseum, Bonn
Austrian Writer Franz Blei, 1914 (*Der
österreichische Schriftsteller Franz Blei*),
oil pigment print, 28 x 19 cm, Münchner
Stadtmuseum, Munich
Portrait (1940) by L. Fritz Gruber

WALKER EVANS
*Bud Fields and His Family, Hale County,
Alabama*, 1936, gelatin silver, 35.5 x 28 cm,
Münchner Stadtmuseum, Munich
Subway Portrait, New York, 1938–40,
gelatin silver, 11 x 13 cm
Portrait (1971) by Arnold Crane

ANDREAS FEININGER
Hudson River Waterfront, New York, 1942,
gelatin silver, 61 x 50.8 cm, Institut für
Kulturaustausch, Tübingen
Portrait (1997) by Volker Hinz, Hamburg,
Institut für Kulturaustausch, Tübingen

GISÈLE FREUND
Virginia Woolf, 1939, dye-transfer print,
40 x 30 cm, Nina Beskow Agency, Paris
*André Gide under Leopardi's Death Mask in
his Apartment at Rue Vanneau, Paris*, 1939
(*André Gide unter der Totenmaske von Leopardi
in seiner Wohnung rue Vanneau, Paris*),
dye-transfer print, 40 x 30 cm, Nina Beskow
Agency, Paris
Self-Portrait

LEE FRIEDLANDER
Galax, Virginia, 1962, gelatin silver, 28 x 35.6
cm, Fraenkel Gallery, New York
Self-Portrait (1969), San Francisco Museum
of Modern Art

MARIO GIACOMELLI
I Have No Hands to Caress My Face, 1961–63
(*Io non ho mani che mi accarezzino il volto*),
gelatin silver, 39 x 30 cm, collection of the
artist
Scanno, 1957, gelatin silver, 29.5 x 38 cm,
collection of the artist
Portrait by Paolo Mengucci

RALPH GIBSON
Infanta, 1987, 22 x 15.8 cm, Ralph Gibson,
Lustrum Press
In Situ, 1988, Ralph Gibson, Lustrum Press
Portrait (1998) by Lesley Loudon

NAN GOLDIN
*Jimmy Paulette and Tabbool in the bathroom,
NYC*, Cibachrome, 75 x 100 cm, Nan Goldin
Studio, New York
Portrait by Christine Frenzl

ERNST HAAS
Homecoming Prisoners, Vienna, 1947 (*Kriegs-
heimkehrer, Wien*) gelatin silver (vintage),
18 x 12 cm, Museum Ludwig, Cologne,
Stiftung, Gruber, ML/F 1983/122
New York, 1966, gelatin silver
Portrait (Munich, 1948, anonymous)

ROBERT HÄUSSER
J.R. 5–9–70, 1970, gelatin silver, 50 x 60 cm,
collection of the artist
Bicyclist, 1953 (*Radfahrer*), gelatin silver,
50 x 55 cm, collection of the artist, WVZ 53-4
Self-Portrait (private)

HEINZ HAJEK-HALKE
Black and White Nude, 1936 (*Schwarz-weisser
Akt*), gelatin silver (print c. 1977), 50 x 60 cm,
estate of Heinz Hajek-Halke/Michael Ruetz,
Berlin
Eva-Chançon, c. 1932, gelatin silver, Galerie
Bodo Niemann, Berlin
Portrait courtesy of Michael Ruetz, Berlin

LEWIS W. HINE
*Sunday Noon, Some of the Newsboys Returning
Sunday Papers*, Hartford, Connecticut, March
1909, gelatin silver (vintage), 11.5 x 16.6 cm,
Dietmar Siegert Collection, Munich
Portrait (1935, anonymous), courtesy of the
George Eastman House, Rochester, New York

DAVID HOCKNEY
The Skater, New York, December 1982,
Polaroids, 66 x 49.5 cm
Portrait by Reinhold Misselbeck, Herbert
Locher Collection

HORST P. HORST
Mainbacher Corset, Paris, 1939, gelatin silver,
24.2 x 19.2 cm, Museum Ludwig, Cologne,
Stiftung Gruber, ML/F 1984/66
Still Life, 1937, gelatin silver, 35.2 x 27.5 cm,
Museum Ludwig, Cologne, Stiftung R. Wick,
MF/F 1992/175
Portrait, © 1991, Martin Hugo Maximilian
Schreiber

LOTTE JACOBI
Käthe Kollwitz, 1929, gelatin silver (vintage),
34 x 25.6 cm, Dietmar Siegert Collection,
Munich
Girl, Berlin, c. 1930, gelatin silver, 20.6 x 15.8
cm, Fotografische Sammlung, Museum
Folkwang, Essen, Inv. No. 1627/82
Self-Portrait, Münchner Stadtmuseum,
Munich

ANDRÉ KERTÉSZ
The Fork, 1928 (*La fourchette, Paris*), gelatin
silver (vintage), 19.4 x 24 cm, Museum
Ludwig, Cologne, ML/F 1977/381, Gruber
Collection
Swimmer Under Water, 1917 (*Nageur sous
l'eau, Esztergom, Hongrie*), gelatin silver
(print c. 1960), 19 x 24.7 cm, Museum
Ludwig, Cologne, ML/F 1977/394, Gruber
Collection
Portrait (1930s, anonymous)

WILLIAM KLEIN
Heads, New York, 1954, gelatin silver,
30 x 24 cm, Magnum Photos
Portrait by Björn Rantil

ALBERTO KORDA
Che Guevara, 1960, gelatin silver, 30 x 40 cm
Quixote Atop a Lamppost, Havana, 1959
(*El Quijote de la Farola, La Habana*), gelatin
silver, 40 x 30 cm, Wolfgang Smuda Collection, Munich
Portrait (anonymous)

JOSEF KOUDELKA
Czechoslovakia, 1968, gelatin silver,
18 x 24 cm, Magnum Photos

DOROTHEA LANGE
Migrant Mother, Nipomo, California, 1936,
gelatin silver (print c. 1950), 32.8 x 26.1 cm,
Museum Ludwig, Cologne, ML/F 1977/442,
Gruber Collection
*Field Hands on a Cotton Plantation, Greene
County, Georgia*, 1937, gelatin silver, The
Library of Congress, Washington
Portrait (1955) by Paul S. Taylor

JACQUES-HENRI LARTIGUE
Grand Prix of the Automobile Club of France,
1912, gelatin silver (vintage), 20.8 x 28.7 cm,
Museum Ludwig, Cologne, MF/F 1977/431,
Gruber Collection
Portrait by Eric Brissaud

HELEN LEVITT
New York, c. 1940, gelatin silver, 27.9 x
35.6 cm, Laurence Miller Gallery, New York
Self-Portrait (1944/45), © Helen Levitt

SALLY MANN
Emmett, Jessie, and Virginia, 1989, gelatin
silver, 20.3 x 25.4 cm, Edwynn Houk Gallery
Untitled, Virginia, 1992, 20.3 x 25.4 cm,
Edwynn Houk Gallery
Portrait (1992), © Jessie and Virginia Mann

ROBERT MAPPLETHORPE
Untitled (*Male Nude*), 1981, gelatin silver,
38.1 x 38.5 cm, Museum Ludwig, Cologne, on
permanent loan from Jeane von Oppenheim,
ML/F Dep. 1989/209
Portrait by Mark Thompson

WILL MCBRIDE
Overpopulation, 1968, gelatin silver,
26.7 x 40.5 cm, Museum Ludwig, Cologne,
Stiftung Uwe Scheid, ML/F 1995/122

JOEL MEYEROWITZ
Vivian, 1980, print on Ektacolor RC,
27.9 x 35.6 cm (paper format), Joel Meyerowitz Studio, New York
Portrait by Ariel Meyerowitz

LISETTE MODEL
Coney Island Bather, New York, 1939–41,
gelatin silver, 34.5 x 27.2 cm, National
Gallery of Canada, Ottawa
Running Legs, Fifth Avenue, New York, 1940–
41, gelatin silver, 49.4 x 39.4 cm, National
Gallery of Canada, Ottawa
Portrait by Imogen Cunningham, © Imogen
Cunningham Trust, Berkeley

TINA MODOTTI
Workers' Demonstration, Mexico, May 1, 1929,
platinum, 20.5 x 18 cm
Worker's Hands, 1926, platinum
Portrait (1924) by Edward Weston, © Center
for Creative Photography, Arizona Board of
Regents

LÁSZLÓ MOHOLY-NAGY
Self-Portrait, Photogram, 1926, bromide print,
23.1 x 17.6 cm, Fotografische Sammlung,
Museum Folkwang, Essen, Inv. No. 100-7a/3
Portrait (anonymous)

STEFAN MOSES
*Self in the Mirror—Ernst Bloch and Hans
Mayer*, 6 August 1963 ("Selbst im Spiegel"—
Ernst Bloch und Hans Mayer, Tübingen), gelatin
silver, 30 x 40 cm, collection of the artist
*Child and Cat with Chinese Animal Masks,
Ammersee, Bavaria*, 1965 (*Kind und Hauskatze mit chinesischen Tiermasken, Ammersee,
Bayern*), gelatin silver, 30 x 40 cm, collection
of the artist
Self-Portrait, collection of the artist

MARTIN MUNKÁCSI
Boys on the Shore of Lake Tanganyika, 1931
(*Néger Fiúk A Tanganyika-Tó—Partján*),
gelatin silver, 30.5 x 23.3 cm, F.C. Gundlach
Collection
Uncle Robert's Poor Being Served Lunch, 1926
(*Róbert Bácsi Szegényei Ebédet Kapnak*),
gelatin silver, 23.2 x 29 cm
Portrait (anonymous), © Joan Munkácsi
courtesy Howard Greenberg Gallery, New
York

ARNOLD NEWMAN
Max Ernst, 1942, gelatin silver (vintage),
24.4 x 19.1 cm, Museum Ludwig, Cologne,
ML/F 1977/554, Gruber Collection
Igor Stravinsky, 1946, gelatin silver, 18.3 x
34.4 cm, Museum Ludwig, Cologne, ML/F
1977/557, Gruber Collection

HELMUT NEWTON
They're Coming!, 1981, gelatin silver (print
c. 1983), 22.4 x 22.8 cm, Museum Ludwig,
Cologne, Stiftung Gruber, ML/F 1984/13
Arielle After a Haircut, 1982, gelatin silver
Portrait (private)

PAUL OUTERBRIDGE, JR.
Shower for Mademoiselle, c. 1937
Ide Collar, 1922, platinum

GORDON PARKS
Ethel Shariff in Chicago, 1963, gelatin silver
Muhammad Ali, 1970, gelatin silver
Portrait (private)

MARTIN PARR
Sedlescombe, from *Think of England*,
1996–2000, c-print, Magnum Photos
Weymouth, Dorset, from *Think of England*,
1996–2000, c-print, Magnum Photos
Portrait by unknown studio photographer,
collection of Martin Parr

IRVING PENN
Pablo Ricasso, 1957, gelatin silver (vintage),
34.1 x 34.1 cm, Museum Ludwig, Cologne,
ML/F 1977/591, Gruber Collection
Portrait by Björn Rantil

WALTER PETERHANS
Portrait of the Beloved, 1929 (*Bildnis der
Geliebten*), gelatin silver, 38.6 x 46.0 cm,
Bauhaus-Archiv, Berlin, Inv. 7217
Pythagorean Paradigm, 1929 (*Pythagorischer
Lehrsatz*), gelatin silver
Portrait (Berlin, 1927) by Grete Stern,
Bauhaus-Archiv, Berlin

ELIOT PORTER
Pool in a Brook, Pond Brook, New Hampshire,
1953, dye-transfer print, 25.4 x 20.3 cm,
Amon Carter Museum, Fort Worth, Texas
*Sculptured Rock, House Rock Canyon, Grand
Canyon, Arizona*, June 13, 1967
Portrait (1957) by Ellen Auerbach

MAN RAY
Kiki—Le Violon d'Ingres, 1924, gelatin silver
(print c. 1965), 38.6 x 30 cm, Museum
Ludwig, Cologne, ML/F 1977/648, Gruber
Collection
Rayograph—Lee Miller (from the series
Electricité), 1931, photogravure, 26 x 20.5 cm,
Dietmar Siegert Collection, Munich
Portrait by Imogen Cunningham, © Imogen
Cunningham Trust, Berkeley

ALBERT RENGER-PATZSCH
Beech Wood, 1936 (*Buchenwald*), gelatin
silver, 40 x 30 cm, Ann and Jürgen Wilde
Collection, Cologne
"Katharina" Colliery in Essen, 1954, (*Zeche
"Katharina" in Essen*), gelatin silver (vintage),
22.4 x 14.3 cm, Museum Ludwig, Cologne,
ML/F 1993/112, Gruber Collection
Portrait (1959) by Sabine Renger

ALEXANDER M. RODCHENKO
Somersault, 1936, gelatin silver (print c. 1950), 40.5 x 27 cm, Museum Ludwig, Cologne, ML/F 1978/1110, Gruber Collection
Trumpet-Playing Pioneer, 1930, gelatin silver (print c. 1950), 37 x 29.5 cm, Museum Ludwig, Cologne, ML/F 1978/1065, Gruber Collection
Self-Portrait (1931)

WILLY RONIS
Le petit parisien, 1952, gelatin silver, collection of the photographer
Strike at Citroën, Paris, 1938, gelatin silver, collection of the photographer

SABASTIÃO SALGADO
Fight Between a Serra Pelada Mineworker and a Policeman, Para, Brazil, 1986 (*Disputa entre trabalhadores da mina de ouro da Serra Pelada e um membro polícia militar do estrado do Parà, Brasil*), gelatin silver, 23.6 x 30 cm, Magnum Photos
Portrait by Björn Rantil

ERICH SALOMON
Ah, le voilà! Le roi des indiscrets (*It's that Salomon Again!*), Paris, 1931, gelatin silver, 18 x 24 cm, Bildarchiv Preussischer Kulturbesitz, Berlin
Night Session of the German and French Ministers at the War Debts Conference in The Hague, January 1930, gelatin silver (print c. 1955), 27.8 x 36 cm, Museum Ludwig, Cologne, ML/F 1977/685, Gruber Collection
Portrait (c. 1930, anonymous)

AUGUST SANDER
Young Farmers in Their Sunday Best, Westerwald, 1913 (*Jungbauern im Sonntagsstaat, Westerwald*), gelatin silver (print c. 1950), 30.4 x 20.5 cm, Museum Ludwig, Cologne, ML/F 1977/705, Gruber Collection
Baker, 1928 (*Konditormeister*), gelatin silver, 29.9 x 21.0 cm, Münchner Stadtmuseum, Munich
Portrait by Chargesheimer, courtesy of the photographic collection of the Museum Ludwig, Cologne

DAVID SEYMOUR
A Hand Grenade Attack, Spain, 1936, gelatin silver, 20 x 25.3 cm, Magnum Photos
Portrait (anonymous)

CINDY SHERMAN
Untitled Film Still, #21, 1978, gelatin silver, 20.3 x 25.4 cm, Metro Pictures, New York

MALICK SIDIBÉ
Twist, 1965, gelatin silver, 50 x 60 cm, private collection
Dance Party, 1972, gelatin silver, 50 x 60 cm, private collection
Portrait (anonymous)

EUGENE SMITH
The Wake, 1950, gelatin silver, 22.2 x 33.1 cm, Center for Creative Photography, The University of Arizona, Tucson
Portrait (Africa, 1954) by Neville Grant, © Courtesy of the Center for Creative Photography, Arizona

EDWARD STEICHEN
Richard Strauss, 1904, gum bichromate (vintage, 33.5 x 21.8 cm, Dietmar Siegert Collection, Munich
Charlie Chaplin, 1931, bromide (vintage), 25 x 19.8 cm, Museum Ludwig, Cologne, ML/F 1977/790, Gruber Collection
Portrait by Lotte Jacobi, Münchner Stadtmuseum, Munich, © Lotte Jacobi Collection, University of New Hampshire

OTTO STEINERT
Pedestrian's Foot, Paris, 1950 (*Ein-Fuss-Gänger*), gelatin silver (vintage), 28.7 x 40 cm, Museum Ludwig, Cologne, ML/F 1977/818, Gruber Collection
Children's Carnival, 1971 (*Kinderkarneval*), bromide print (vintage), 30 x 39.5 cm, Photographic Collection, Museum Folkwang, Essen, Inv. No. 65/129
Portrait by Lotte Jacobi, Münchner Stadtmuseum, Munich, © Lotte Jacobi Collection, University of New Hampshire

ALFRED STIEGLITZ
Steerage, 1907, chloride print (vintage), 11 x 9.2 cm, Alfred Stieglitz Collection, The Art Institute of Chicago
Exhibition in the 291 gallery, New York, 1915
Portrait by Lotte Jacobi, Münchner Stadtmuseum, Munich, © Lotte Jacobi Collection, University of New Hampshire

PAUL STRAND
The Family, Luzzara, Italy, 1953, gelatin silver, 24 x 30 cm, Paul Strand Archive, Aperture Foundation
Portrait by Hazel Kingsbury

JOSEF SUDEK
A Walk in the Magic Garden, 1954–59 (*Procházka po kouzelné zahrádce*), 18 x 24 cm, Arts and Crafts Museum, Prague, Inv. UPM GF-32.202
Roses, 1956, gelatin silver (vintage), 29.3 x 24 cm, Dietmar Siegert Collection, Munich
Self-Portrait (probably 1914)

YEVGENY A. TSCHALDEY
The Reichstag, 1945, gelatin silver, 49 x 39 cm, Anna Bibicheva-Tschaldey, Moscow
The Sea of War, Arctic Ocean, 1941, gelatin silver, 28.2 x 40 cm, Anna Bibicheva-Tschaldey, Moscow
Portrait (private)

UMBO
The Latest Offer—In Profile, 1928 (*Das neueste Angebot en profil*), gelatin silver, 23.6 x 17.7 cm, private collection
Ruth. Her Hand, 1927 (*Ruth. Die Hand*), gelatin silver, 22.4 x 16.8 cm, private collection *Self-Portrait* (1952), print from Lothar Schnepf, Cologne

JEFF WALL
A Sudden Gust of Wind (after Hokusai), 1993, large transparency on lightbox, 229 x 377 cm, Tate Gallery, London

WEEGEE
The Critic, New York, 1943, gelatin silver (vintage), 27.7 x 35.3 cm, Sprengel Museum, Hannover, on permanent loan from the Ann and Jürgen Wilde Collection
Lovers at the Movies, c. 1940, infra-red photograph, gelatin silver (vintage), 27 x 34.5 cm, Dietmar Siegert Collection, Munich
Portrait with the Speed Graphic (1942, anonymous)

EDWARD WESTON
Oceano, 1936, gelatin silver, 19.2 x 24 cm, Münchner Stadtmuseum, Munich
Cabbage Leaf, 1931, gelatin silver, 18 x 23 cm, Lane Collection
Portrait (c. 1920, anonymous, attributed to Johan Hagemeyer), © Center for Creative Photography, Arizona Board of Regents

GARRY WINOGRAND
Untitled, 1950s, gelatin silver, 26.2 x 33.7 cm, Center for Creative Photography, The University of Arizona, Tucson
Portrait (1952) by Ed Feingersh

WOLS
Untitled, n.d., gelatin silver
Self-Portrait, n.d., gelatin silver

HEINRICH ZILLE
Nine Boys Practicing Handstands, before 1900 (*Neun Jungen üben Handstand*), gelatin silver, 20.7 x 26.2 cm, Berlinische Galerie, Berlin
Cobbler Shop, 1899 (*Schusterwerkstatt*), gelatin silver, 8.9 x 11.1 cm, Berlinische Galerie, Berlin
Portrait by H.-J. Preetz-Zille